WILD ANIMALS
STRANGE, DANGEROUS & WONDERFUL

WILD ANIMALS
STRANGE, DANGEROUS & WONDERFUL

TOM JACKSON AND BARRY MADDEN

Copyright © 2025 Amber Books Ltd

This material has been previously published as three books:
Endangered Animals, *Dangerous Animals* and *Strange Animals*

Published by Amber Books Ltd
United House
North Road
London N7 9DP
United Kingdom

www.amberbooks.co.uk
Facebook: amberbooks
YouTube: amberbooksltd
Instagram: amberbooksltd
X(Twitter): @amberbooks

All rights reserved. With the exception of quoting brief passages for the purpose of review
no part of this publication may be reproduced without prior written permission from the
publisher. The information in this book is true and complete to the best of our knowledge.
All recommendations are made without any guarantee on the part of the author or publisher,
who also disclaim any liability incurred in connection with the use of this data or specific details.

ISBN: 978-1-83886-531-3

Project Editors: Michael Spilling and Anna Brownbridge
Designers: Mark Batley and Keren Harragan
Picture Research: Terry Forshaw

Printed in China

Contents

Introduction	6
Dangerous Animals	8
Endangered Animals	100
Strange Animals	196
Index	286
Picture Credits	288

Introduction

We share this world with a multitude of wonderful creatures, from tiny insects that go about their lives largely unnoticed, to huge marine mammals that enthrall us with their size and majesty. In this book, you will be introduced to some of the world's most incredible animals. Impressive for the skills they possess as evolved hunters, and masters of their environment;

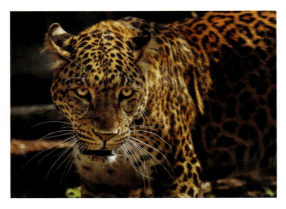

dangerous in their role as ruthless predators, possessing speed, strength and acutely tuned senses. Unfortunately, most of the animals you will read about are under threat from habitat destruction, poaching, human encroachment and ignorance meaning many now only exist in captivity. Collectively we need recognize not just the great importance of nature for its own sake, but also for our own wellbeing. We hope this book inspires you to look afresh at the wild, and help conserve wild places and things so that the creatures featured, together with many others, can prosper.

ABOVE:
The jaguar is the largest cat species in the Americas and the third largest in the world.

OPPOSITE:
A giant of the African bush, there are two recognised species of African elephant, the African bush (savannah) elephant (as shown here), and the smaller African forest elephant. They use their trunks to suck up water and to gather food, and their strong tusks to strip bark, dig for water or fight.

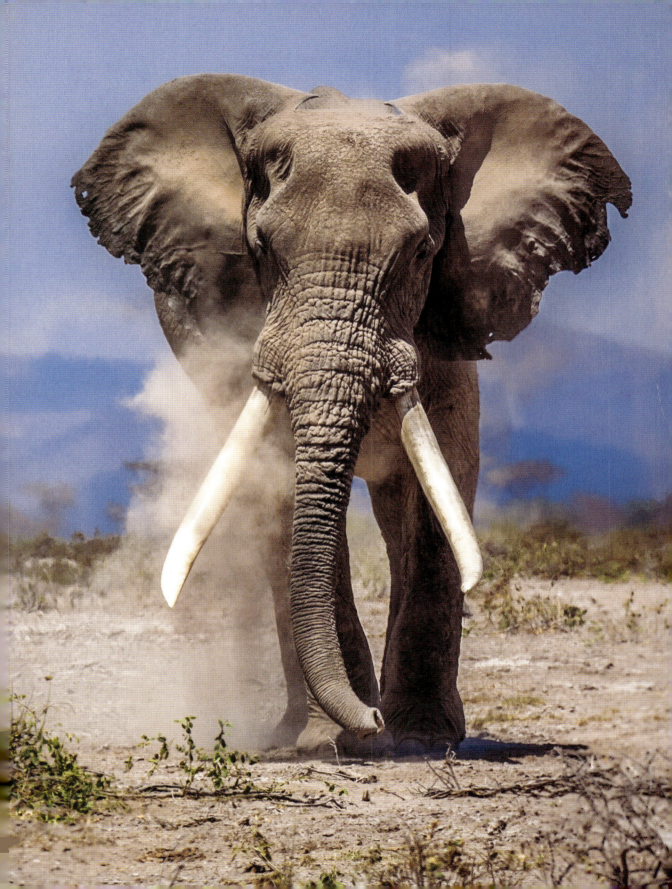

Dangerous Animals

Some animals, such as the African elephant, are familiar and revered; others, particularly top predators like lions, are respected and feared. Increasing population and associated urbanisation results in much pressure on wildlife and wild habitats. In some countries, such as the UK, all apex predators have been exterminated over past centuries, and the remaining wildlife is under constant threat.

To balance this, in some areas of mainland Europe, changes to rural lifestyles and economics, with an associated movement of populations to cities, has allowed recolonisation by wolves, bears and lynx.

Also included are some of South and Central America's most amazing predatory animals, showcasing their special features and highlighting their particular skills.

In addition, Australasia is home to some of the most venomous snakes, spiders and jellyfish inhabiting the planet.

This chapter also showcases some of the ocean's apex predators, those whose size, speed, agility, intelligence and power are such that they are unchallenged in their domains. Some, like the great white shark, will be old acquaintances; others, such as the lionfish, may be less well known but are equally as deadly. All play out their lives in an environment alien to us, but form part of an intricate web of life, bound together as part of a fragile ecosystem more prolific and bounteous that anywhere else on Earth.

OPPOSITE:
Great white sharks are notable for their size, with larger females growing up to 6.1 metres (20ft) in length.

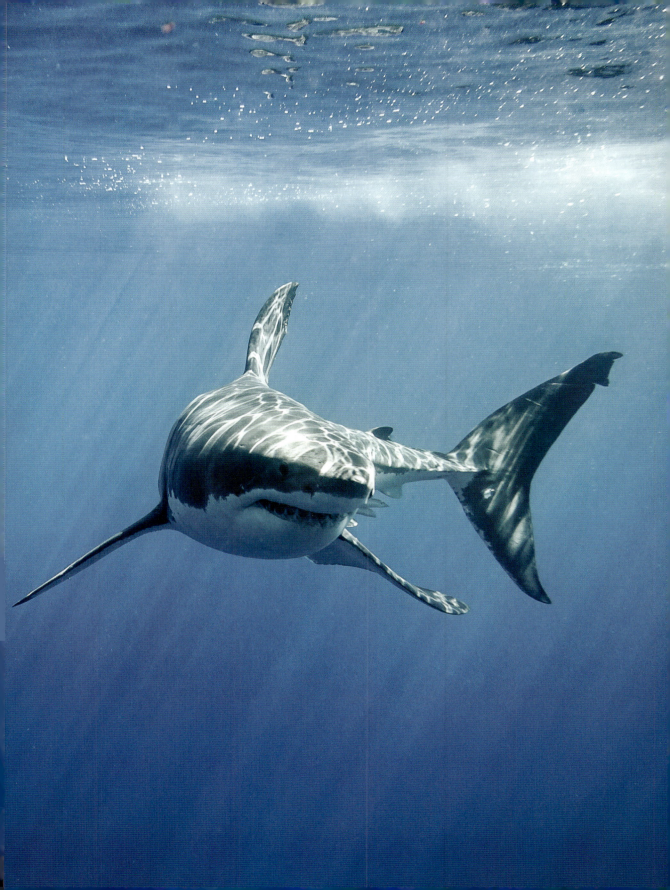

Bull elephants fighting
Weighing in excess of 5.5 tonnes (5.4 tons) and reaching a shoulder height of up to 4m (13ft), bull elephants are impressively strong animals. Here, two mature bulls tussle for mating rights with a group of females. Fighting is intense and sometimes results in serious injury or death.

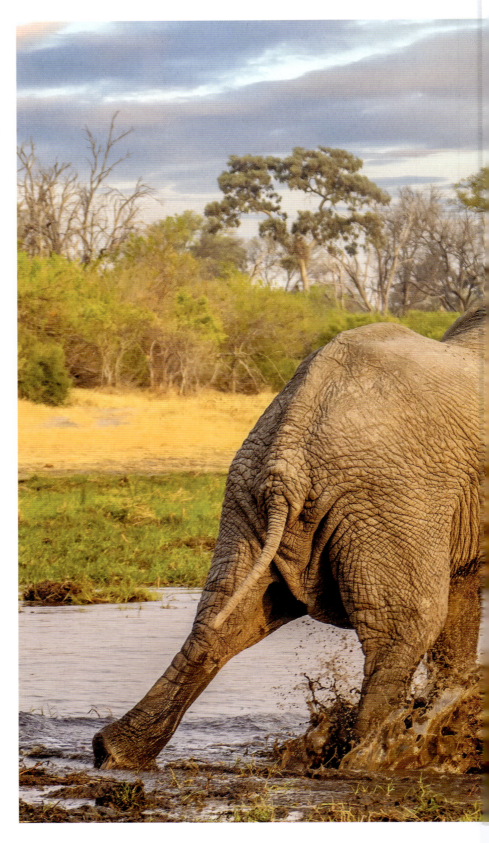

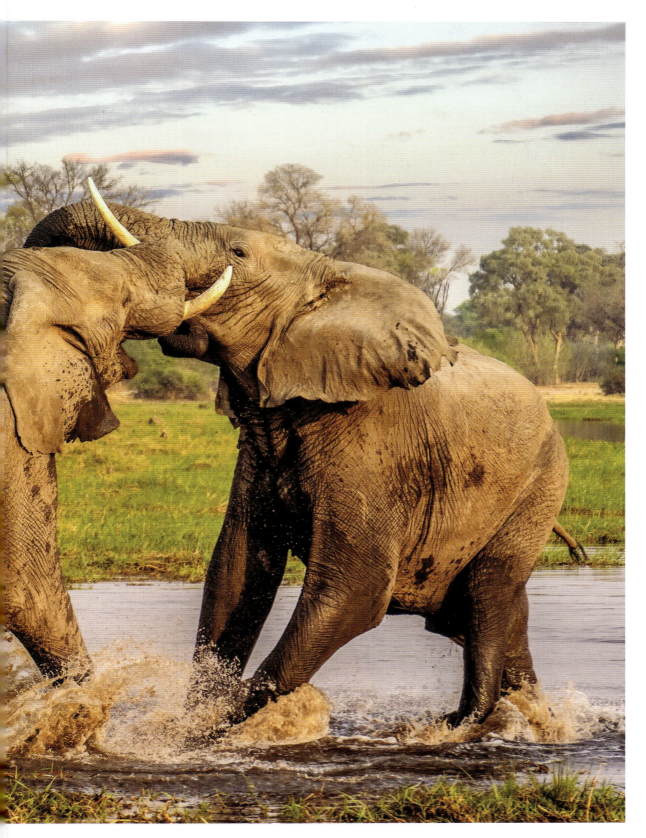

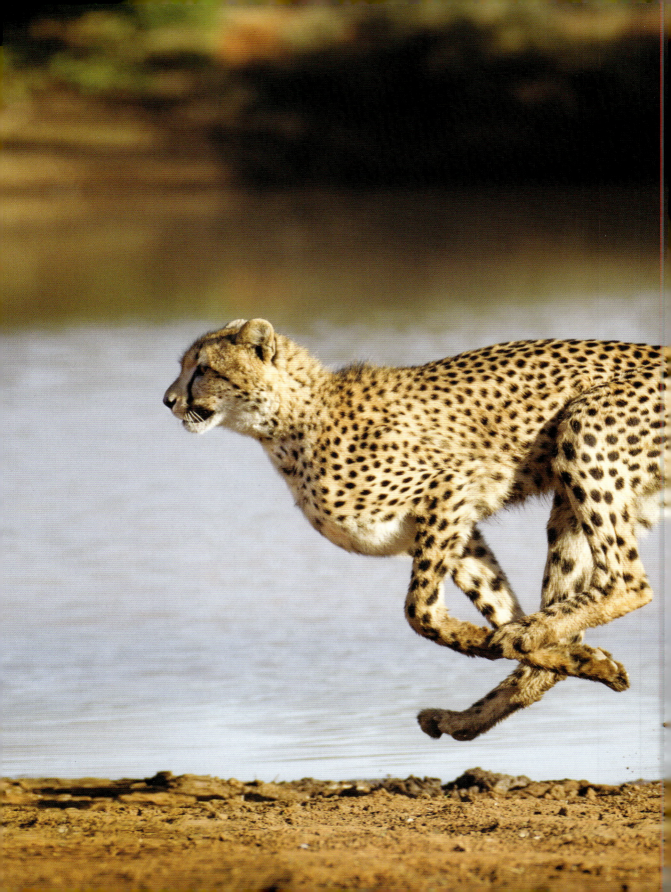

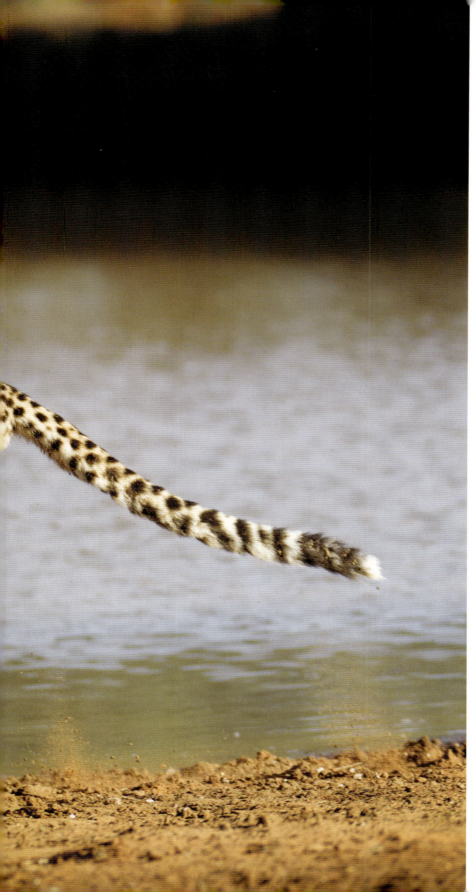

Cheetah running at high speed
Cheetahs have long legs and heavily weighted tails to provide maximum manoeuvrability when hunting at high speed. The body is covered in small round, black spots forming a pattern unique to the individual. Cheetahs typically reach shoulder heights of 70–90cm (27–35in), with a body length of 115–150cm (45in–59in).

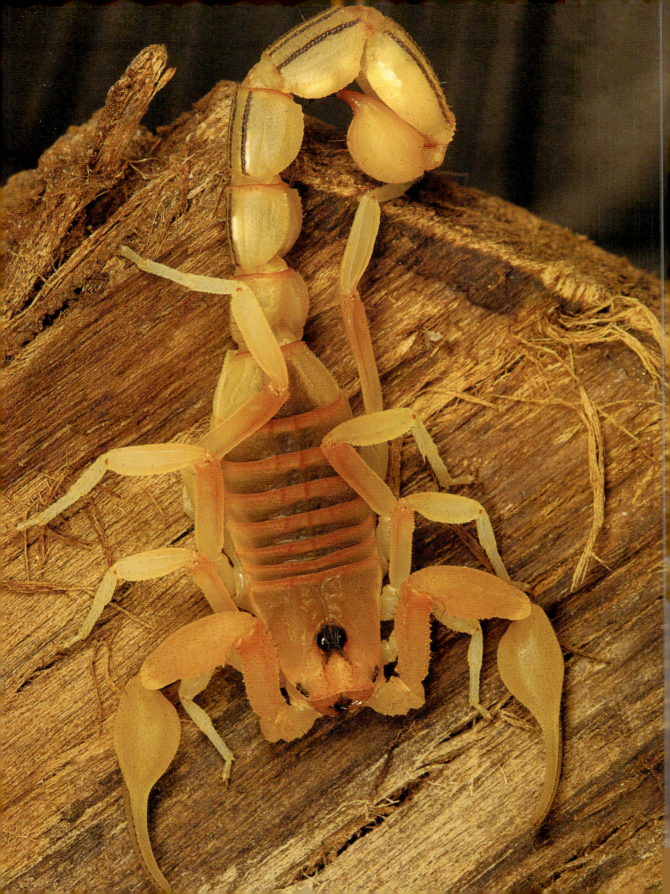

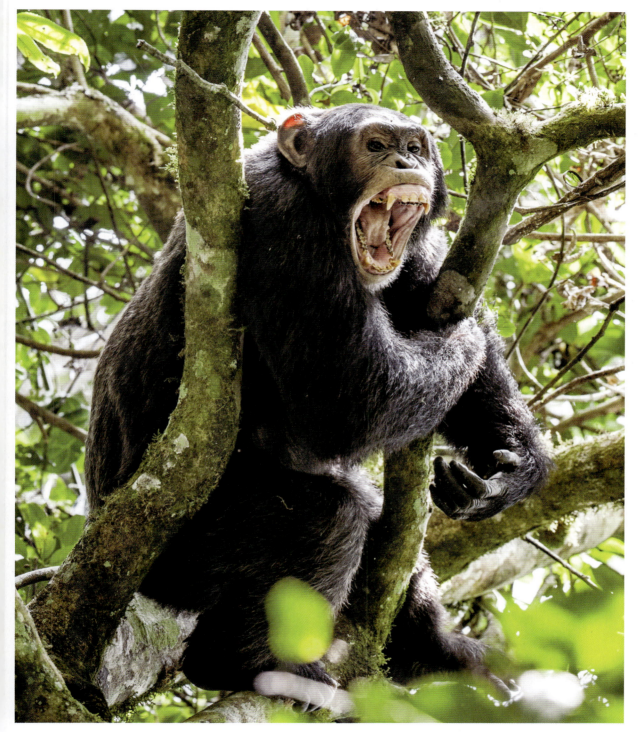

OPPOSITE:
Fat-tailed scorpion
A resident of the desert regions of North Africa, this scorpion, measuring 7–9cm (2.7–3.5in), is one of the deadliest on earth. In fact, its scientific name 'Androctonus' roughly translates from Greek as 'man-killer'. If untreated, its venom will attack the central nervous system and can cause death within a few hours.

ABOVE:
Chimpanzee
Chimpanzees are our closest living relatives. They occupy tropical areas of Africa where they live in hierarchical social groups governed by a dominant male. Groups are highly territorial and will aggressively defend their patch from other troops. Chimpanzees communicate by using facial expressions and various vocalisations.

15

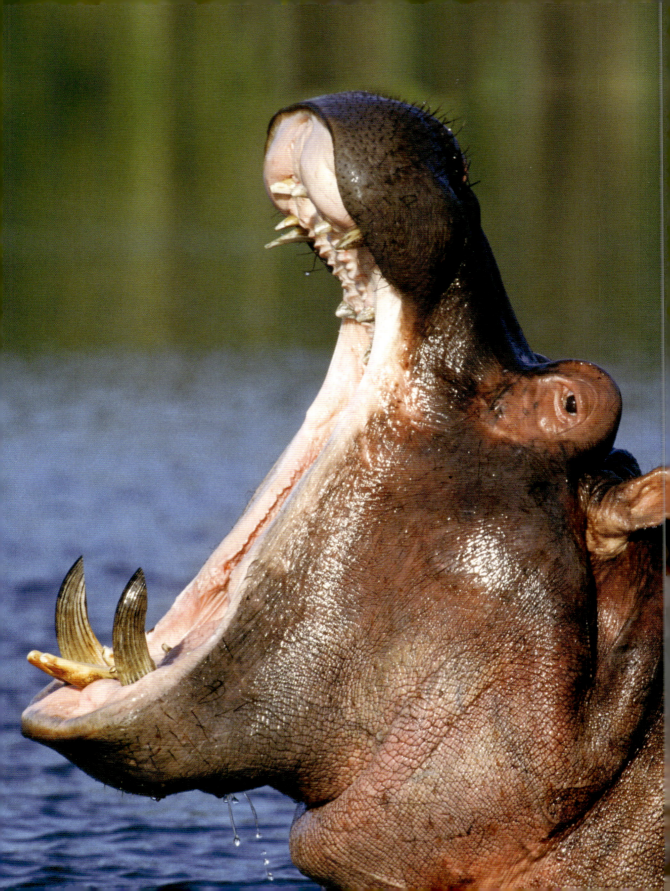

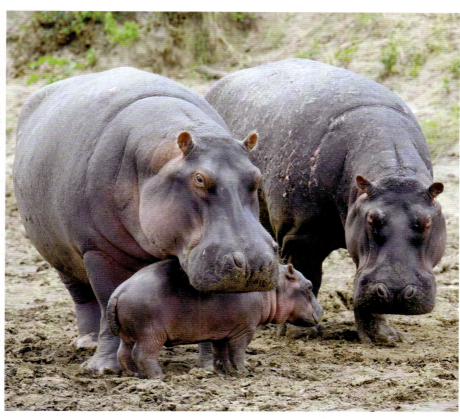
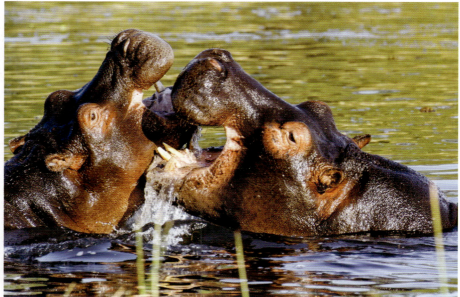

ALL PHOTOGRAPHS:
Hippopotamus
These social riverine animals are highly territorial. Males will often fight for dominance, using their large gape and pointed 'tusks' to inflict injury on a rival. Aggressive males sometimes target trespassing boats which can lead to capsizing. Hippos are thought to be responsible for up to 500 human deaths annually.

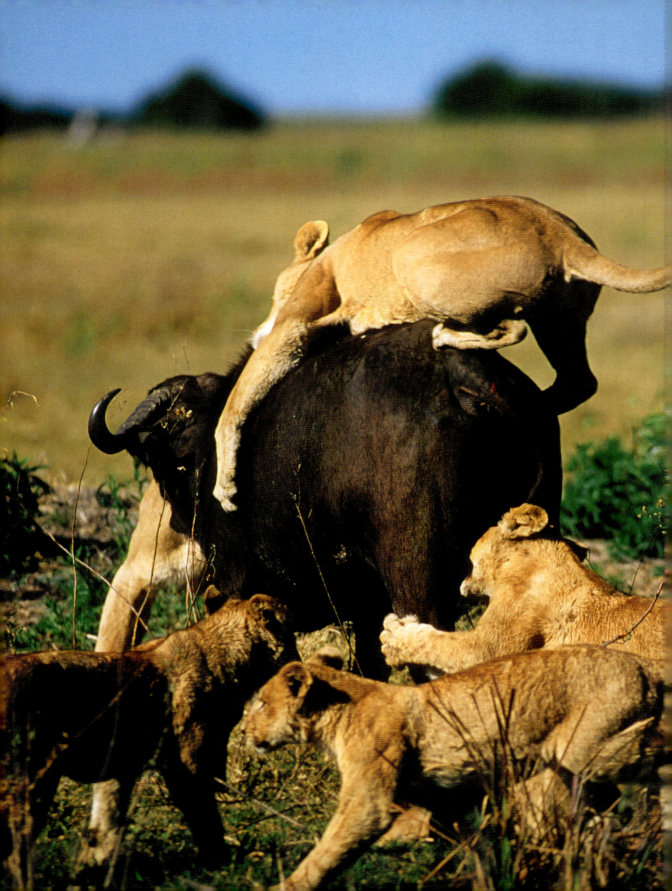

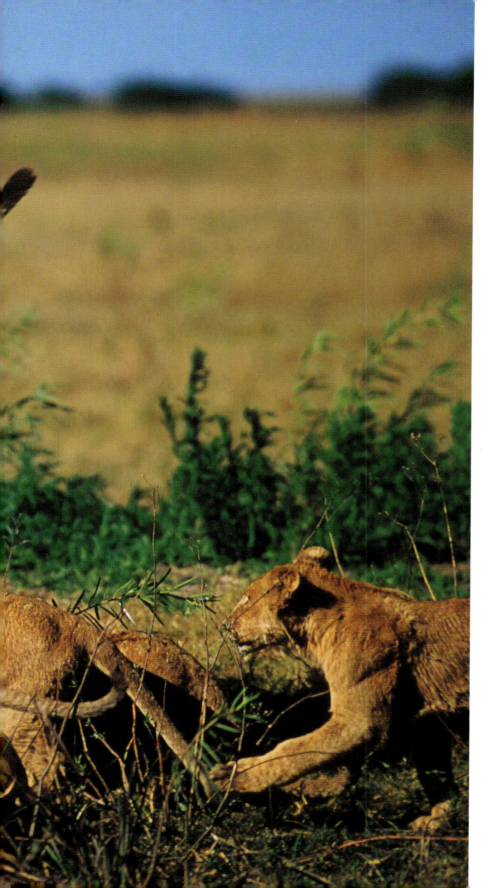

Lions attacking a buffalo
The 'King of Beasts' is a title well earned by this powerful and efficient predator. Here, a pride of females attacks a buffalo, which they will overpower and wrestle to the ground. The fatal bite will be administered to the neck, effectively suffocating the buffalo before the whole pride eats its fill.

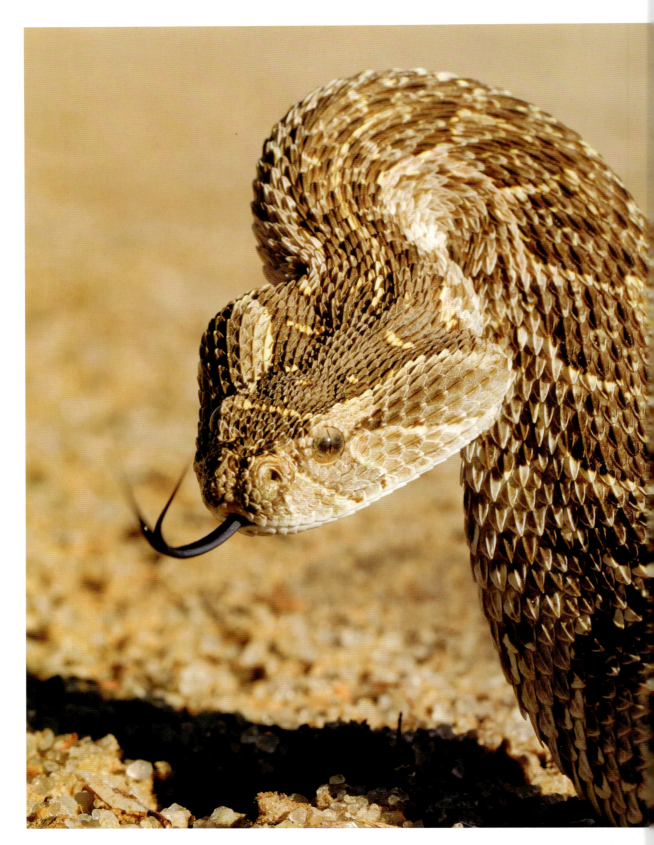

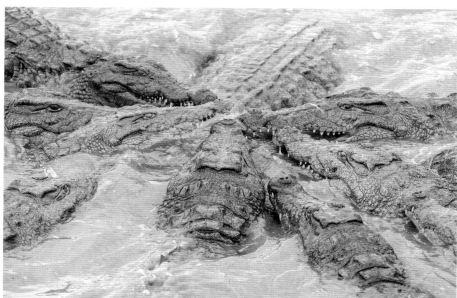

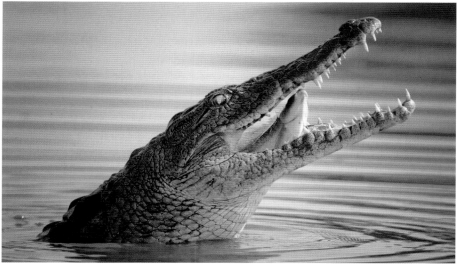

LEFT:
Puff adder
This highly venomous, 1m (3.3ft) long snake occurs throughout Africa's dryer regions. It is responsible for the majority of snakebite fatalities due to its mainly nocturnal habit of remaining motionless on paths in highly populated areas waiting for small mammals and lizards to stray close.

ABOVE TOP AND BOTTOM:
Nile crocodile feeding
Nile crocodiles are apex predators, occurring in aquatic habitats across most of the African continent. Mature individuals mainly hunt by ambush, submerged in water for long periods of time patiently waiting for prey. Mass feeding (above top) on large carcasses is a common habit. Crocodiles have a diet of fish, carrion and just about any live animal they can catch. A crocodile has successfully caught a large fish (above bottom) which will be swallowed whole.

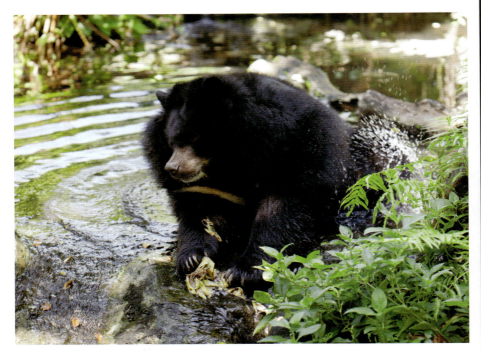

ALL PHOTOGRAPHS:
Asiatic black bear
These animals are superbly adapted to life in forests. They are omnivorous, with a wide-ranging diet including honey, fruit, invertebrates and seeds. They are a protected species throughout their range, such as these bears kept in captivity. However, they sometimes come into conflict with commercial farming and are consequently persecuted in some remote regions when in the wild.

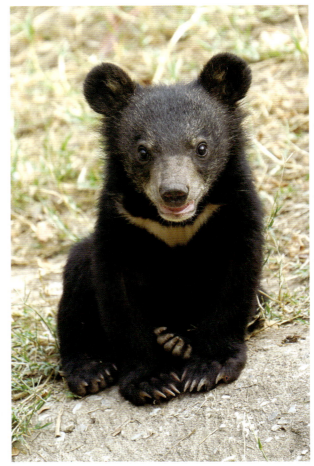

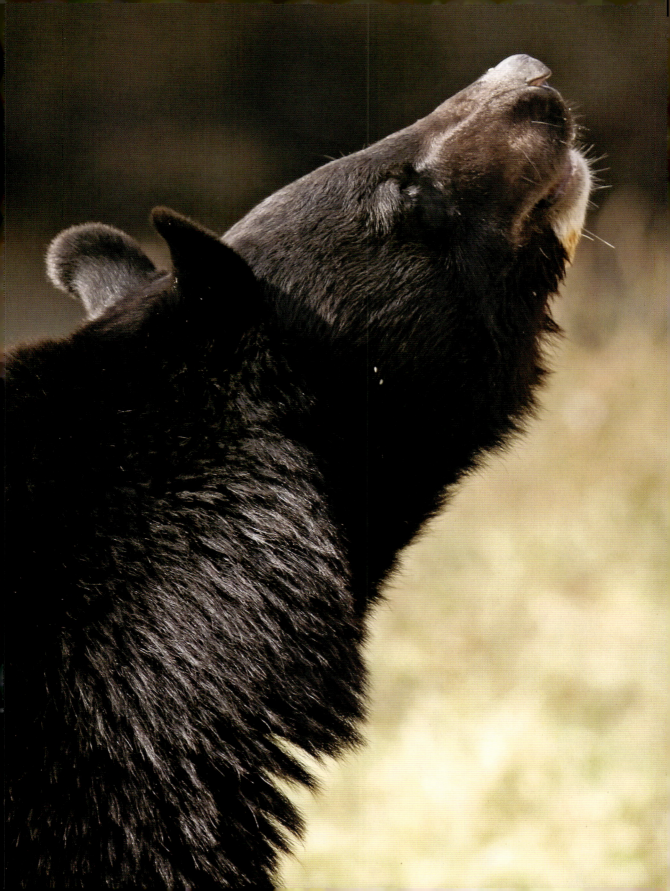

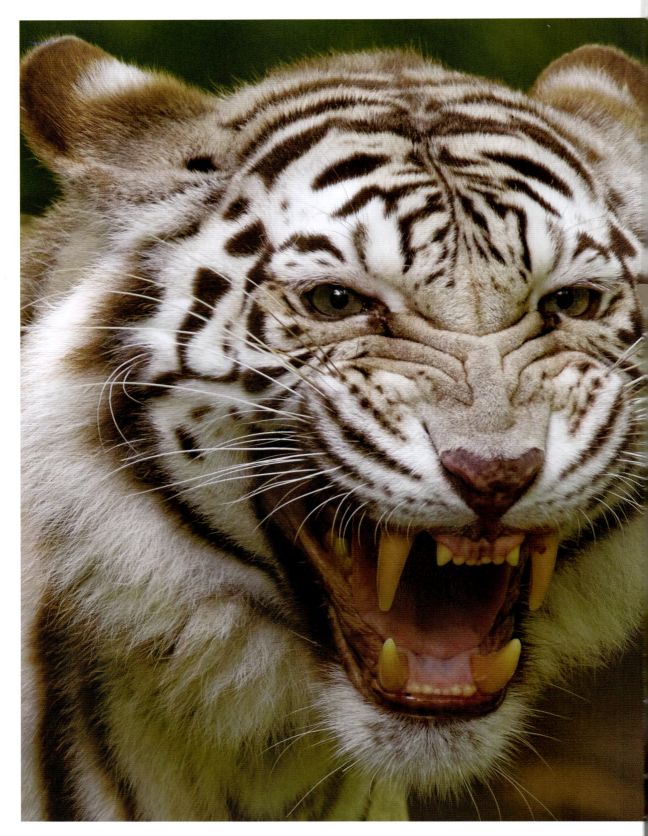

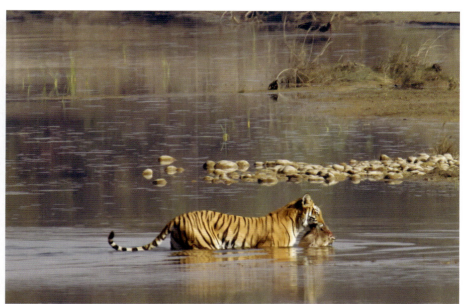

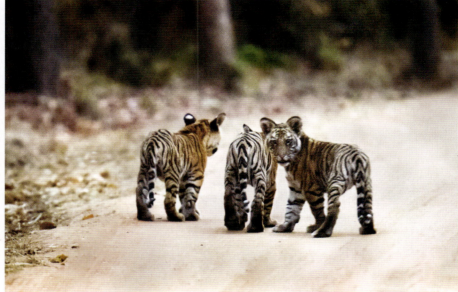

ALL PHOTOGRAPHS:
Bengal tiger
Bengal tigers are native to the Indian subcontinent. Sadly, these animals are believed to be extinct in the wild and only exist today in captivity. These are strong animals with exceptional hearing and eyesight. They have the largest canines of any big cat, measuring some 10cm (4in). They hunt deer and other animals by stalking, when their orange colouration, broken by a series of black lines, acts as perfect camouflage.

Box jellyfish
There are over 50 species of box jellyfish occurring across the world's oceans. Some species are highly venomous, with their sting causing severe pain and even death to humans. The name derives from the square, box-like bell with a tentacle on each corner. These tentacles can reach a length of 3m (10ft).

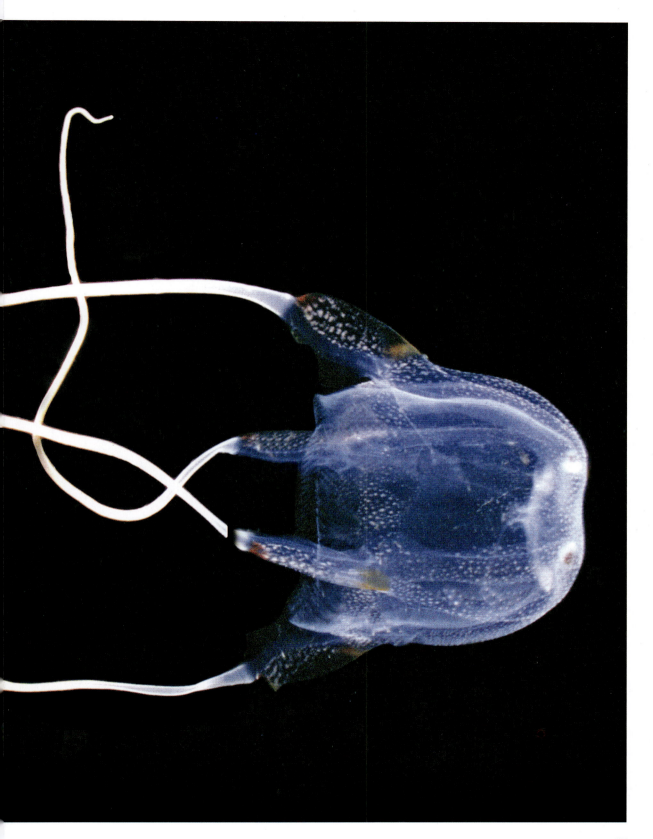

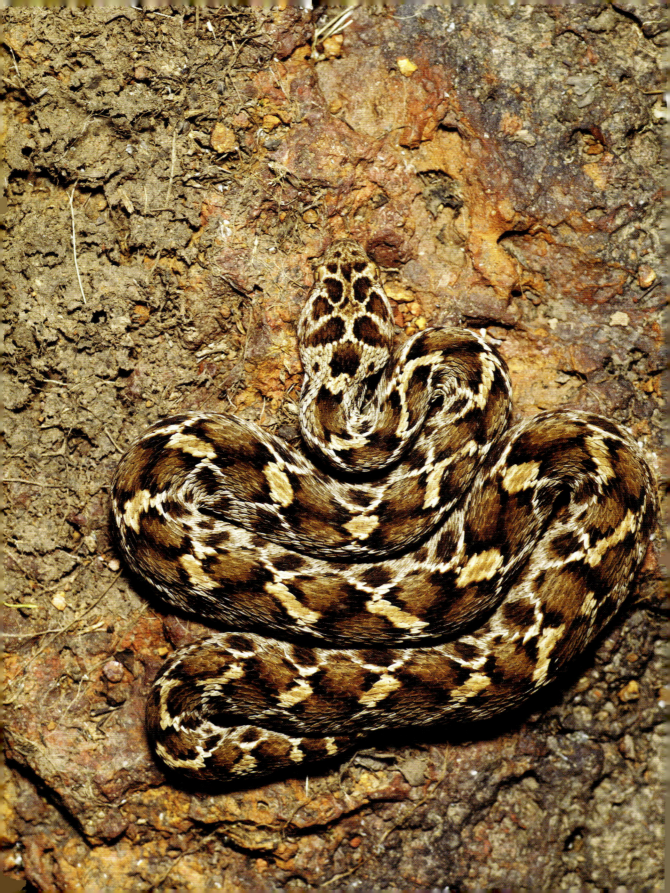

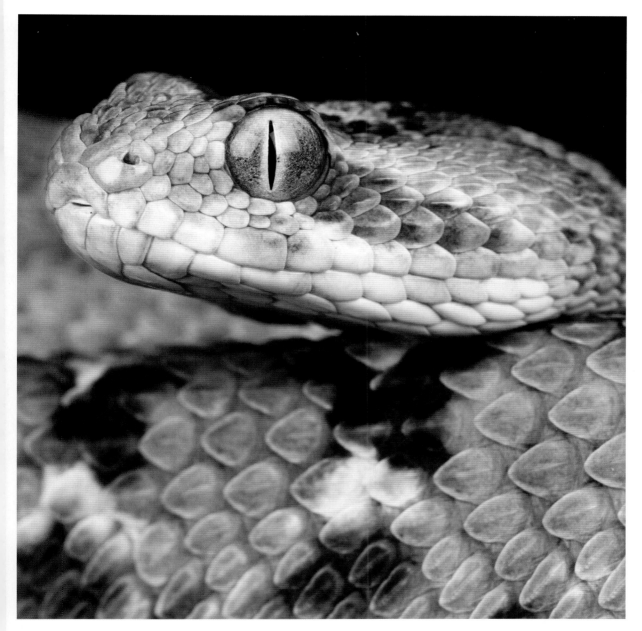

BOTH PHOTOGRAPHS:
Indian saw-scaled viper
So-called after the serrated scales on its flanks, this snake grows to an average length of 60cm (24in). Its repuscular habits, aggressive nature and excellent camouflage make it one of the most dangerous snakes. However, nowadays, human deaths are rare due to effective and widely available antivenom.

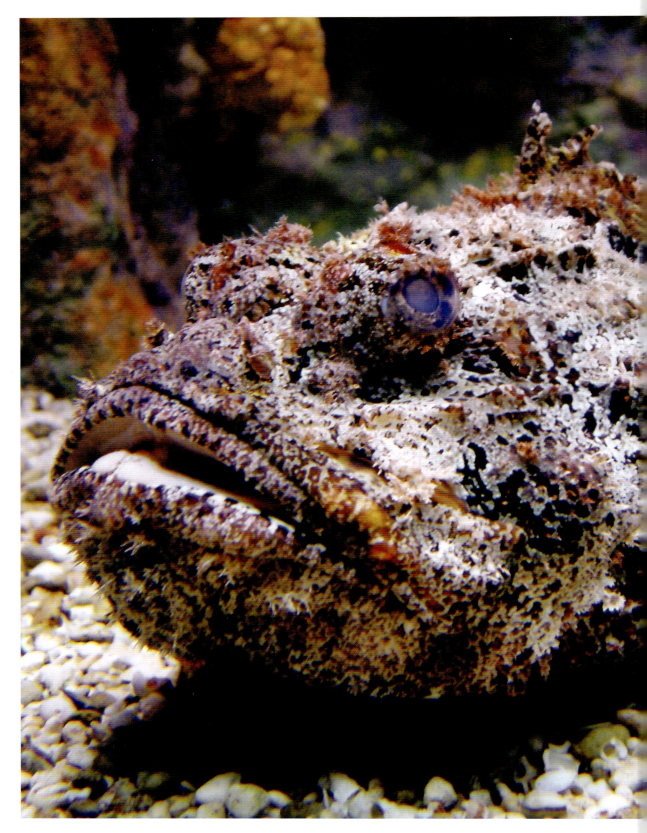

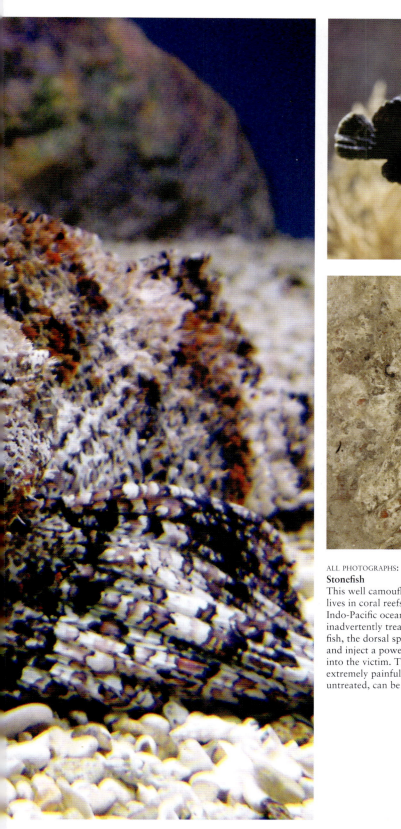
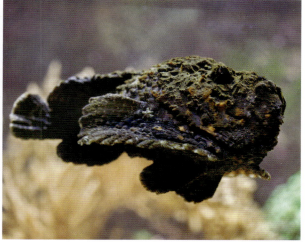

ALL PHOTOGRAPHS:
Stonefish
This well camouflaged fish lives in coral reefs of tropical Indo-Pacific oceans. If a person inadvertently treads on the fish, the dorsal spines raise and inject a powerful venom into the victim. This sting is extremely painful and, if left untreated, can be fatal.

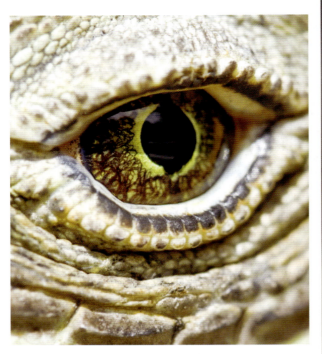

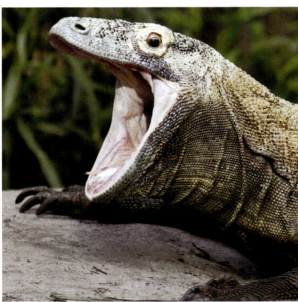

ALL PHOTOGRAPHS:
Komodo dragon
Endemic to a few Indonesian islands, this large lizard, reaching up to 3m (10ft) long, is an apex predator. It hunts by ambushing a wide range of live prey, but will also feed on carrion. It has an unwarranted fearsome reputation, since attacks on humans are actually very rare.

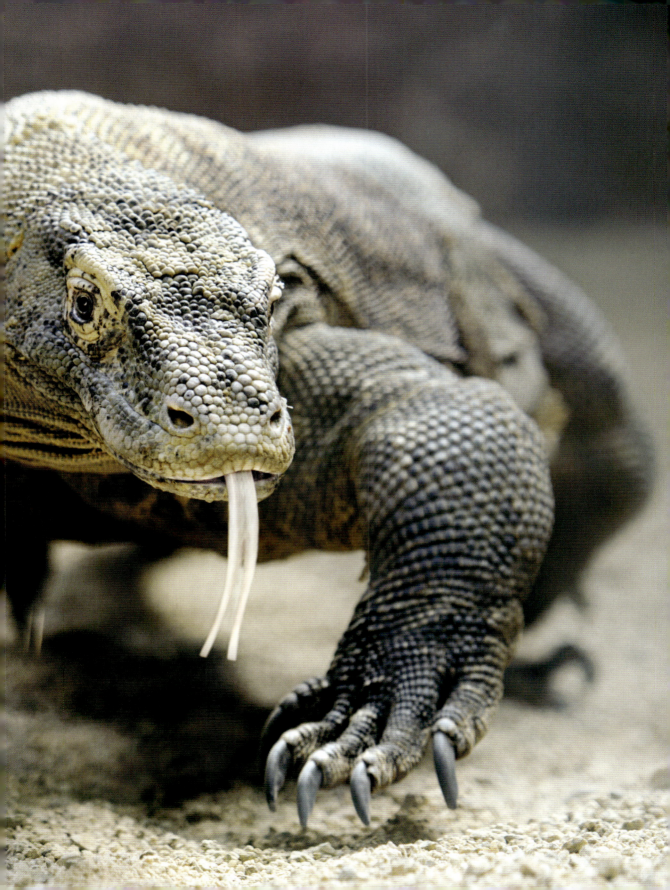

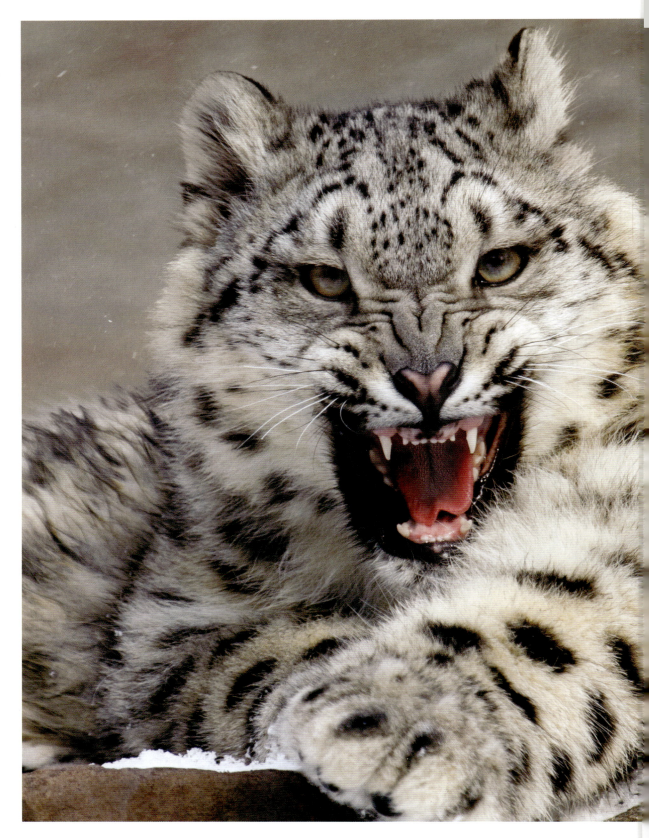

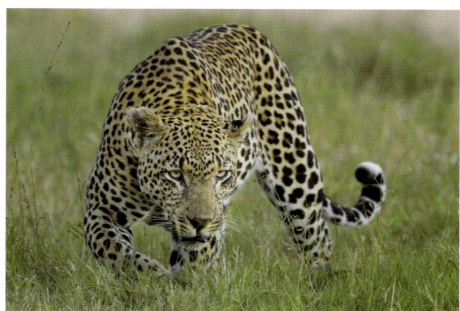
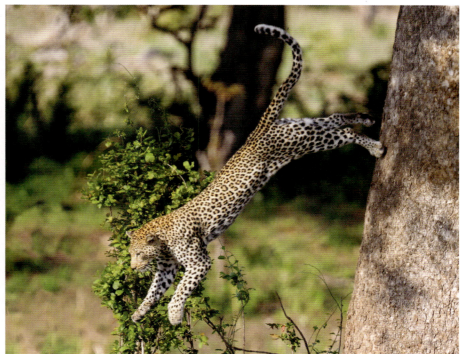

LEFT:
Snow leopard
This beautiful and endangered species inhabits mountainous areas of central and southern Asia. There are fewer than 10,000 left in the wild, with poaching and the illegal fur trade adding to ongoing decline. It feeds on wild sheep and goats.

ABOVE TOP AND BOTTOM:
Leopard
This powerful creature is at home in forest habitats. It is stealthy and able to stalk its preferred prey of deer, primates and other medium sized animals to close distance. Though attacks on humans are rare, some fatalities are recorded every year.

Reticulated python
'Reticulated' means 'net-like', a reference to the intricate patterns on this snake's skin. It is the world's longest snake, with specimens regularly measuring over 6m (20ft). It hunts by waiting motionless for a victim to come close, before enveloping it in its coils and squeezing it to death. Prey is then swallowed whole.

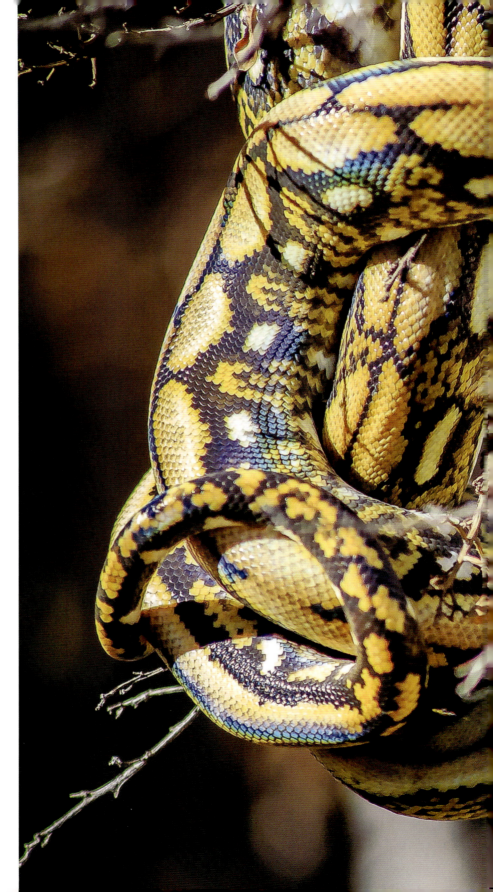

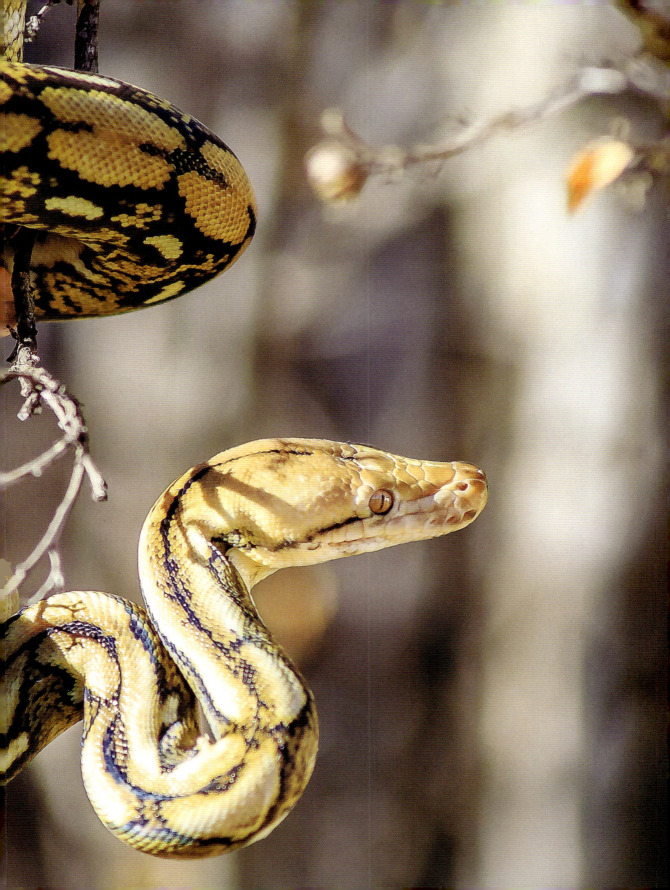

BOTH PHOTOGRAPHS:
Tiger snake
A highly venomous Australian snake with a number of distinctive geographic forms. Some forms are clearly banded, thus giving the species its name, others are completely black. It is responsible for 17 per cent of recorded snake bites, but these are rarely fatal thanks to effective and widely available antivenom.

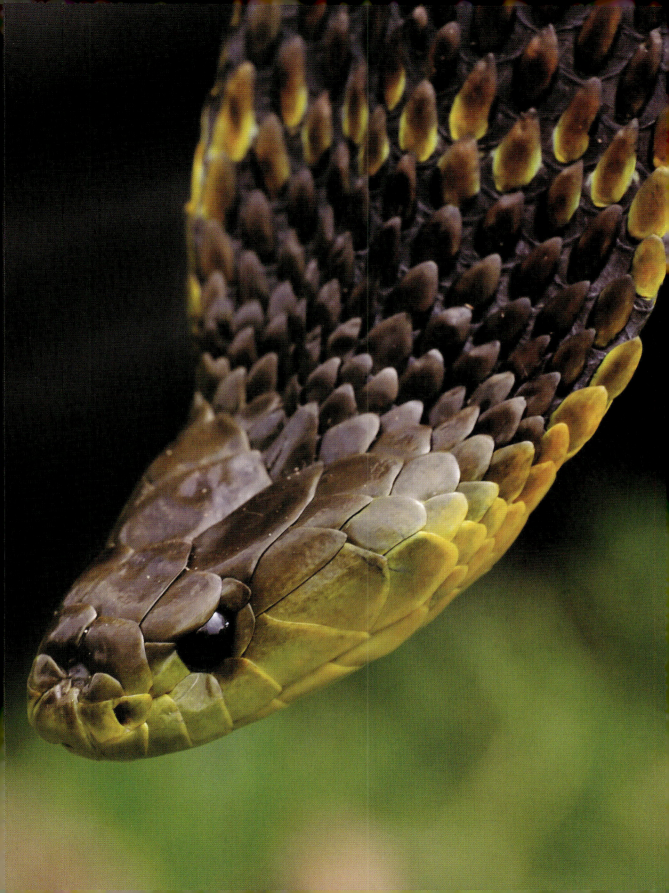

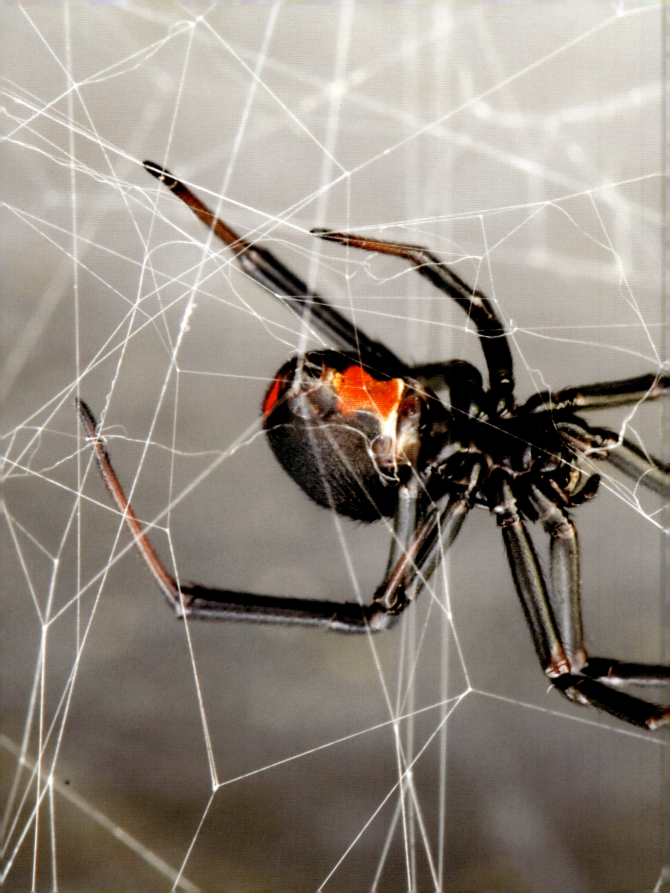

Redback spider in a web
Redbacks prefer to make their webs in warm locations, which often includes human habitations. The female is credited with biting several thousand people every year. The bite causes severe pain which can last for days but is rarely fatal, although a small number require antivenom.

ALL PHOTOGRAPHS:
Saltwater crocodile
A thriving species, it inhabits brackish wetlands and river systems, but can also swim long distances in saltwater. Males reach lengths of 6m (19.6ft) with females being about half that size. The Australian population is estimated to be 100,000–200,000 adults.

OVERLEAF:
Sydney funnelweb spider
This particular species, ranging in size from 2–5cm (0.8–2in), makes its home in and around the Sydney area of Australia. It is highly venomous with fangs that can pierce human skin. For this reason, bites are treated as a medical emergency. When threatened, the spider rears up and displays those formidable fangs.

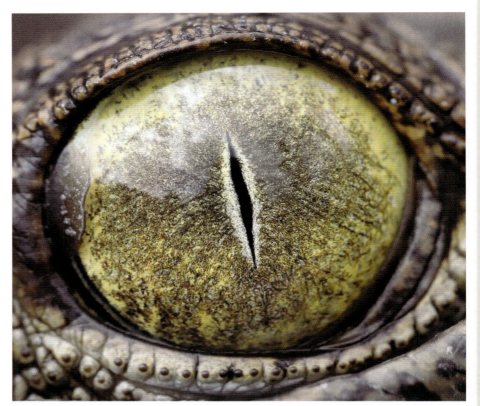

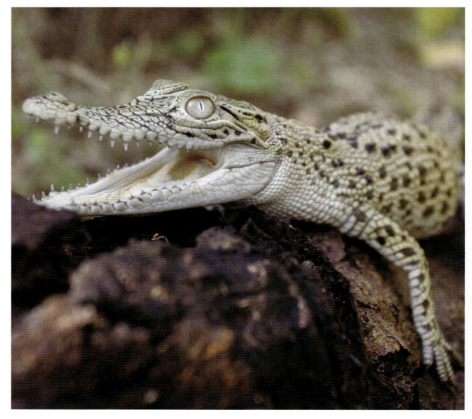

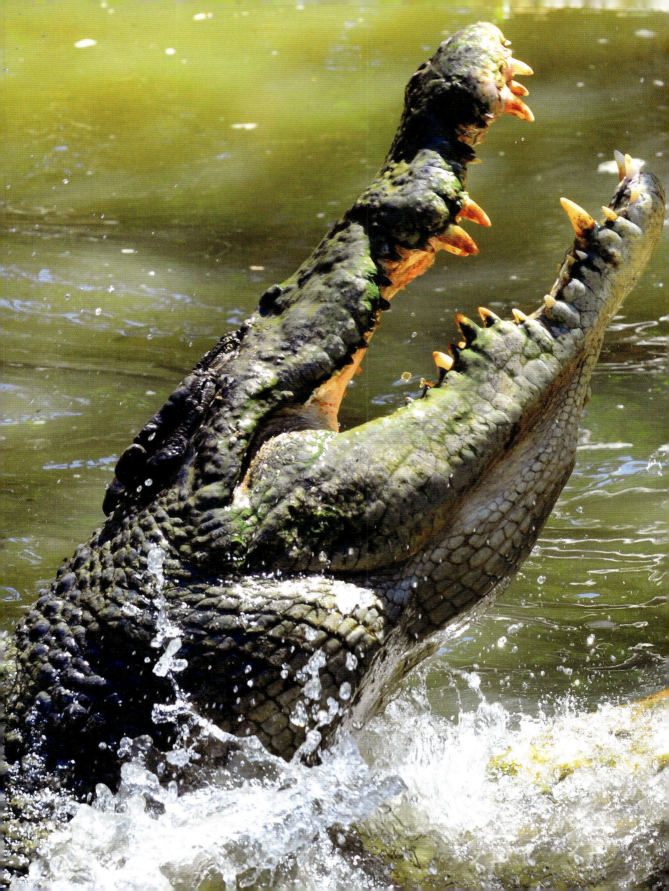

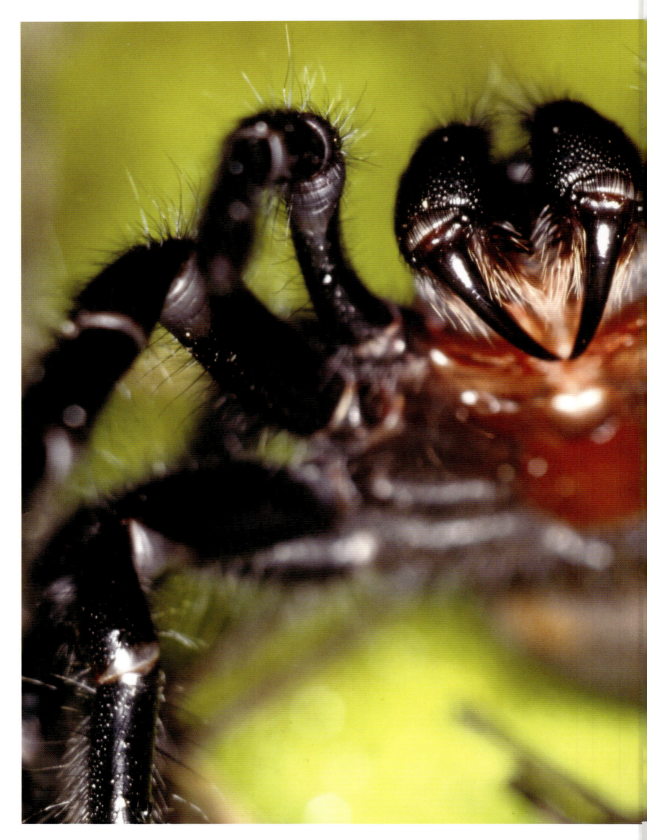

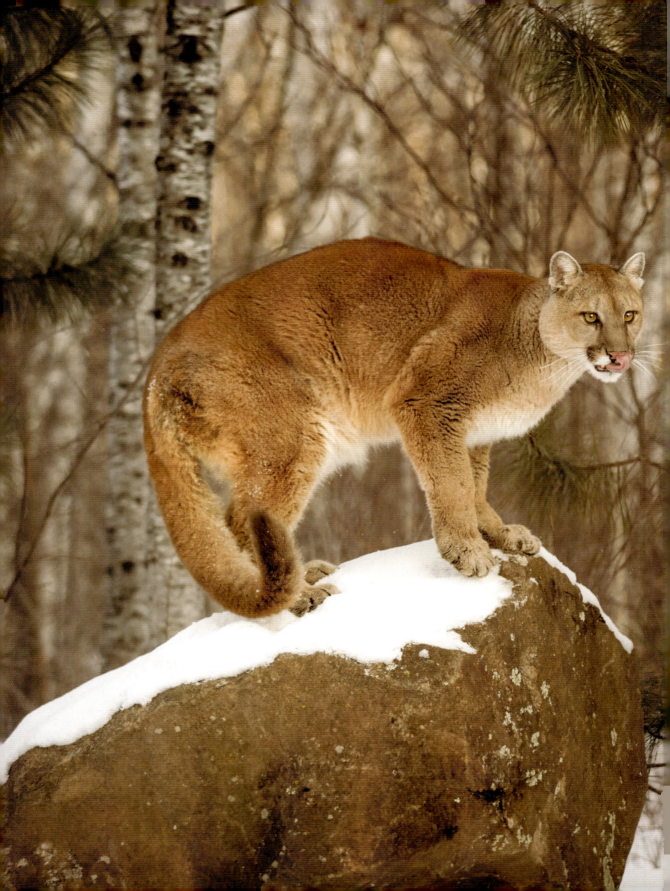

LEFT:
Puma
Despite numerous encounters between humans and this majestic cat, attacks are very rare. Moreover, the continued decline of the species in North America can be directly attributed to hunting, which is still legal in every US state except California, and other aspects of human encroachment. This means that some pumas, such as this one, live in captivity.

OVERLEAF:
American alligator
The American alligator can be found in southern states of the USA where they inhabit freshwater swamplands, lakes and marshes. It is usually a solitary animal, but is commercially farmed for its hide, when large numbers will gather around feeding stations as pictured in the image overleaf.

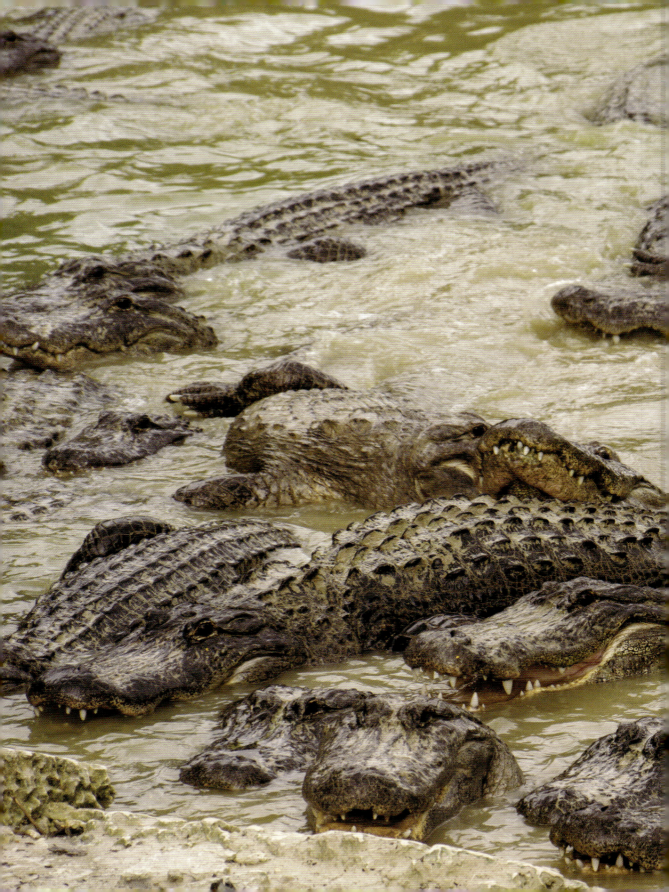

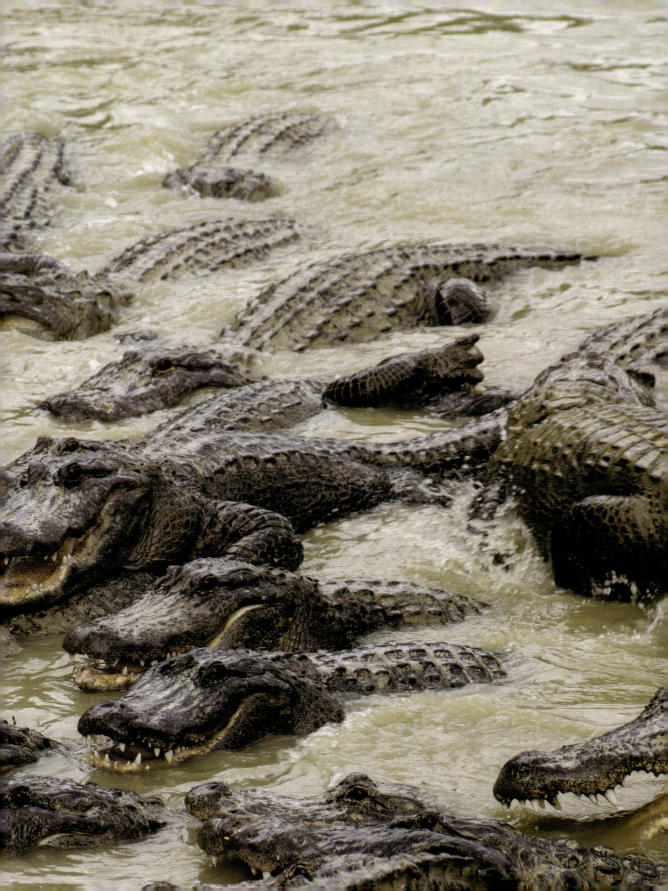

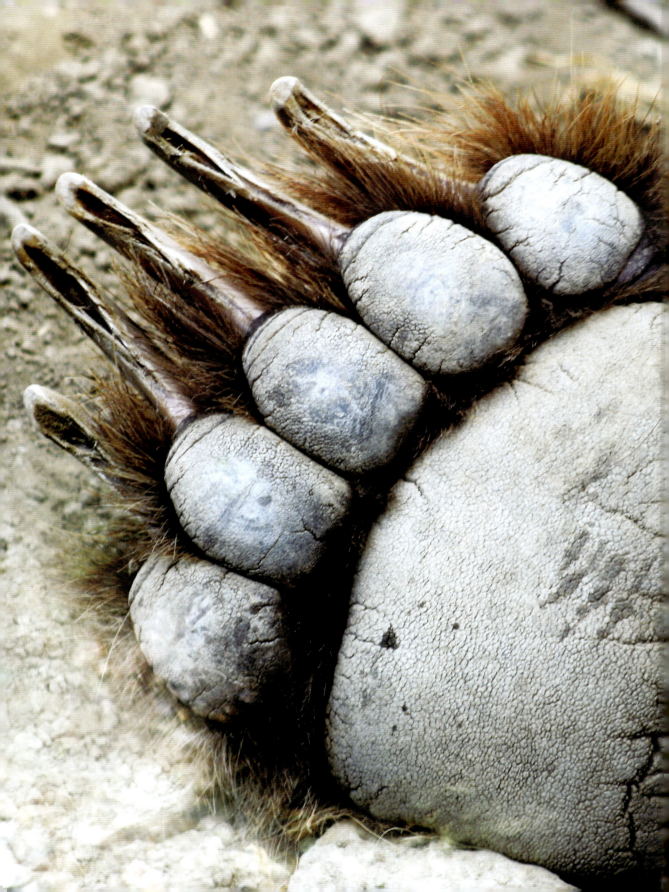

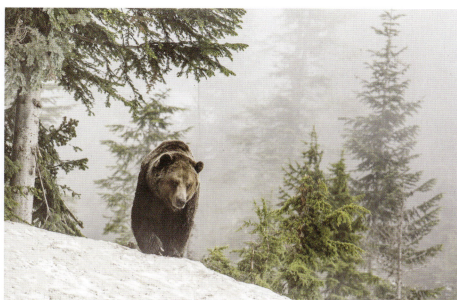
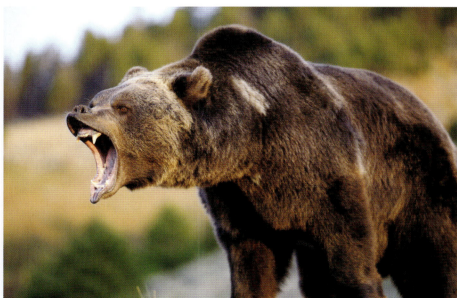

ALL PHOTOGRAPHS:
Grizzly bear
Also known as the North American brown bear, the term 'grizzly' relates to the blonde-tipped fur present on the backs of these impressive and extremely powerful animals. They inhabit Alaska, western Canada and some northwestern states of the United States. A grizzly bear's sharp claws, which it used to climb, dig and catch food, are 5–7cm (2–3in) long.

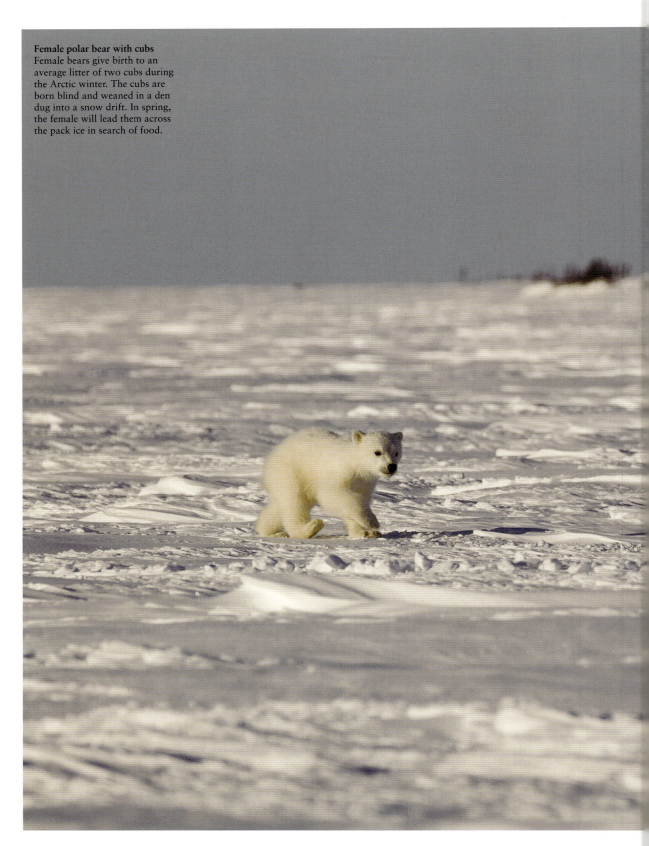

Female polar bear with cubs
Female bears give birth to an average litter of two cubs during the Arctic winter. The cubs are born blind and weaned in a den dug into a snow drift. In spring, the female will lead them across the pack ice in search of food.

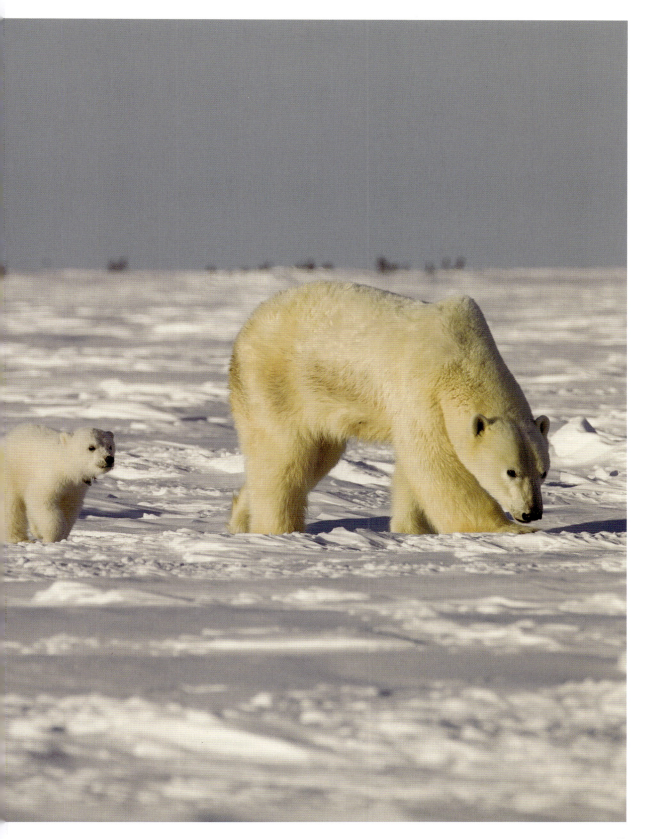

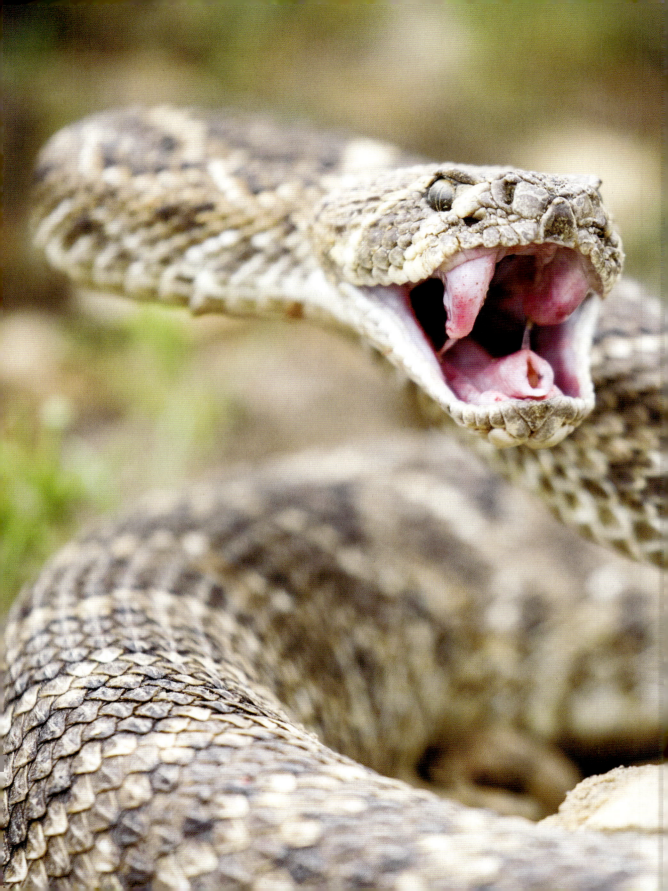

Western diamond rattlesnake
A species inhabiting the southwestern states of the United States, it can be identified by prominent black-and-white bands above the rattle at the end of its tail. It averages lengths of 1–1.5m (3.3–5ft), and uses heat-sensing receptors to track its prey of small mammals and birds. The retractable fangs measure 5cm (2in) and release a potent venom which attacks its victim's blood system.

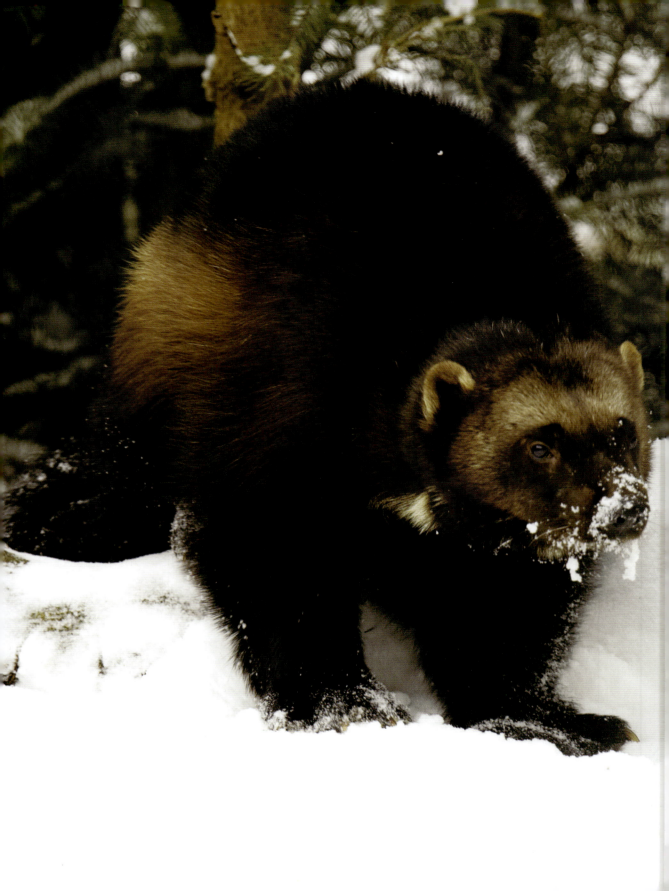

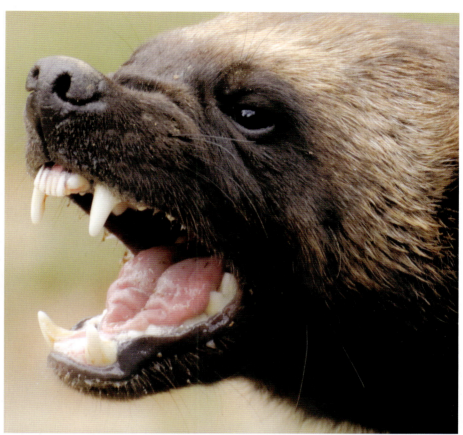
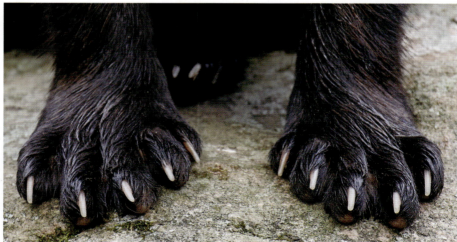

ALL PHOTOGRAPHS:
Wolverine
Wolverines have a widespread distribution around the Arctic regions of North America, being well adapted to survive in this inhospitable climate. They have earned a fearsome reputation, but rarely come into contact with humans. In fact, their fur, which is resistant to frost, is prized amongst hunters, who take a toll on the population.

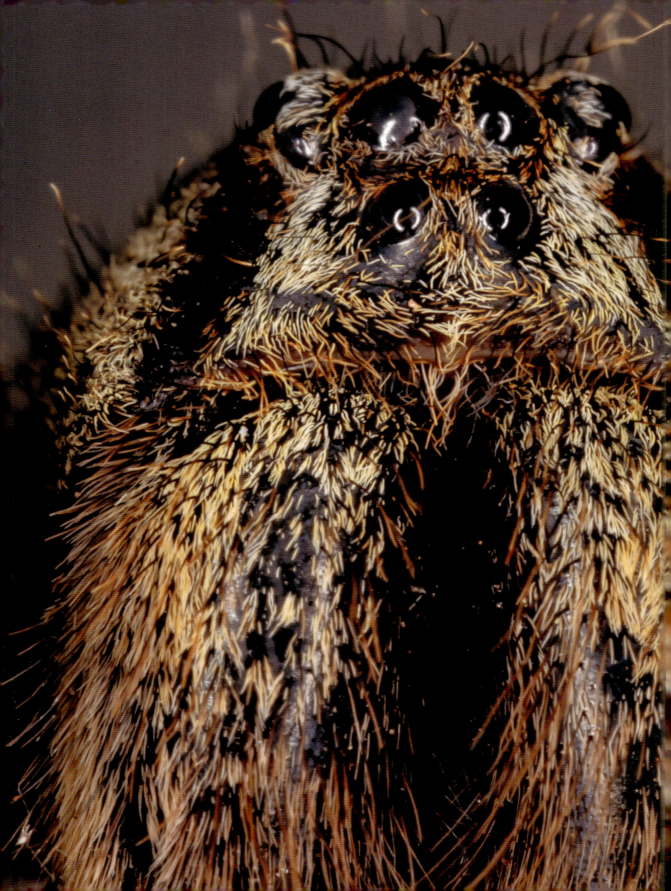

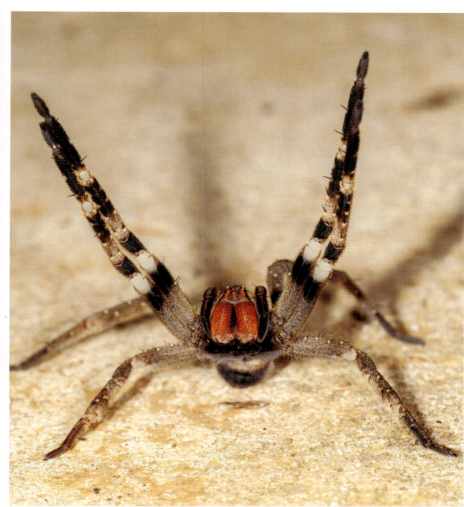

BOTH PHOTOGRAPHS:
Brazilian wandering spider
These eight-eyed spiders have a body covered with thick brown hair. When threatened, they hold their front legs high, revealing an identifying black-and-white underside pattern, together with red jaws. Their bite can be painful, and on rare occasions fatal, although they often administer a 'dry bite' without releasing venom.

RIGHT TOP, MIDDLE AND BOTTOM:
Black caiman
These cold-blooded animals spend a lot of time basking in the sun with their mouths wide open. They have been mercilessly hunted in the past for their skins, suffering a serious depletion in numbers during the 20th century. Happily, numbers are recovering, although continued habitat destruction poses further long-term threats to the species.

OPPOSITE:
Common lancehead snake
'Lancehead', or commonly the French 'fer-de-lance', is a reference to the snake's pointed head shape. Found in tropical lowlands east of the Andes, it is coloured in various shades of brown, green and grey, which provides excellent camouflage for this 120–150cm (4–5ft) predator of small rodents, frogs and lizards.

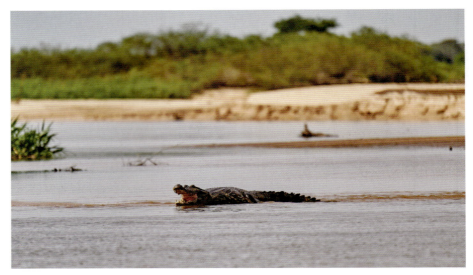

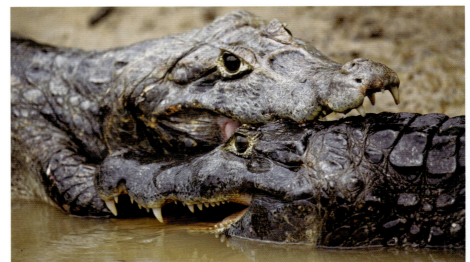

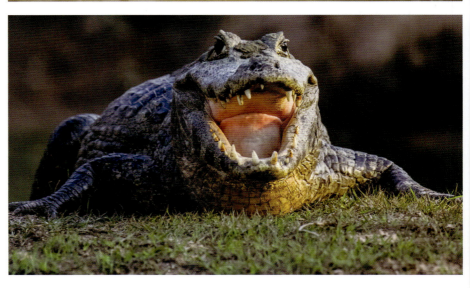

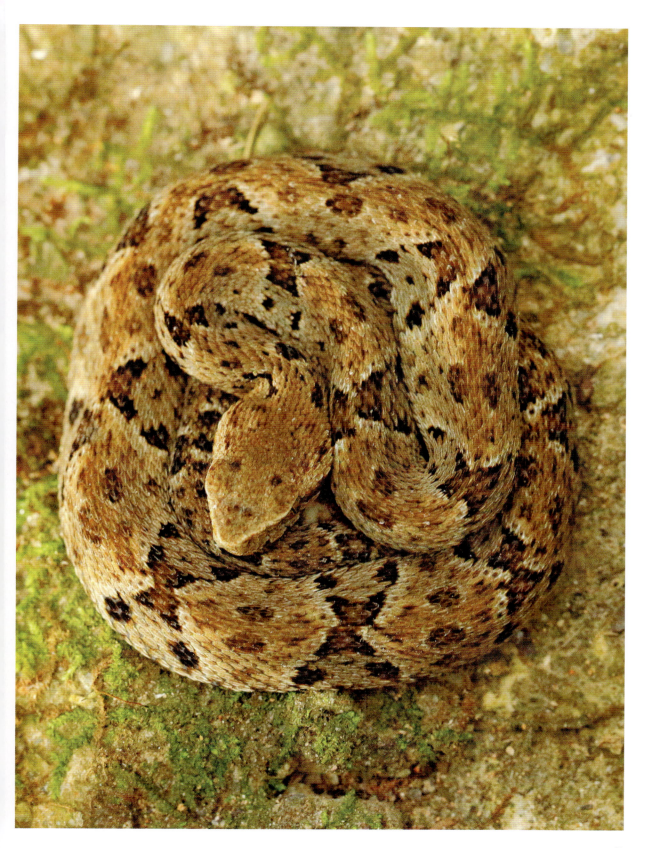

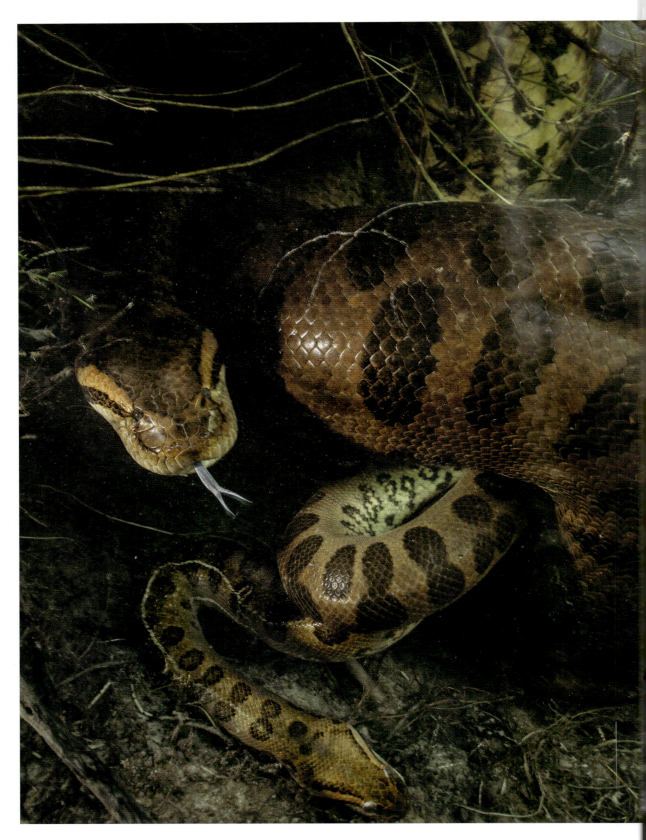

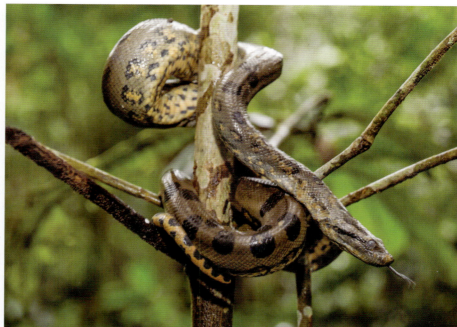
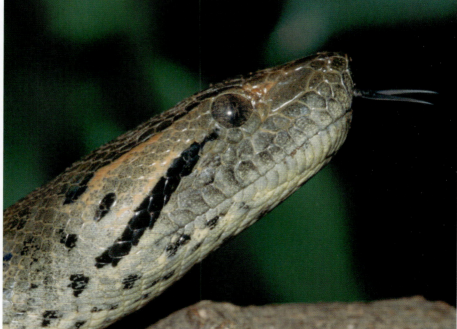

ALL PHOTOGRAPHS:
Green anaconda
So-called because of its green-coloured skin, this is one of the world's longest snakes, with males averaging 5m (16.4ft). It is mainly an aquatic hunter, preying on any suitably sized creature it can ambush as it stops to drink or feed. Anacondas are constrictors, grabbing prey in their jaws before suffocating the victim in its powerful coils.

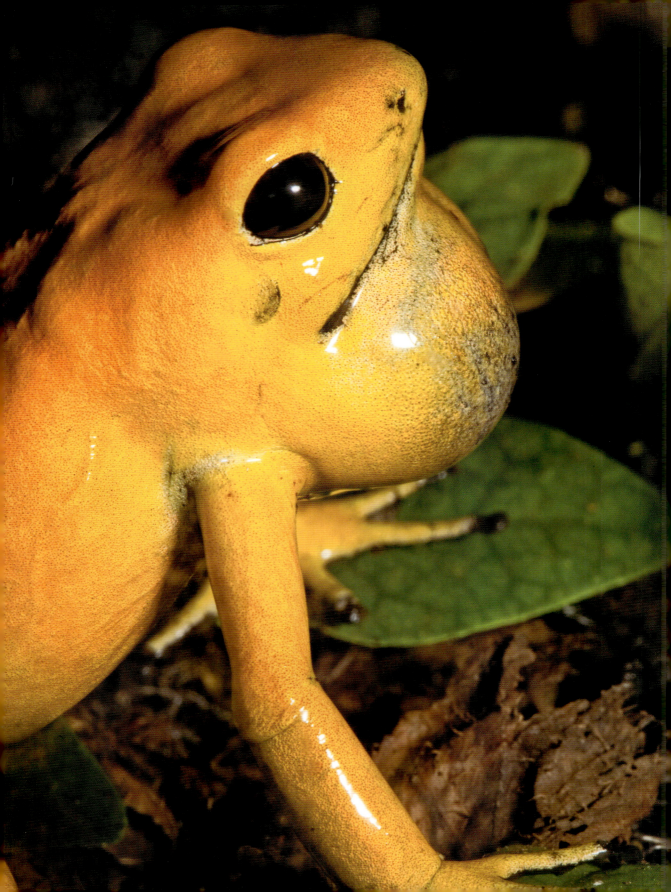

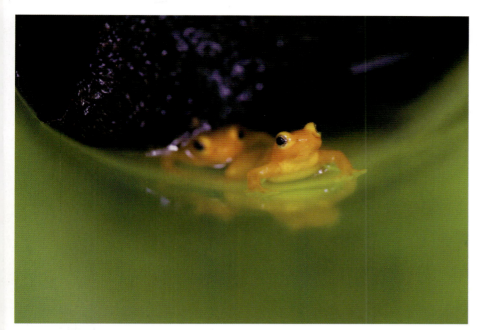

ALL PHOTOGRAPHS:
Golden dart frog
This frog is not venomous (it does not inject poison into its prey), but instead has extremely toxic skin. Indigenous tribes soak their hunting arrows in the poison exuded by frogs, which they catch and expose to gentle heat. The poison remains potent for two years or more.

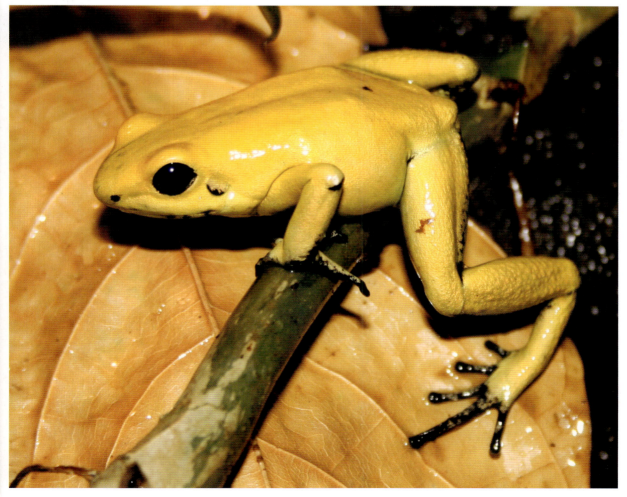

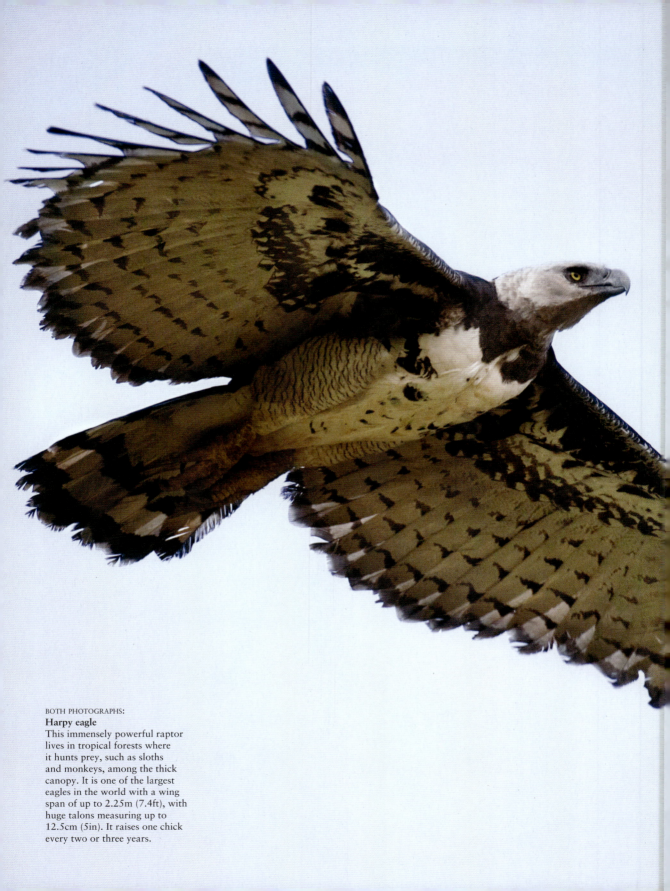

BOTH PHOTOGRAPHS:
Harpy eagle
This immensely powerful raptor lives in tropical forests where it hunts prey, such as sloths and monkeys, among the thick canopy. It is one of the largest eagles in the world with a wing span of up to 2.25m (7.4ft), with huge talons measuring up to 12.5cm (5in). It raises one chick every two or three years.

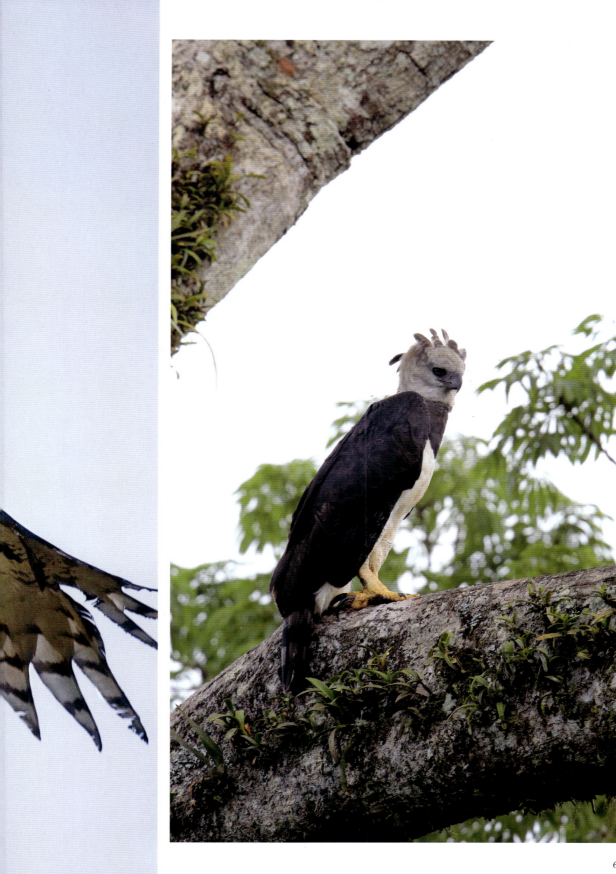

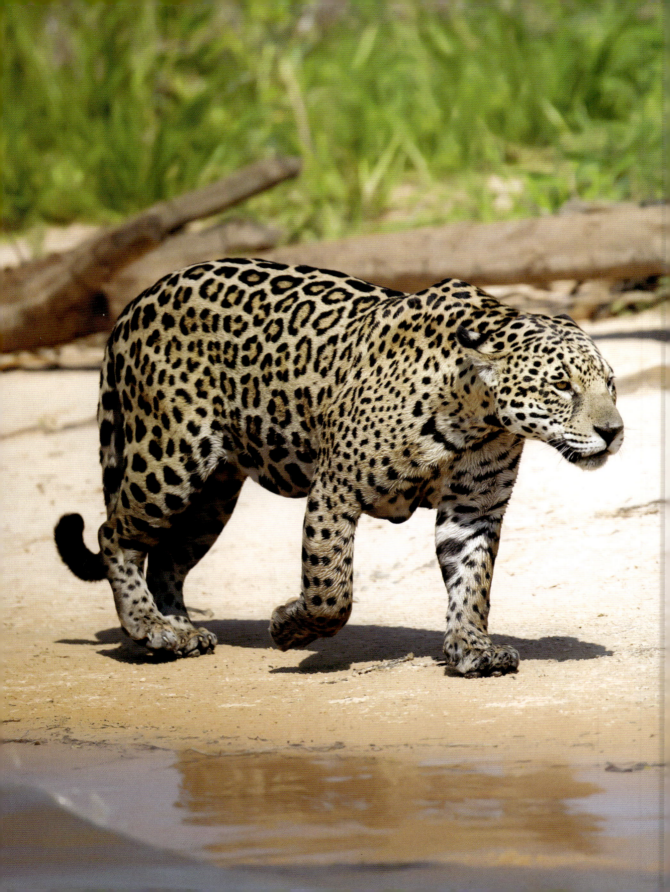

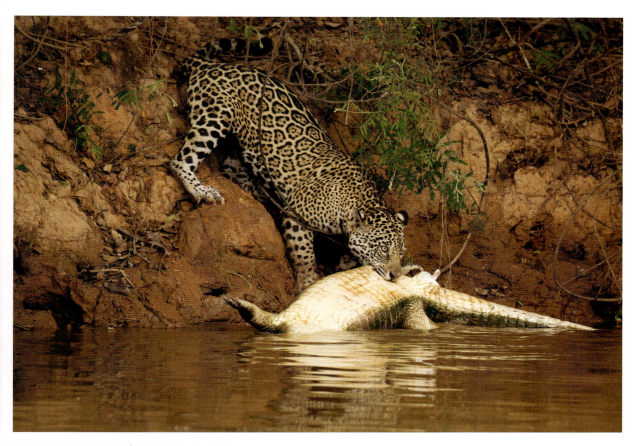

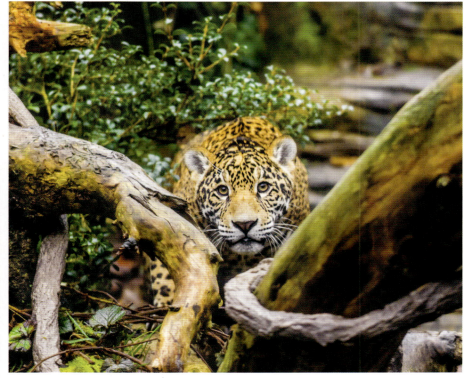

ALL PHOTOGRAPHS:
Jaguar
The jaguar is one of the largest species of cat, measuring up to 1.8m (6ft). It is a powerful predator, stealthily stalking its prey before the final pounce. Its strong jaws allow it to take prey, such as caiman, which it will catch in water and carry to dry land to consume.

Maned wolf
So-called in reference to the black mane running from its head and along the back, this long-legged, reddish canine is one of the largest, measuring 1m (3.3ft). It lives in semi-open grasslands across central South America, where it hunts small mammals and birds, and forages for fruit and tubers.

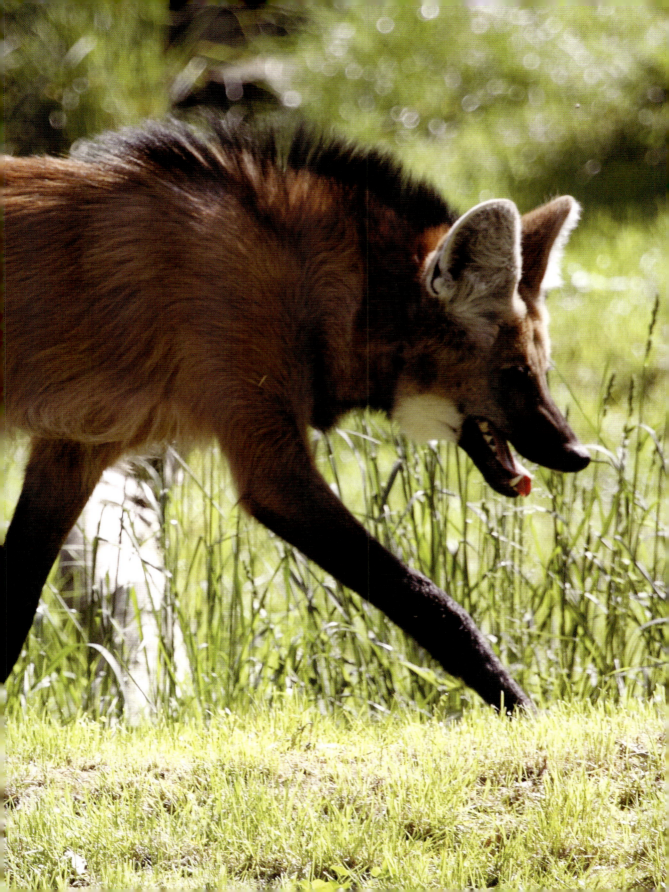

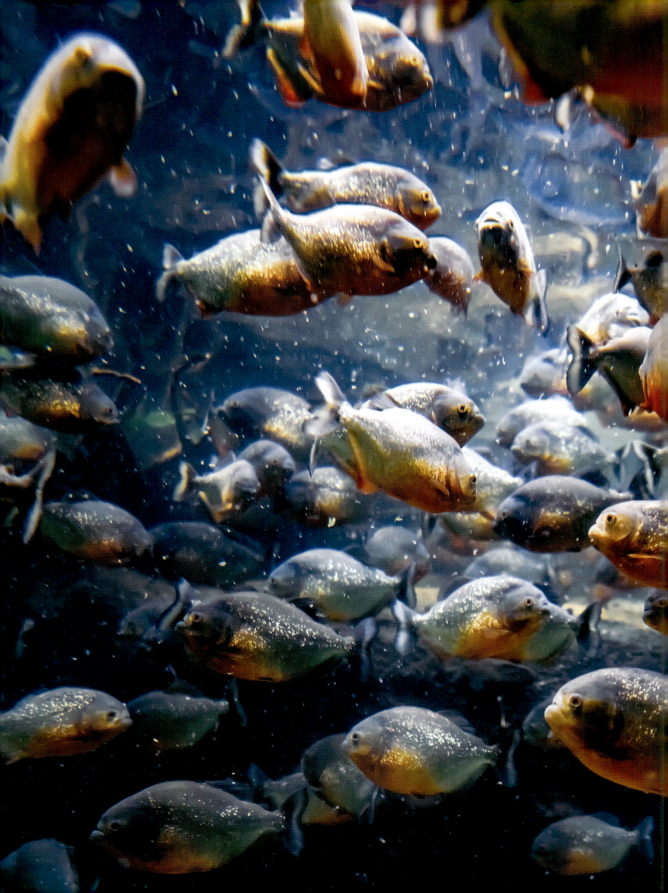

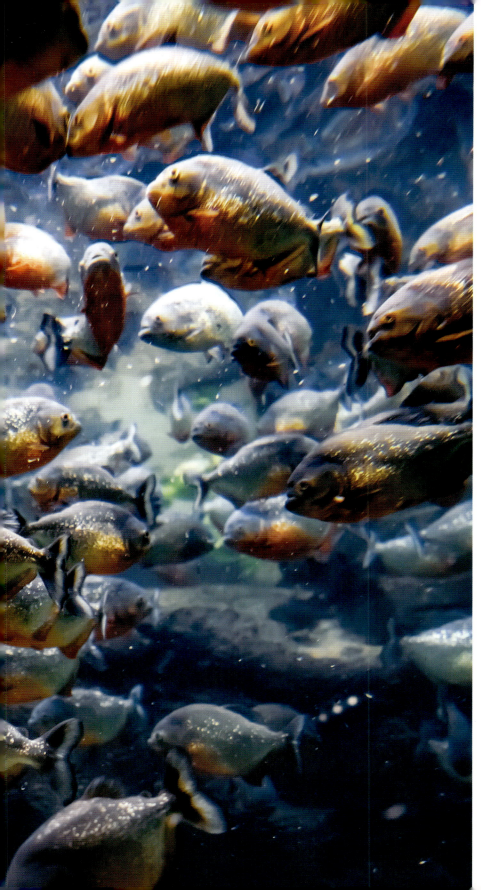

School of red-bellied piranhas
Piranhas form schools as a protective strategy against predators, such as caimans and some water birds. Some piranha species grow to over 30cm (12in) and, rather than eating humans, are instead eaten by them, as a popular culinary dish.

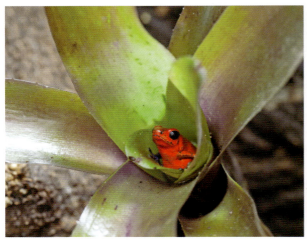

ALL PHOTOGRAPHS:
Strawberry poison-arrow frog
Adult toxicity is obtained from its diet of ants and mites, with the bright colouration serving as a warning to predators. An essential element in the development of tadpoles involves the female feeding them her own unfertilised eggs. In this way, the young obtain sufficient toxin to prevent predation.

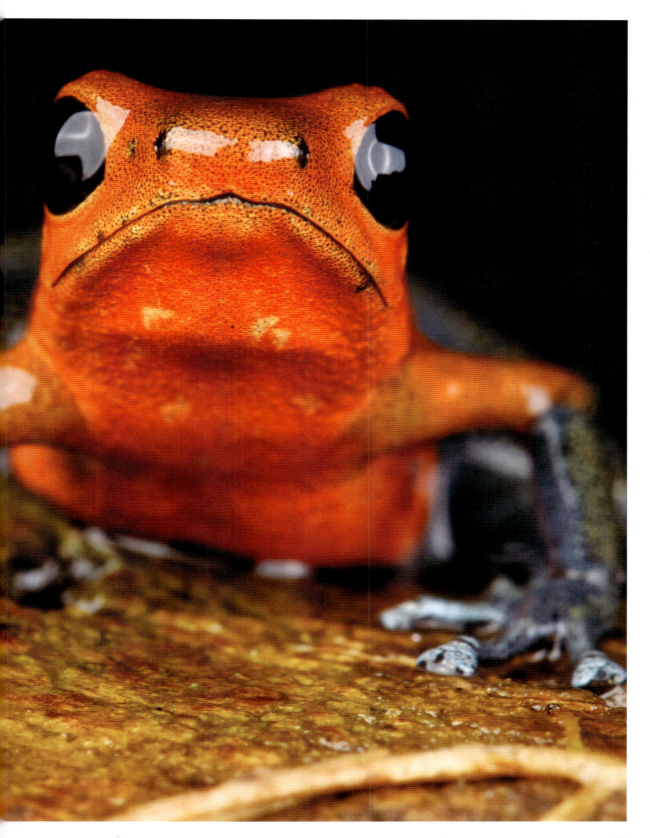

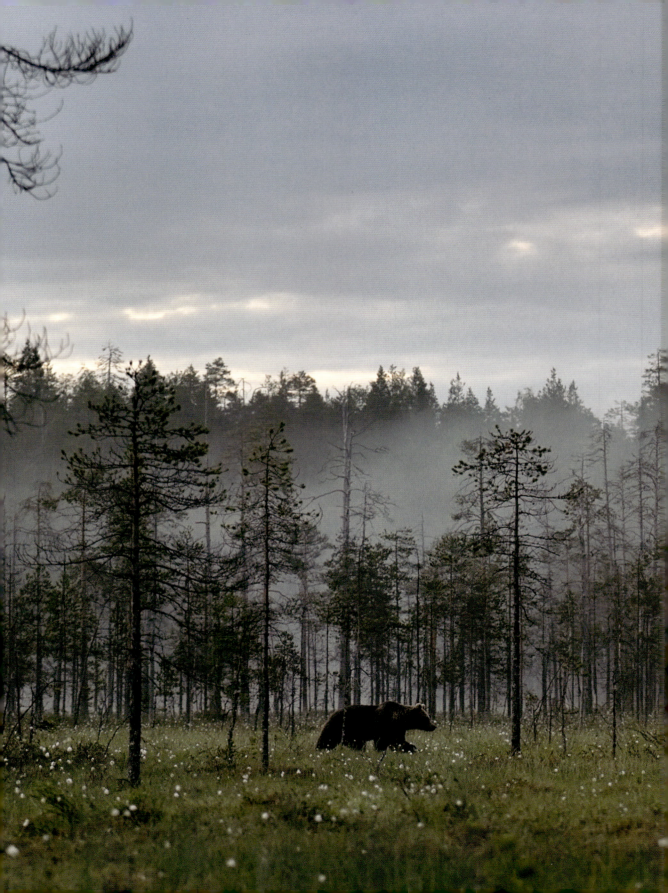

Brown bear
This bear mainly inhabits the large, forested areas of Russia, Scandinavia and eastern Europe, with smaller populations elsewhere. Although a fully protected species, in some areas, population expansion is resulting in an increase in encounters with humans, and fatal collisions with vehicles.

BOTH PHOTOGRAPHS:
Eurasian lynx
This shy and elusive animal ranges across Western Europe to Central Asia. It has a brown coat spotted liberally with black, white underparts and a short, black-tipped 'bobbed' tail. The ears have a distinctive tuft of black hair. With a maximum body length of about 1m (3.3ft), it is the largest of the world's four species of lynx.

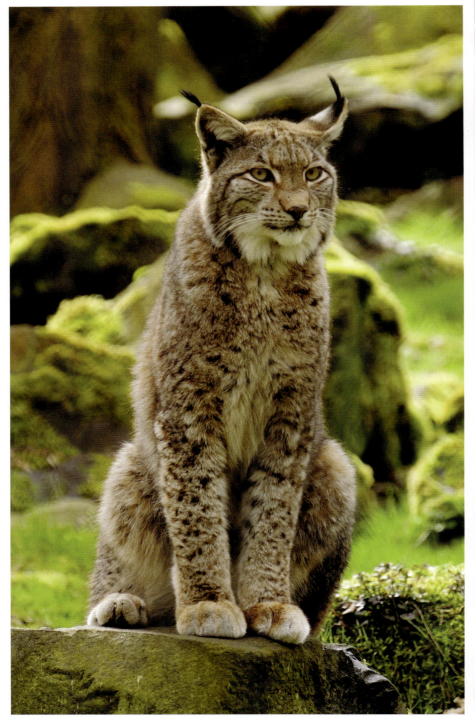

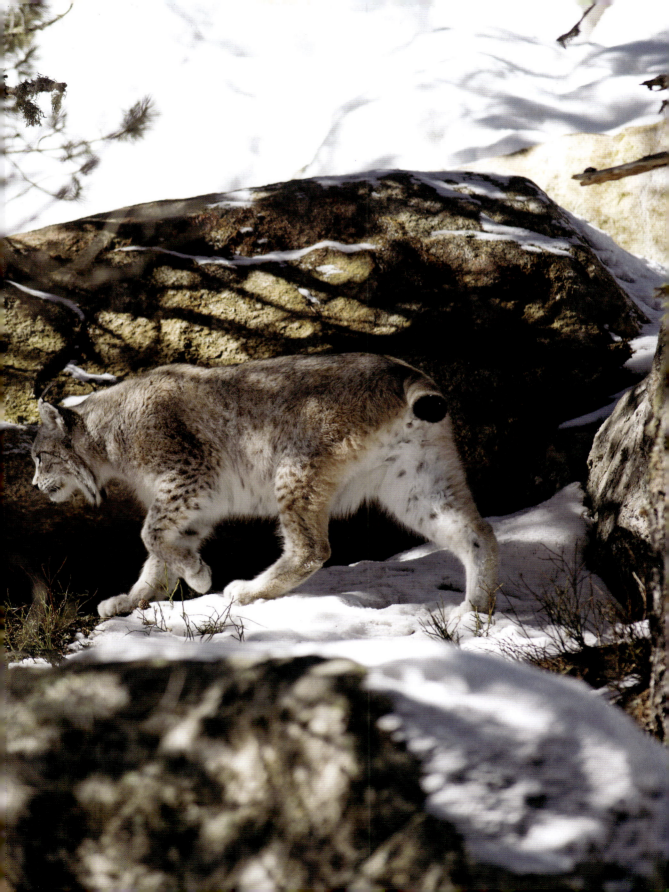

Grey wolf at kill
Wolves are intelligent, social animals living in packs with a hierarchical structure. They hunt deer, goats and wild boar, but will also attack livestock if natural prey is scarce. They feature strongly in mythology, where their howls portent the unleashing of dark forces. But in fact, attacks on humans are extremely rare.

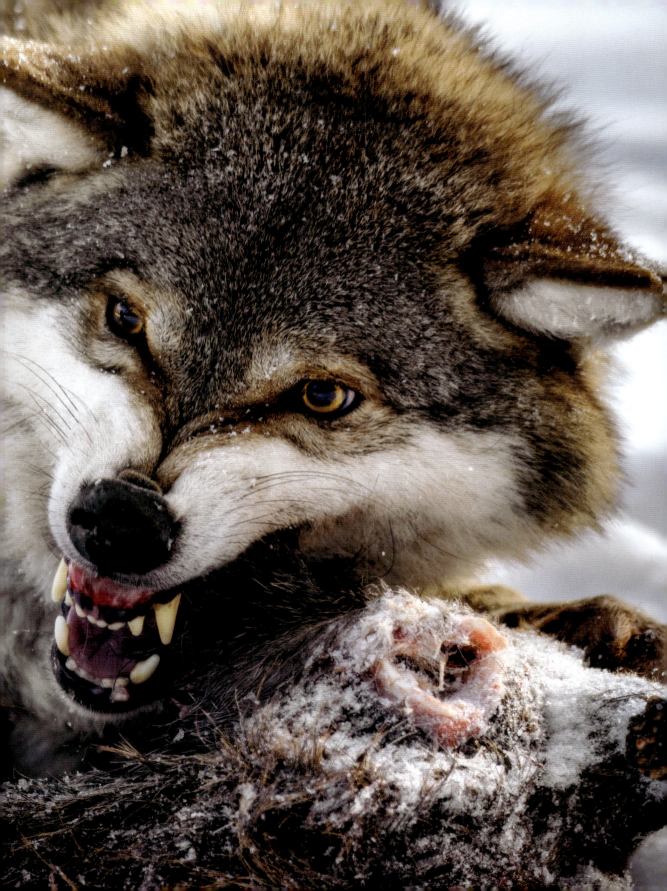

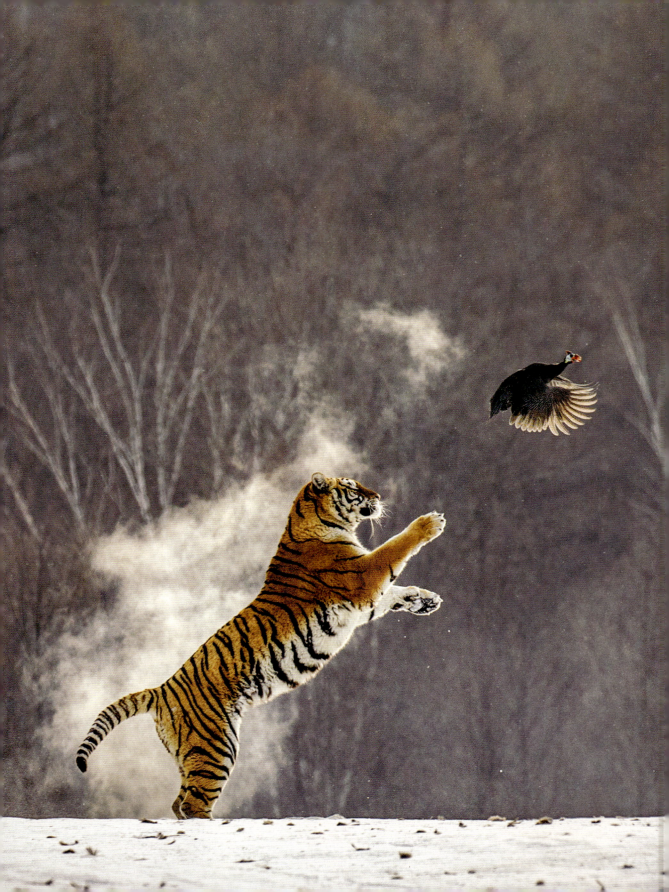

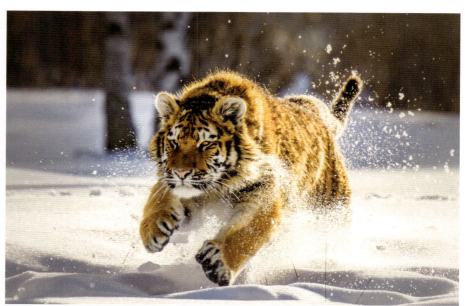
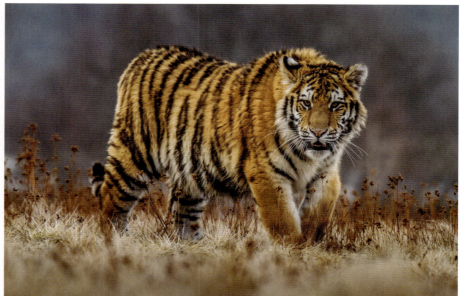

ALL PHOTOGRAPHS:
Siberian tiger
Common prey include deer, moose and wild boar, as well as other small mammals and birds. Competition with brown bears can be intense, with many fatal encounters between them witnessed by scientists, either from direct attack or disputes over food. Conversely, wolf numbers are severely lowered in tiger territories.

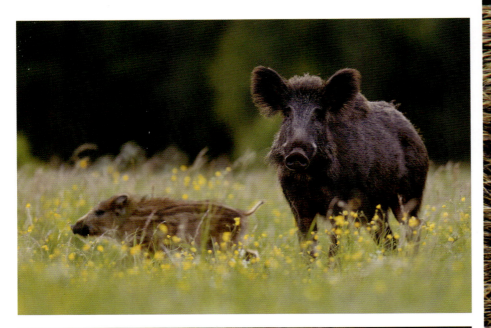

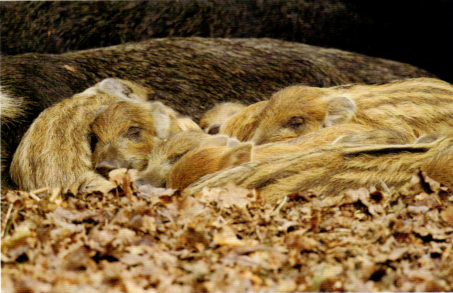

ALL PHOTOGRAPHS:
Wild boar
A common, dark-haired, inhabitant of oak and beech forests, the wild boar lives in groups of related females and their young. Males are solitary and have an average body length of 150cm (5ft). Its varied diet comprises roots, tubers, nuts, seeds, eggs, fish, molluscs and shoots. It also eats carrion, earthworms and small rodents.

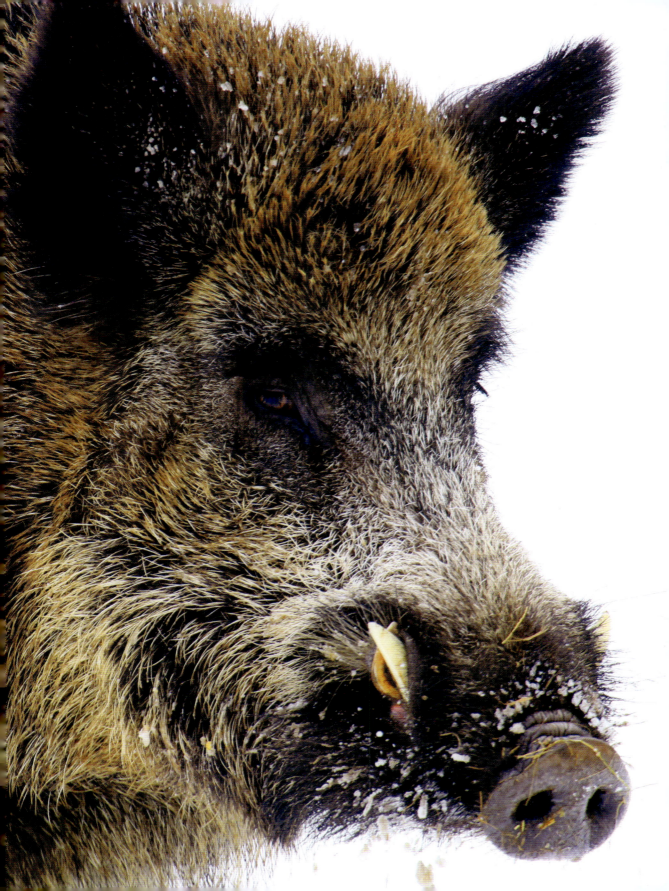

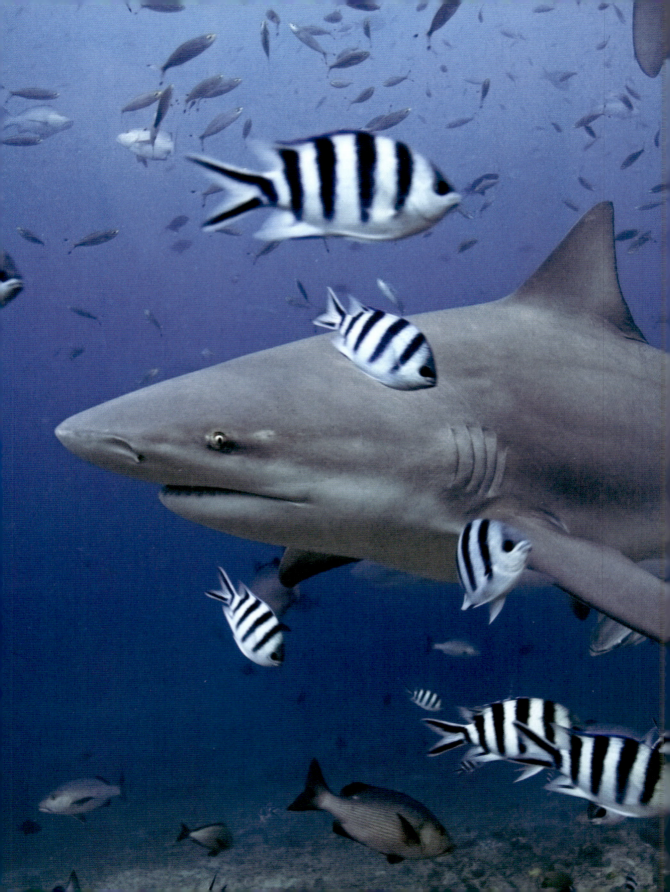

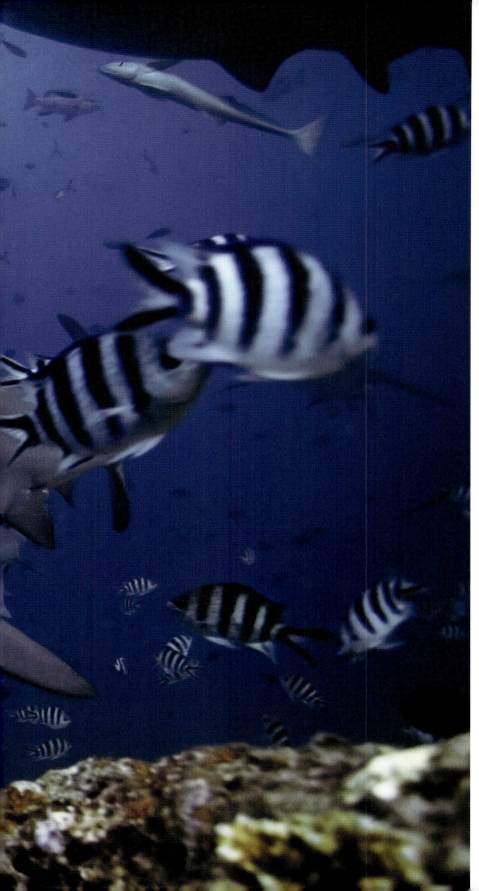

Bull shark
Bull sharks are found throughout warm oceans of the world. They are an unpredictable and aggressive species, recognised by their compact shape and broad snout. Their topside is grey and the underside white. They are unusual amongst sharks in that they are able to tolerate freshwater habitats.

Blue-ringed octopus
This is the octopus of James Bond fame, administering the coup de grâce to his adversary in Ian Fleming's original *Octopussy* story. If handled roughly they are capable of injecting an extremely powerful neurotoxin which, if left untreated, is capable of killing a human within a few minutes.

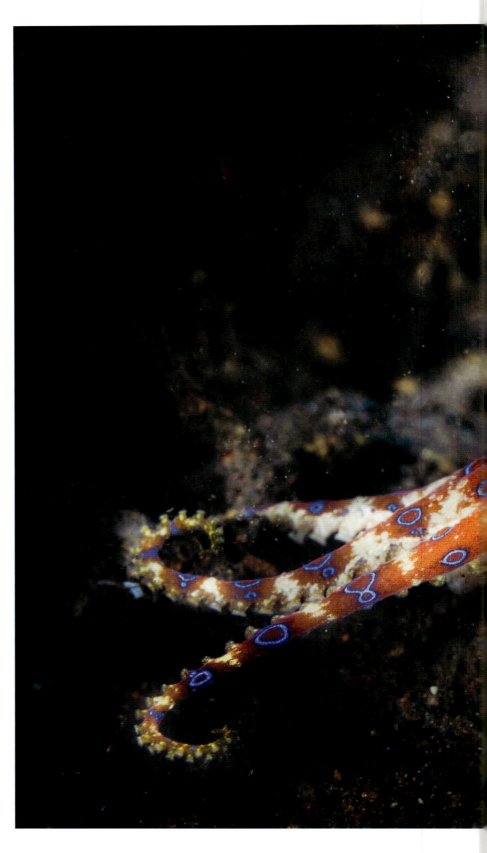

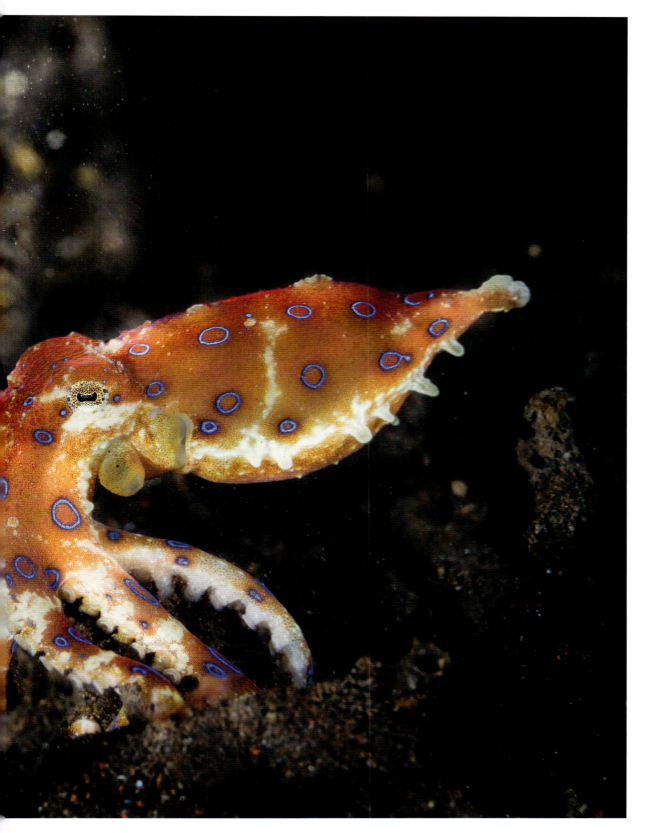

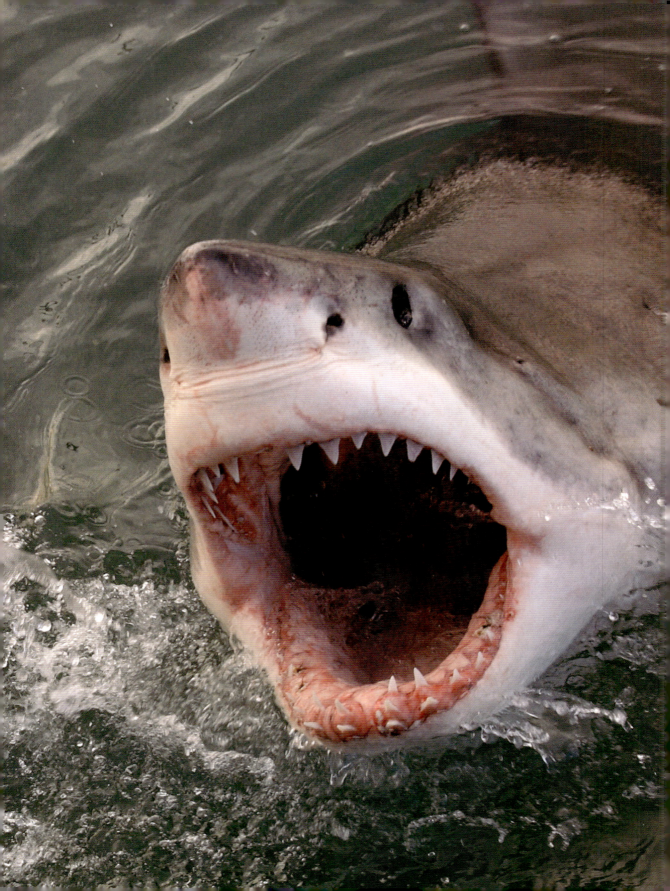

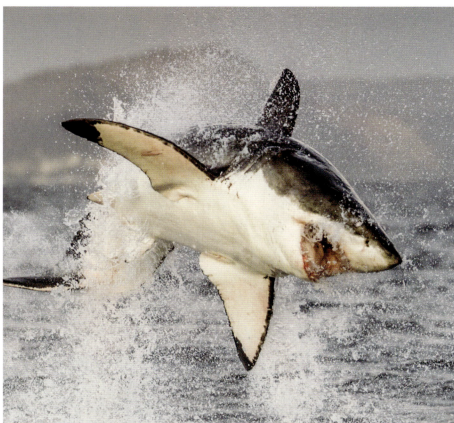
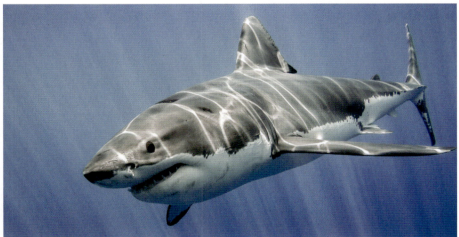

ALL PHOTOGRAPHS:
Great white shark
The great white has huge jaws full of razor-sharp, triangular teeth used to rip flesh. These sharks feed on fish, dolphins, turtles and sea mammals, ambushing seals from below and hitting them at high speed. During these attacks, sharks can reach speeds of up to 40km/h (25mph), their momentum carrying them clear of the surface.

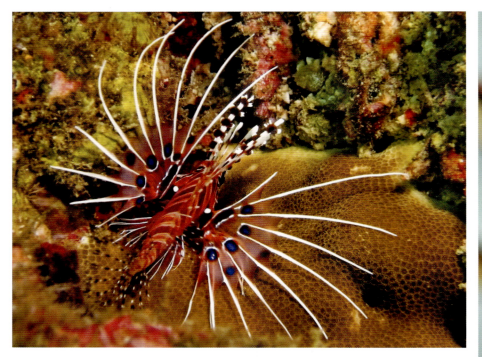

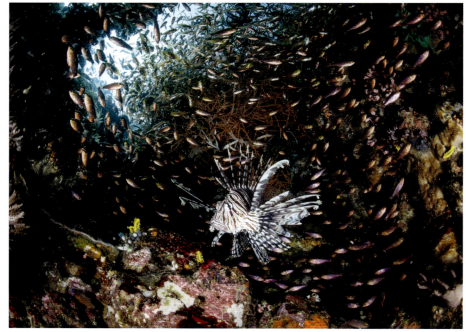

ALL PHOTOGRAPHS:
Lionfish
The lionfish is a group of distinctively shaped and patterned venomous fish, native to the Indian and Pacific Oceans. It can grow to 50cm (1.5ft), and administer venom via its long spines. It has become an undesirable invasive species outside its native range, where its voracious appetite represents a major threat to fragile ecosystems.

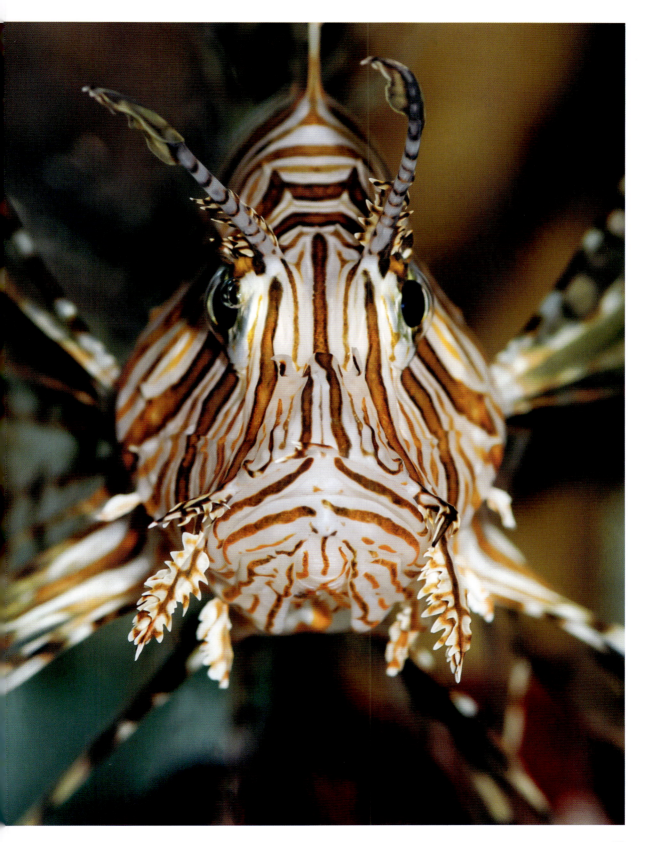

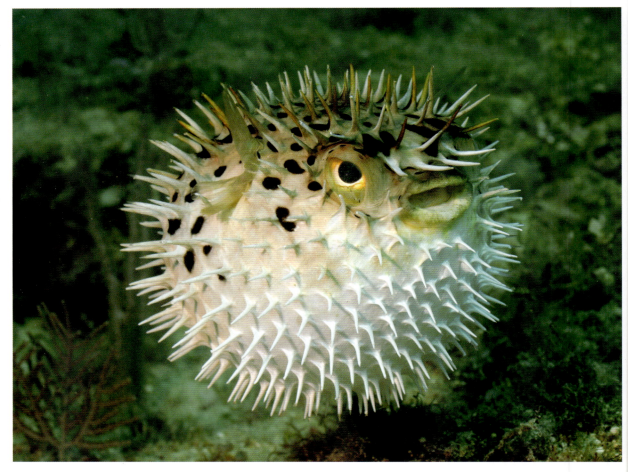

ABOVE AND RIGHT:
Puffer fish
A defence mechanism of this 50cm (1.6ft) long fish is to inflate its stomach with air or water, making it almost spherical and therefore less palatable to predators. All species also have sharp spines that help to deter any aggressor. The skin and internal organs of most species are highly toxic.

OPPOSITE:
Orca male breaching
Orcas, or killer whales, are the largest members of the dolphin family. Mature males grow to 8m (26ft) and have long, pointed dorsal fins up to 1.8m (6ft) long. Females are smaller and have a much reduced, curved dorsal fin. They are found in all the oceans of the world.

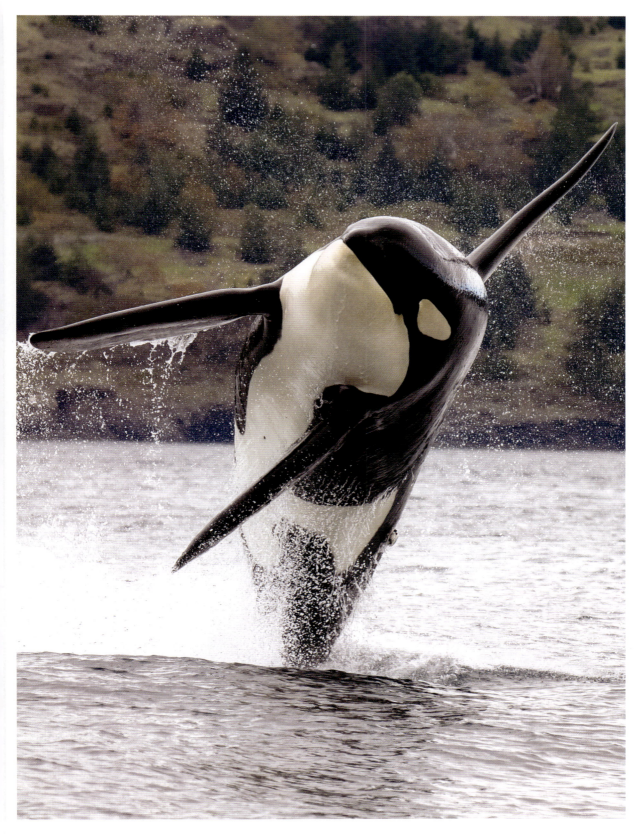

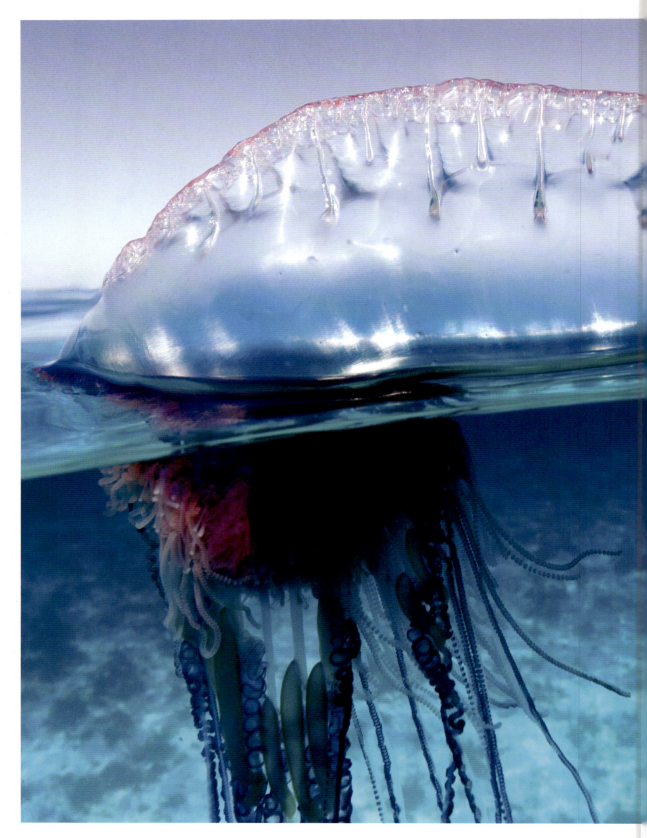

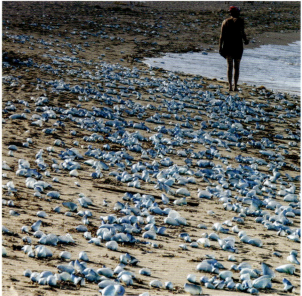

ALL PHOTOGRAPHS:
Portuguese man o' war
This jellyfish is a colonial organism made up of many genetically identical components, each having a discrete function. The sail like 'bladder' is the most obvious component, but the trailing 10m (33ft) tentacles are highly venomous, and used to stun prey such as fish and shrimps. This sting is very painful to humans, but rarely fatal.

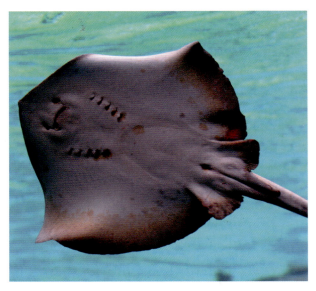

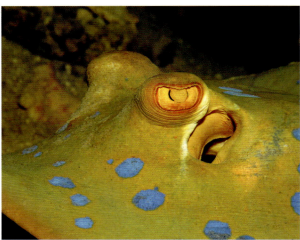

ALL PHOTOGRAPHS:
Stingray
There are over 200 species within this group inhabiting warm, tropical oceans where they feed on plankton, crustaceans, molluscs and fish. They hunt by foraging or ambush, some using their strong teeth to crush prey. The 'sting' is used for defence, and although it causes severe pain, it is not often fatal.

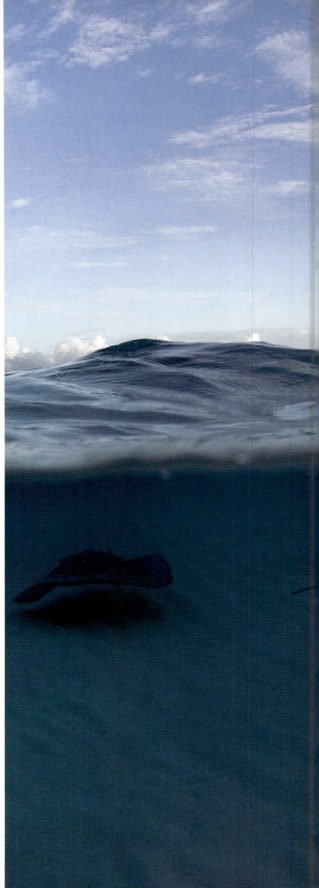

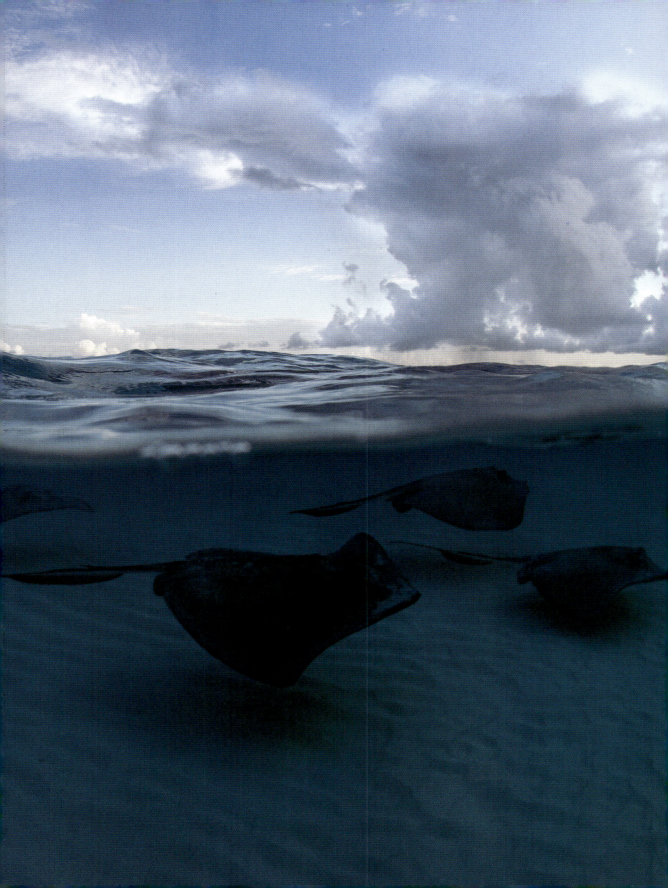

Endangered Animals

The natural world is facing a crisis. A total of 680 vertebrates have been driven to extinction in the last 500 years, including the dodo, the marsupial tiger, and Steller's sea cow. Yet that could just be the beginning. Three-quarters of all land habitats have been degraded by humans, if not completely altered. It is estimated that about one million species of animal are now threatened with extinction.

The oceans are being impacted by climate change as well, and even small increases in water temperature can reduce the quantity of oxygen dissolved in it, thus compressing most sea life into a shrinking band of water beneath the surface. The Arctic is warming at twice the rate of other parts of the planet. The direct activities of humans, such as fishing and pollution, are also having an impact on the balance of marine ecosystems. More than 5,000 ocean species are listed as endangered, and people are realising that our vast seas are not an endless resource.

Extinction is a natural process, but naturalists calculate that the current rate of extinction is 1,000 times faster than normal. That scale of threat suggests that we are in a mass extinction of the kind last seen when the dinosaurs were wiped out.

The plight of the natural world is well understood thanks to publicized reports of the perils faced by iconic animals, such as the panda, rhino or tiger. As this chapter shows, there are plenty more beautiful creatures in grave danger.

OPPOSITE:
The orang-utang is the rarest great ape. Their numbers are still in decline as their jungle home is steadily destroyed by fire and farmers.

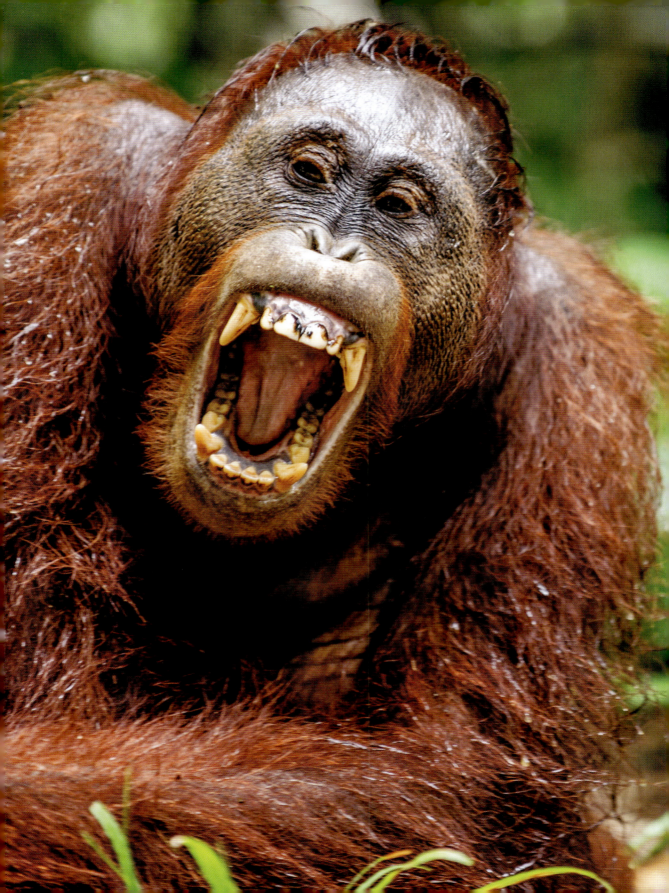

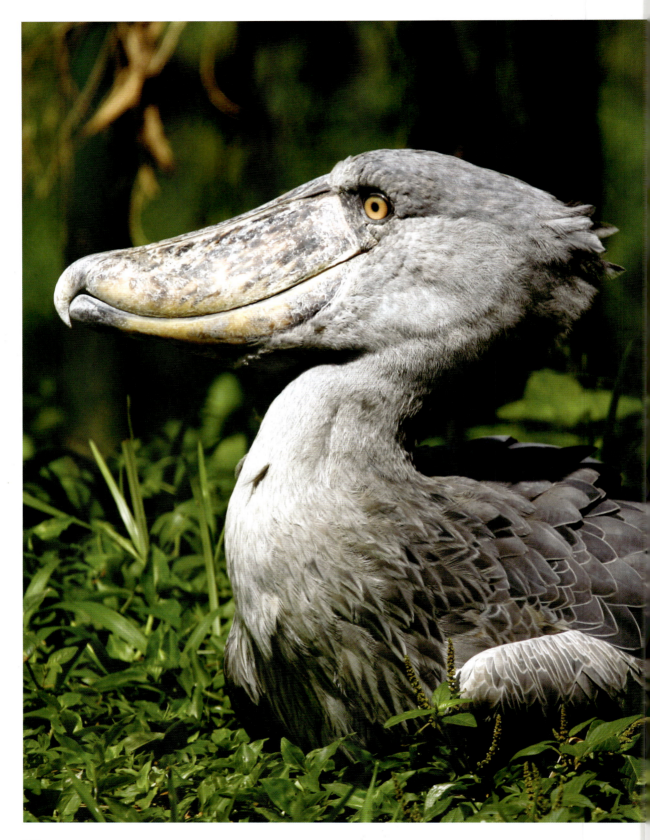

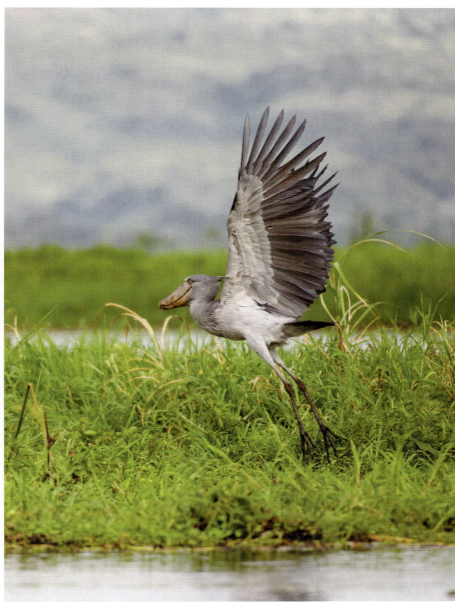

BOTH PHOTOGRAPHS:
Shoebill
Named for its highly distinctive beak, this chunky bird lives in the wetlands around Africa's Great Lakes. The bill is adapted to scooping up fish in the muddy water. There are about 5,000 left in the wild, and numbers are dropping as available habitats are drained for agricultural use.

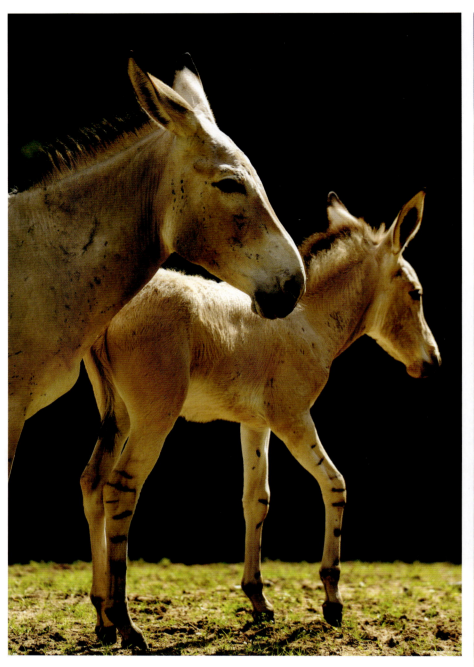

BOTH PHOTOGRAPHS:
African wild ass
Surviving in a few patches along the western Red Sea coast, this wild ancestor of the donkey is critically endangered with fewer than 200 living outside of captivity.

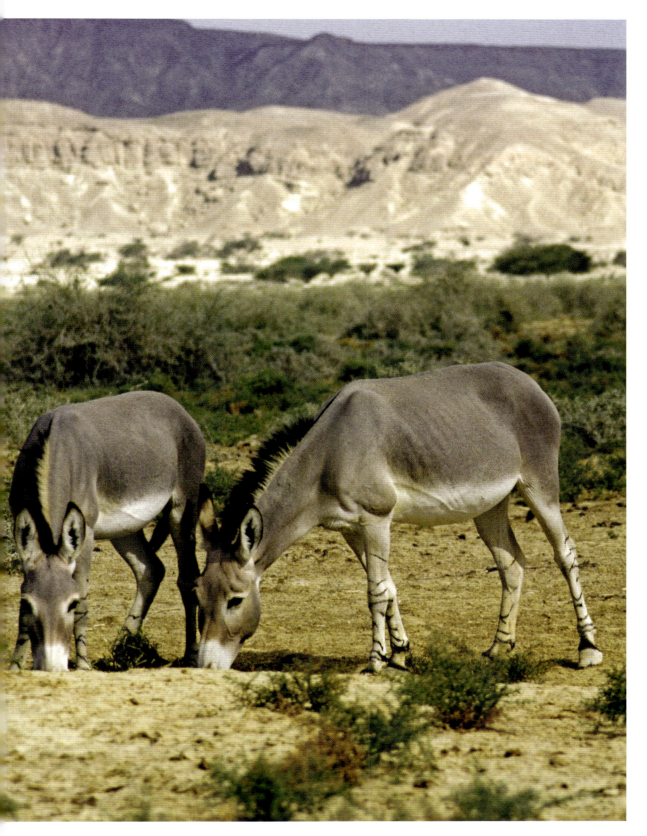

ALL PHOTOGRAPHS:
African wild dog
Found mostly in Botswana, Africa, with fragmented populations clinging on in other parts of the continent, this long-legged dog species is a pack hunter like the wolf, but is more closely related to the jackal. There are an estimated 1,400 left. The packs need a large territory to find enough food. They are being crowded out of the more fertile areas and now survive mostly in dry semi-desert regions.

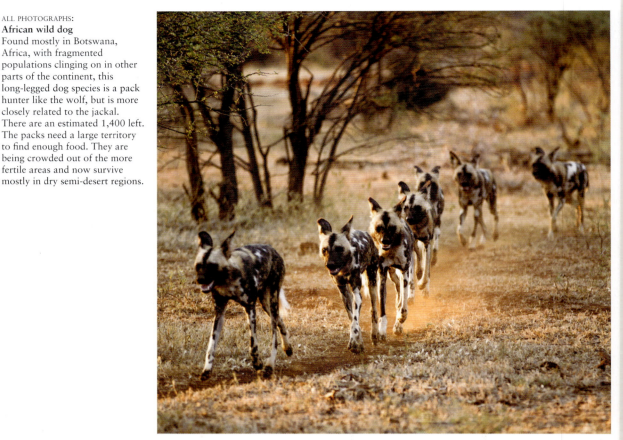

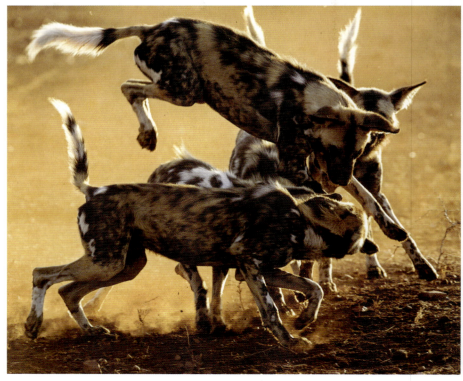

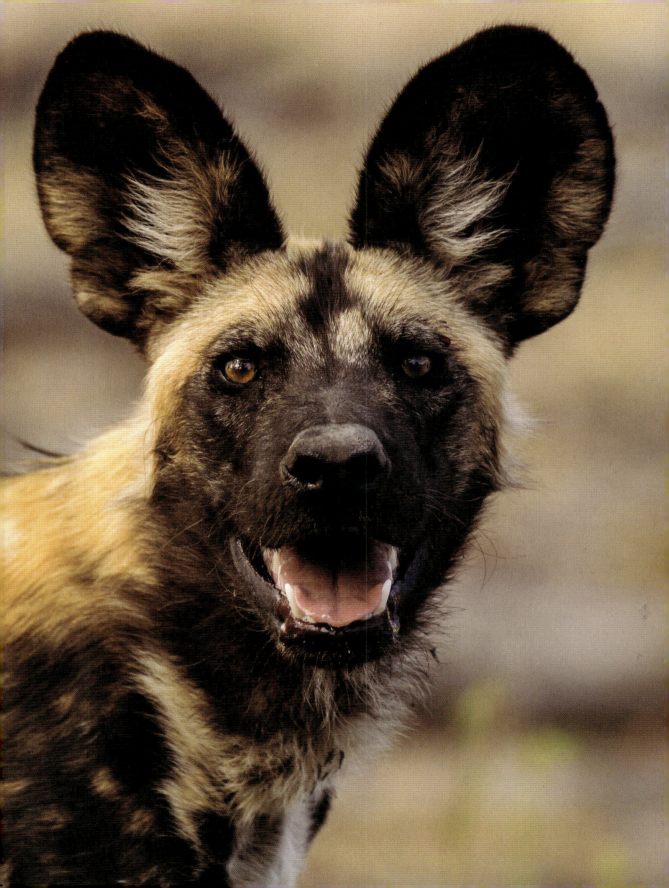

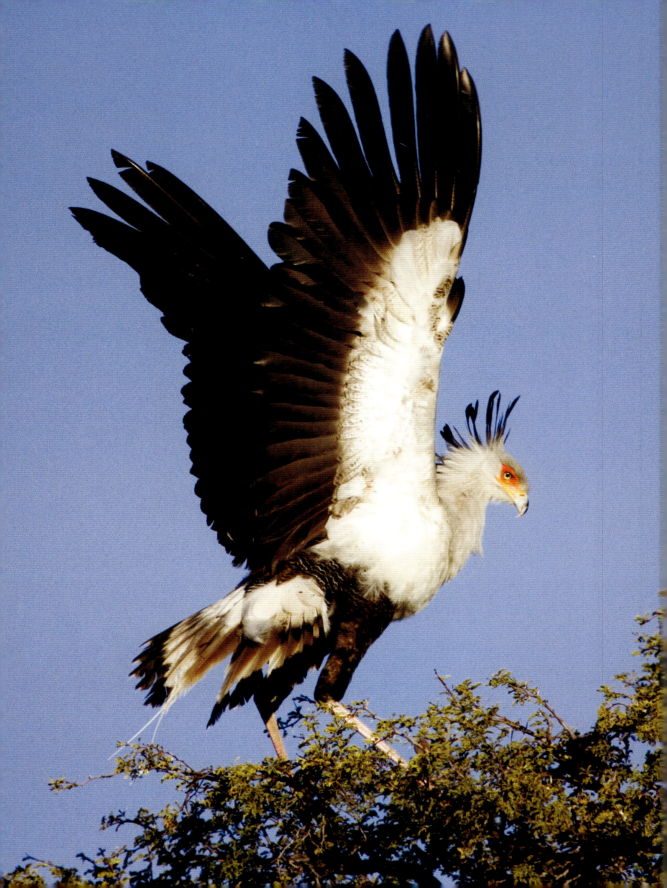

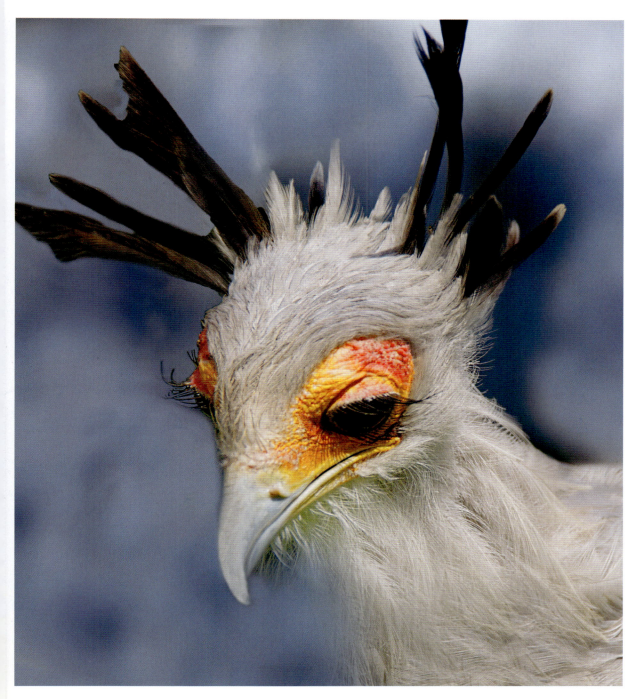

BOTH PHOTOGRAPHS:
Secretarybird
Said by some to be named after the typewriter sound of its call, others suggest the way this insect-eating bird walks reminded people of the centaur archer Sagittarius, and that name was mangled over the years. The secretarybird has suffered a rapid decline in recent years as its habitat is fragmented by new roads.

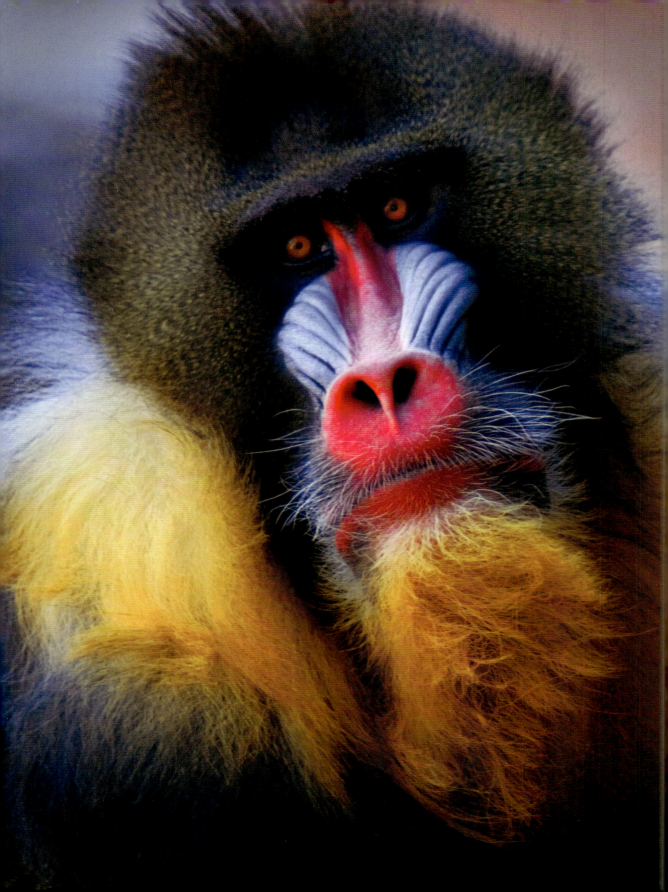

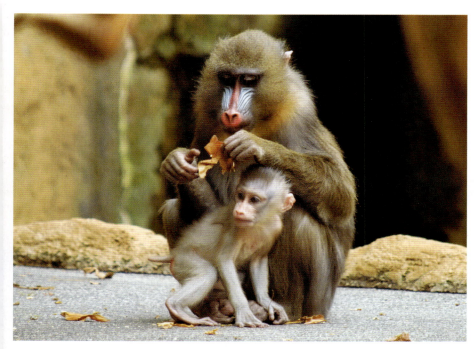

ALL PHOTOGRAPHS:
Mandrill
The largest monkey species of all, the mandrill lives in the mountain forests north of the mouth of the Congo. Their numbers in the wild are unknown since they live in the heart of dense jungles, but they are thought to be in decline. Hence many are kept in captivity such as these monkeys. The male mandrills are famed for having impressive facial marking that flare with colour in times of tension and excitement.

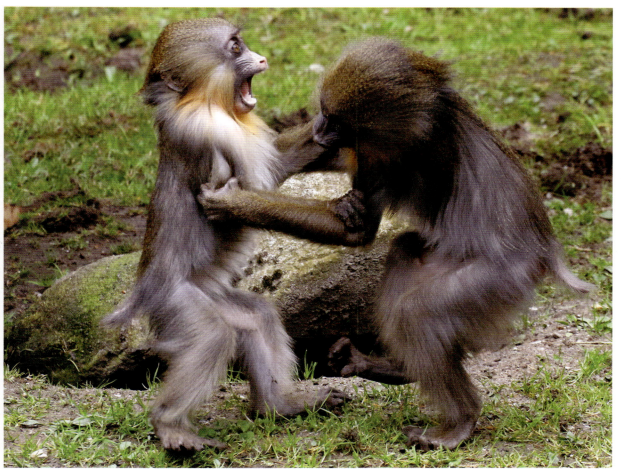

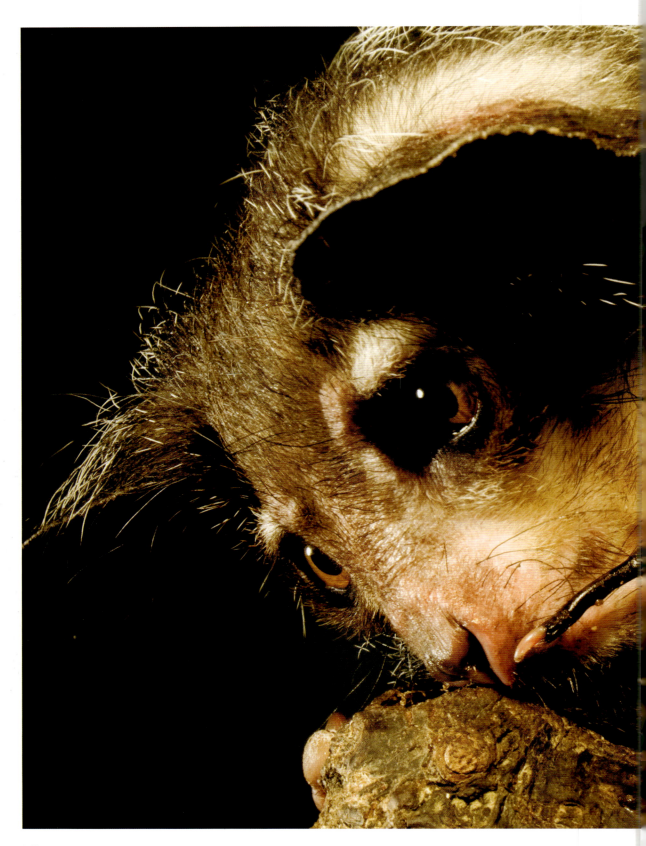

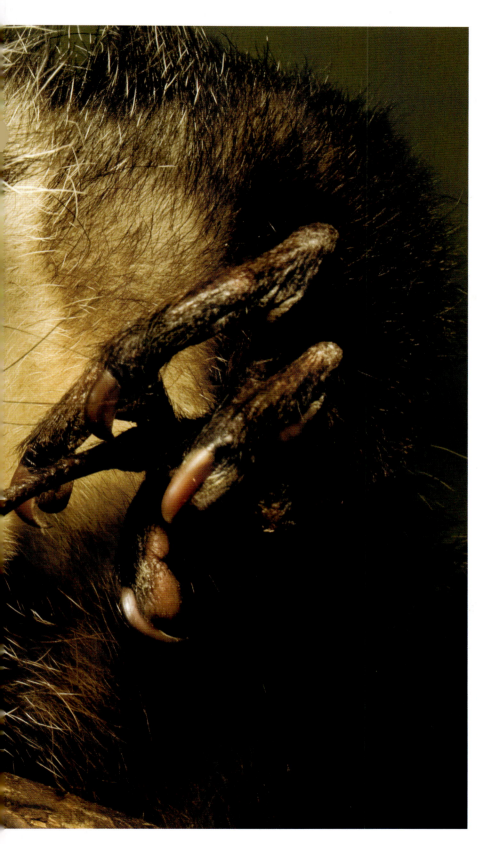

Aye-aye
All the lemurs in Madagascar are endangered in some way, but this highly unusual nocturnal species is especially vulnerable. Due to this they are often spotted in zoos wildlife conservation areas such as this one. It uses its elongated finger to tap on tree branches listening out for hollow sounds that show a juicy grub is lurking under the bark. The animals' forest home is under threat, and local people see the ghoulish creature as evil and must kill it on sight.

OVERLEAF:
Black rhinoceros
Hunted relentlessly for its nose horn, conservation efforts saved the black rhino from extinction. There are now 3,500 black rhinos in the wild with numbers rising. The black species is contrasted with the white rhino, which is not white at all but instead has a *wide* mouth for cropping grass. The black rhino's more beak-like mouth is suited for browsing leaves from woodland shrubs.

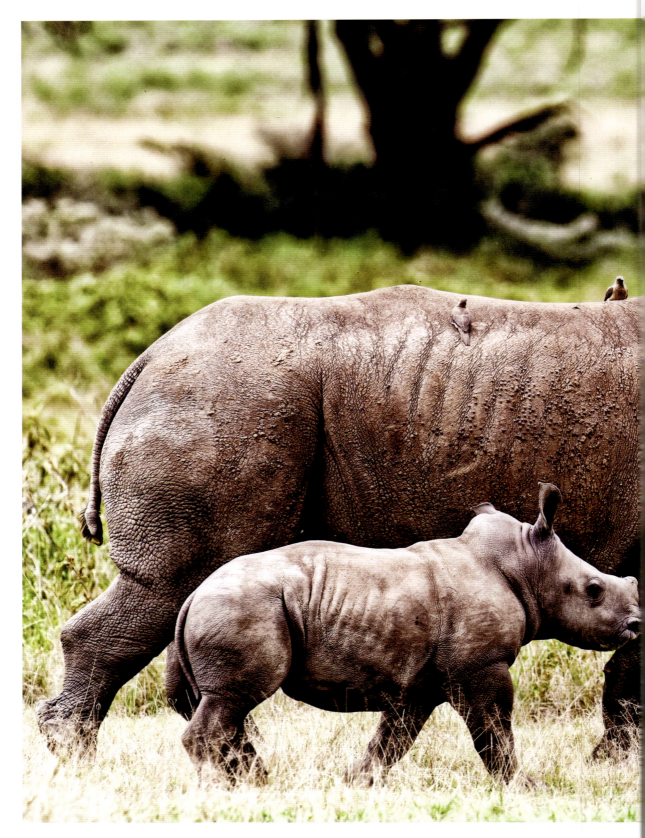

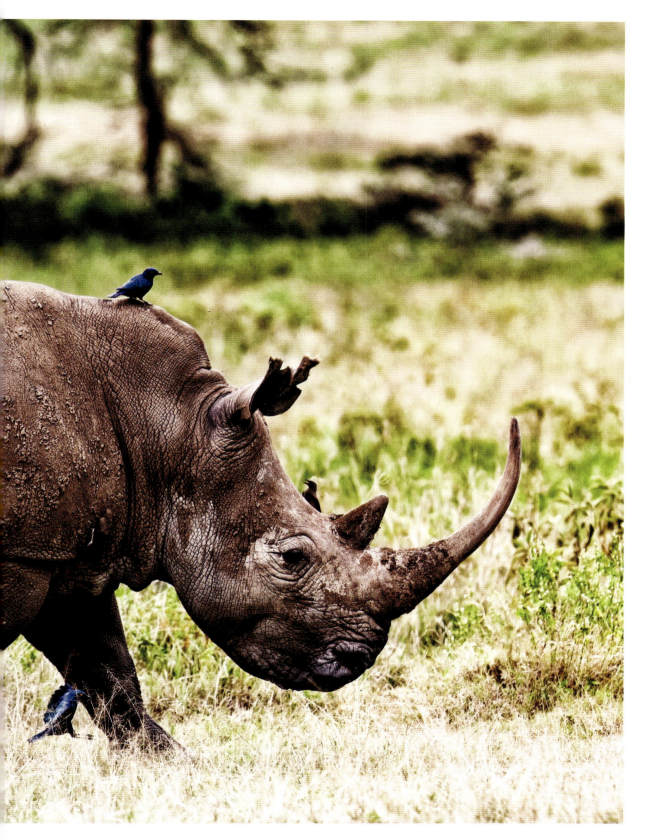

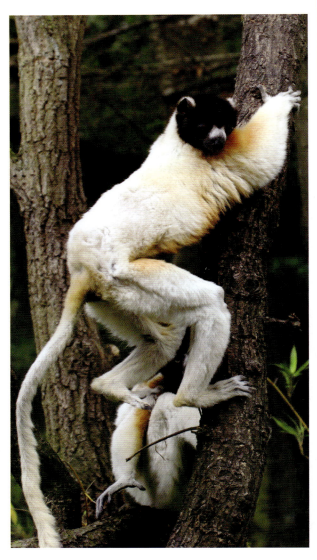

BOTH PHOTOGRAPHS:
Crowned sifaka
Pronounced 'shi-far-kuh', these large lemurs are famed for the way they leap between the tall trunks of their forest home in Madagascar. As these forests thin and fragment, the sifakas are put under pressure. Unlike other lemurs, these species – the black crowned and golden crowned, respectively – are unable to walk on the ground, just hop, so cannot move across gaps in the forest.

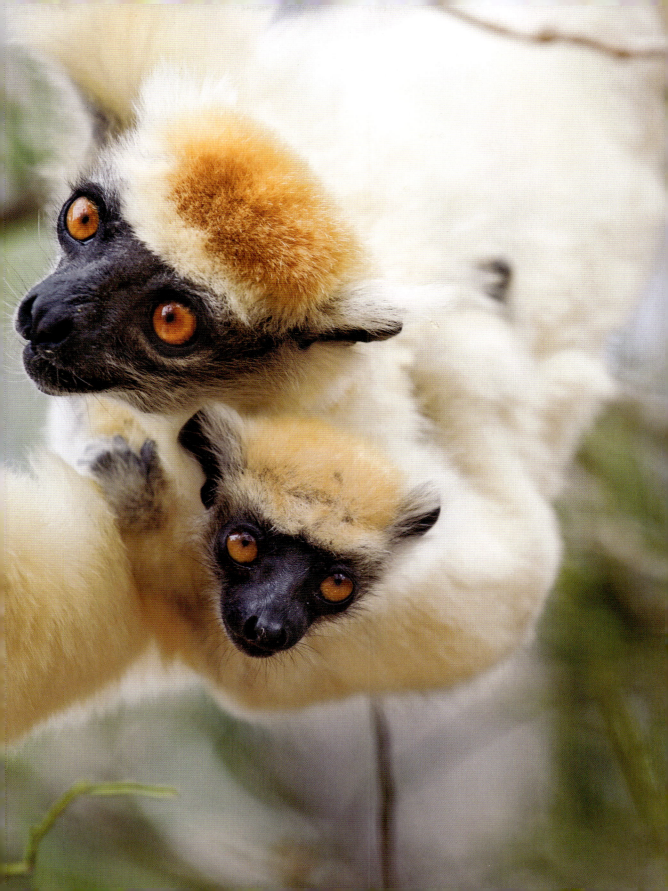

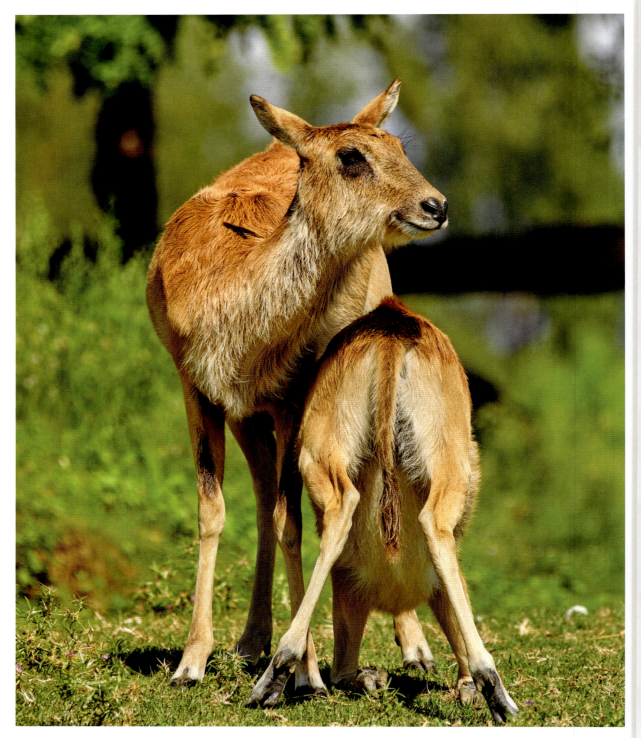

ABOVE:
Nile lechwe
The brown coats show these are female lechwes, with the males having a black coat. These antelopes live in the swamps of South Sudan formed by the White Nile. This habitat is shrinking and so is the lechwe population.

OPPOSITE:
Mountain gorilla
A subspecies of the critically endangered eastern lowland gorilla, this small band of herbivorous primates lives in the cloud forests that straddle the borders of Uganda, Congo and Rwanda in Africa.

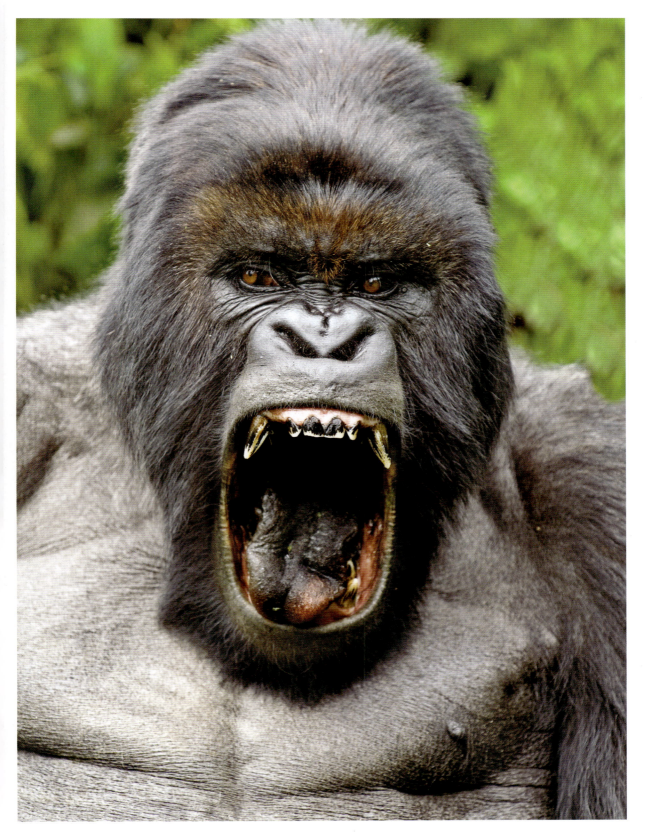

Giraffe
The tallest animal on Earth has a complex classification, with some authorities preferring to see the many separate populations being different species, some more endangered than others. Nevertheless, taken together, this iconic animal is still vulnerable to extinction due to habitat loss and poaching.

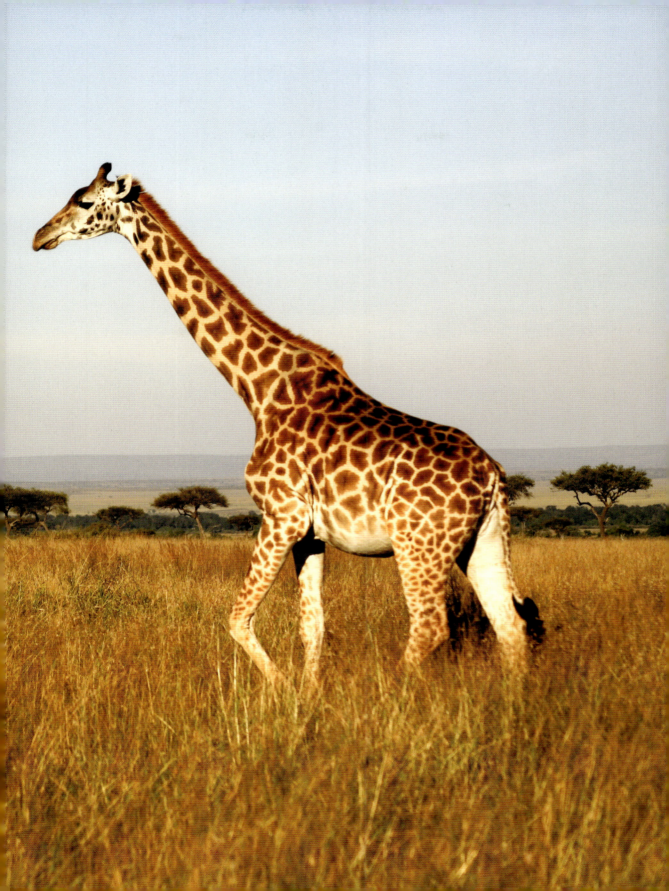

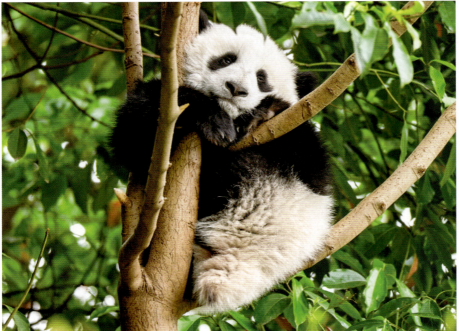

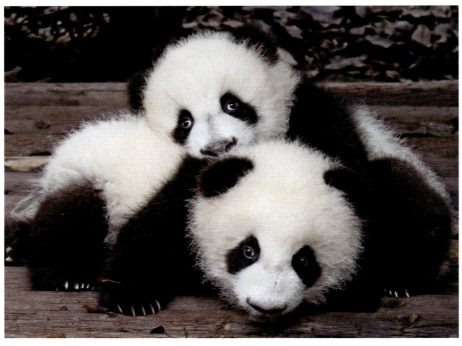

ABOVE TOP:
Giant panda
The giant panda is a singular offshoot of the bear family that lives only in the steep mountain forests of southern China. By the end of the 20th century there were perhaps just 3,000 living wild.

ABOVE BOTTOM:
Panda cub
The future of pandas has been secured by breeding cubs in captivity like these – often using in vitro fertilization techniques – and then reintroducing them to the wild.

RIGHT:
Bamboo diet
Pandas eat only the leaves and stalks of bamboo that grow in dense glades in their forest habitat. Pandas are unable to survive on any other food sources.

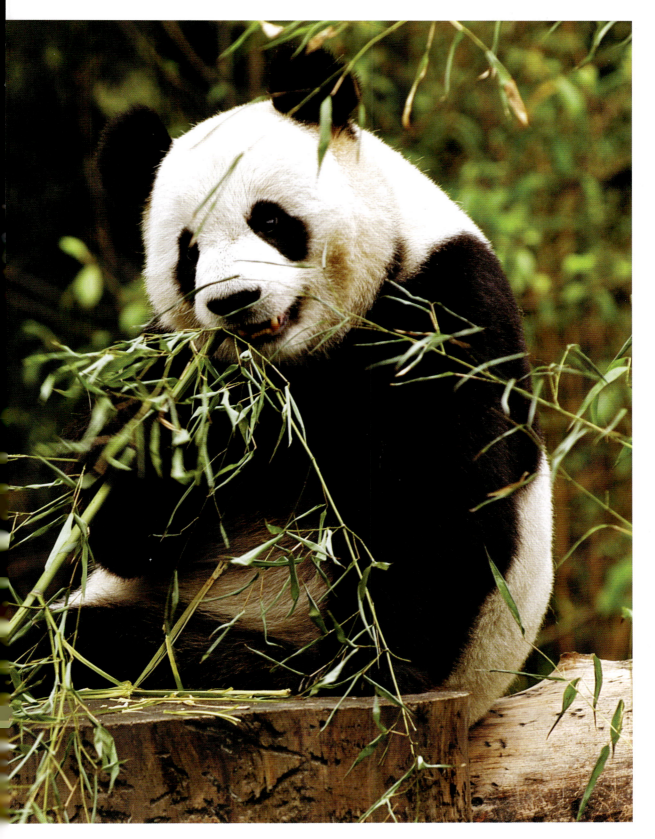

Asian elephant
Unlike African elephants, their smaller cousins over in south and east Asia have been widely domesticated as a beast of burden. However, the number of truly wild Asian elephants is around 50,000 and falling.

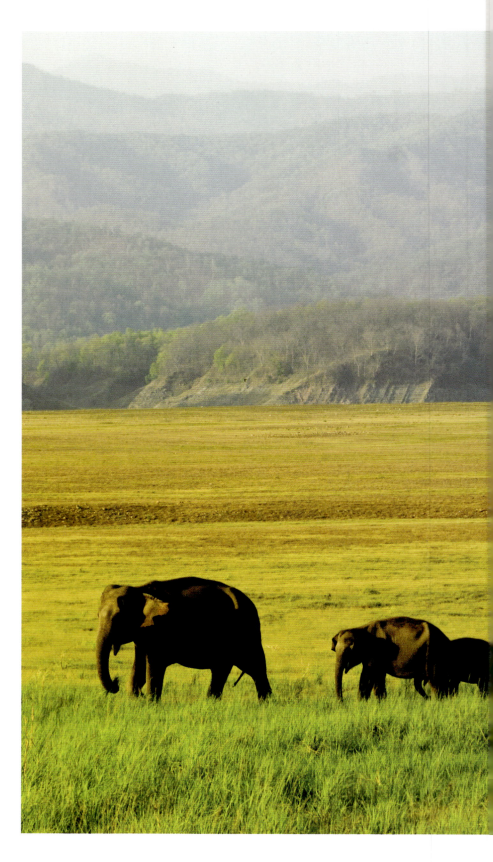

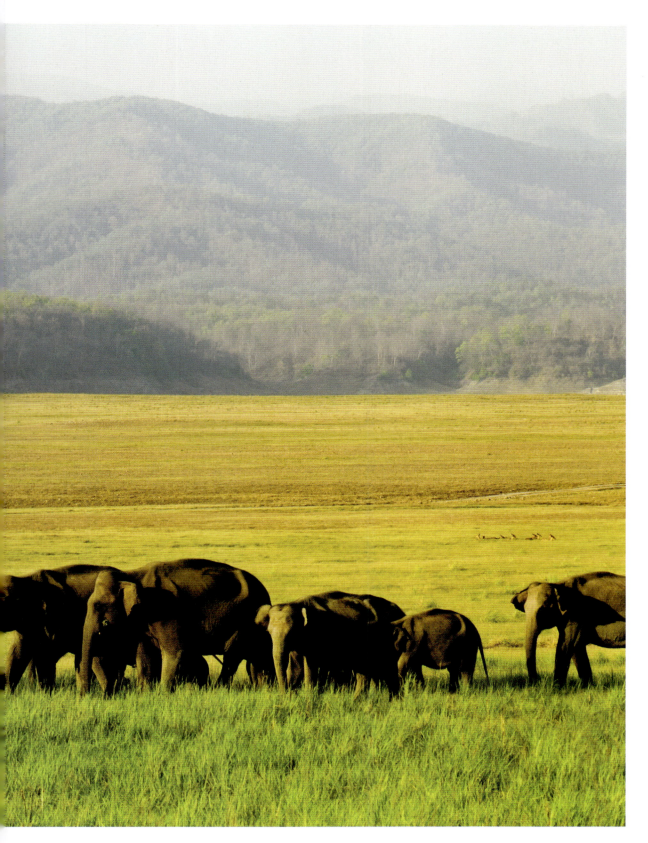

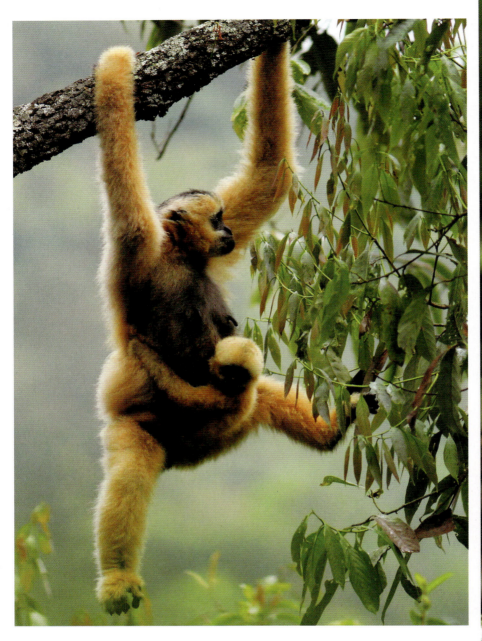

ABOVE:
Black-crested gibbon
The gibbons (or lesser apes) all live in and around the forests of Southeast Asia. There are 18 species, including this one from the north of Indochina, and every one is under threat from extinction, often critically so. The gibbons, which swing high in the branches, are suffering due to deforestation.

RIGHT:
Clouded leopard
This is the smallest of the big cats, which roar instead of purr. It lives in the forests of East Asia and is hunted for its mottled coat.

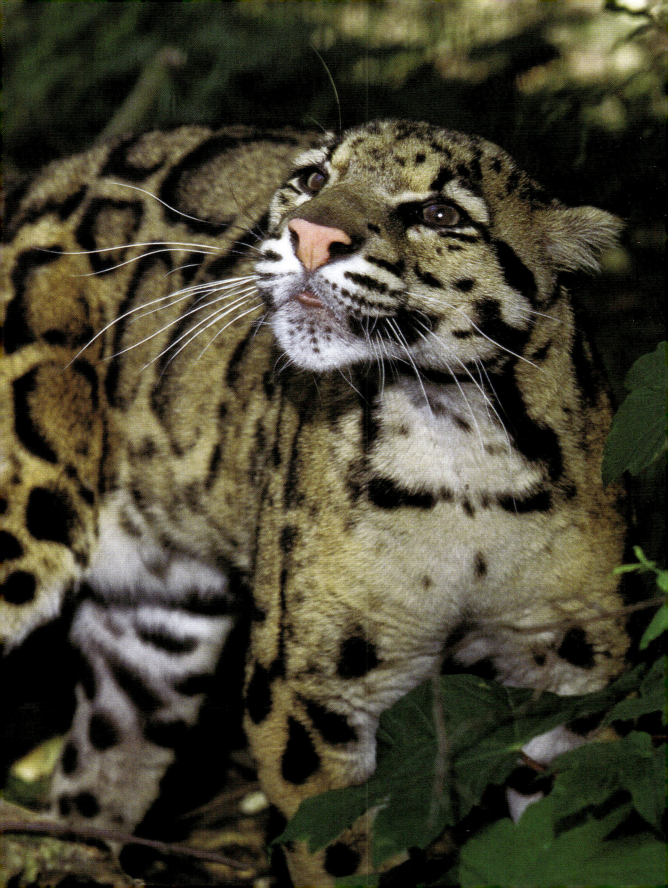

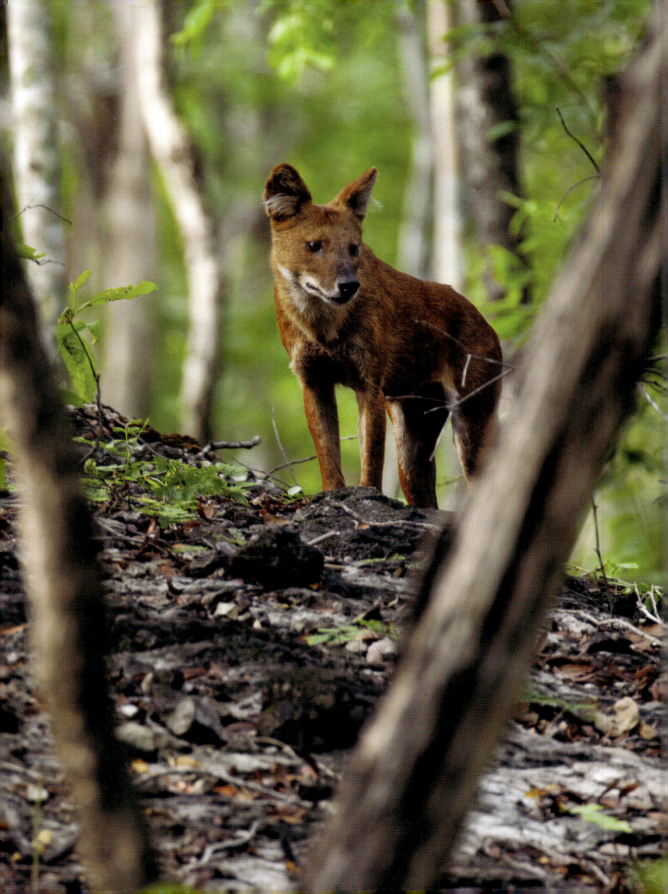

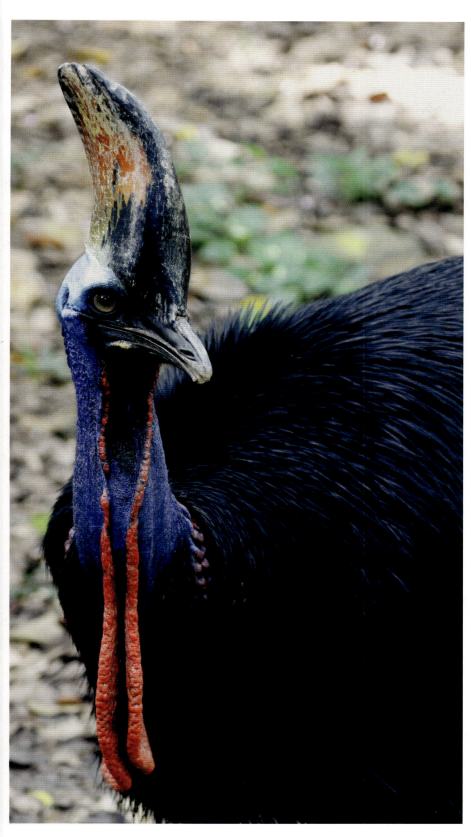

OPPOSITE:
Dhole
Also known as the Asia red dog, the dhole is a pack hunter from the forests of Central and South Asia. Although it seldom attacks livestock, the dogs are traditionally persecuted across their range.

LEFT:
Double-wattled cassowary
This is one of the three flightless cassowary species in the forest of New Guinea that requires protection from deforestation and hunting.

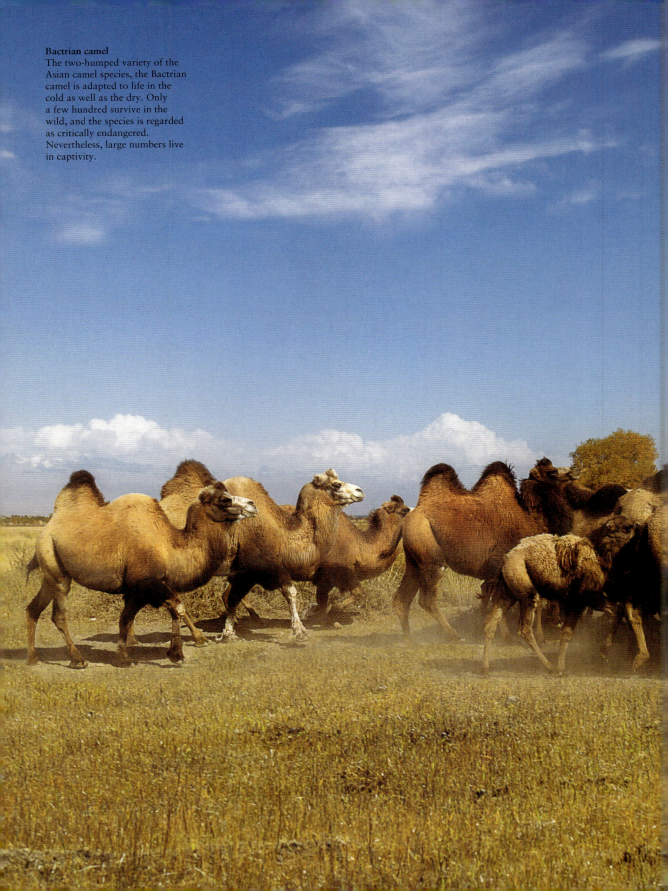

Bactrian camel
The two-humped variety of the Asian camel species, the Bactrian camel is adapted to life in the cold as well as the dry. Only a few hundred survive in the wild, and the species is regarded as critically endangered. Nevertheless, large numbers live in captivity.

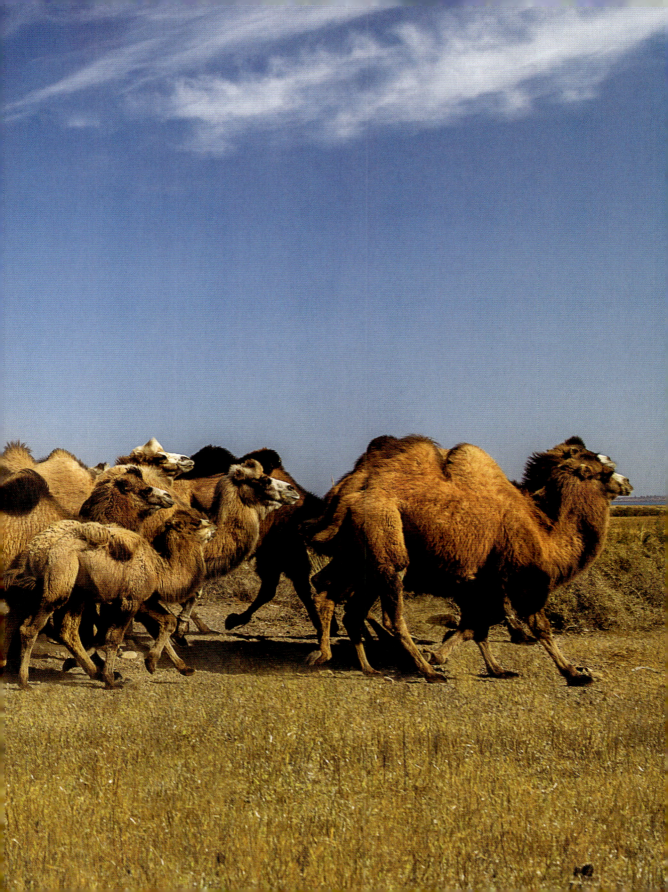

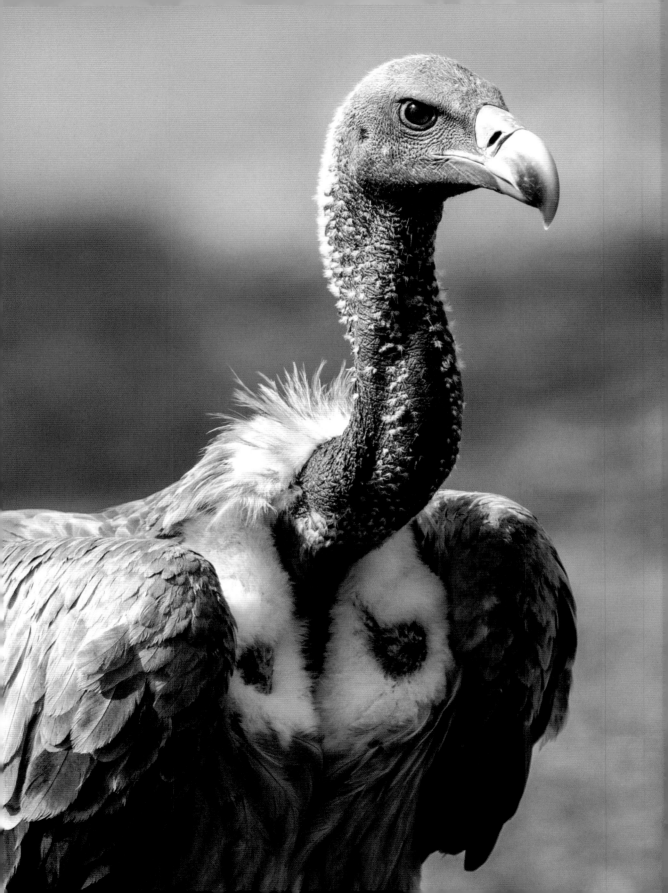

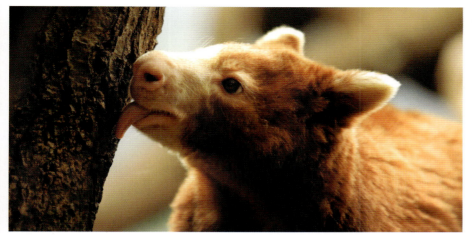
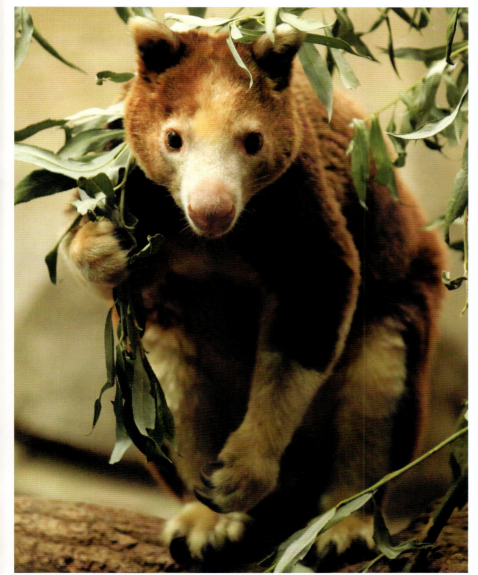

OPPOSITE:
Indian vulture
Once a significant scavenger in South Asia, the Indian vulture is now critically endangered due to a calamitous misuse of drugs given to oxen and other beasts of burden that allowed them to work harder. Once these animals die, the drug pass to the vultures that scavenge on their remains, leading to kidney failure and death. Today the species is being supported by captive breeding until this problem is resolved.

LEFT TOP AND BOTTOM:
Huon tree kangaroo
The tree kangaroos live in the forests of New Guinea (as does this species) and Queensland. The little marsupials are all at risk from deforestation and hunting.

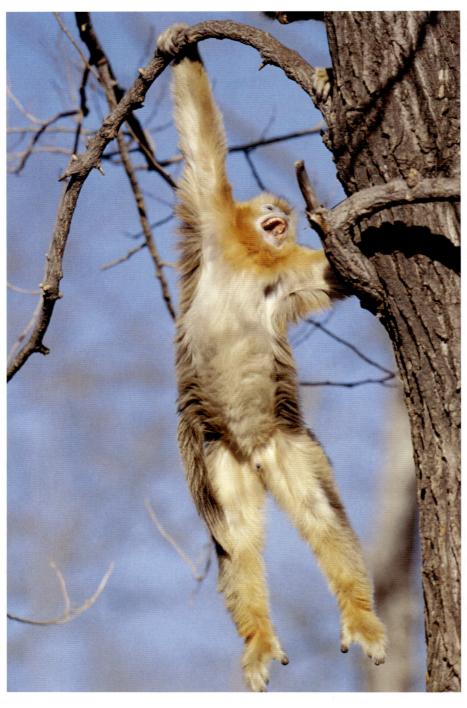

BOTH PHOTOGRAPHS:
Golden snub-nosed monkey
This distinctive Chinese monkey is falling in number due to the degradation of its habitat. Its staple food is lichen that grows on dead trees in the forest, but these logs are often removed by people for firewood.

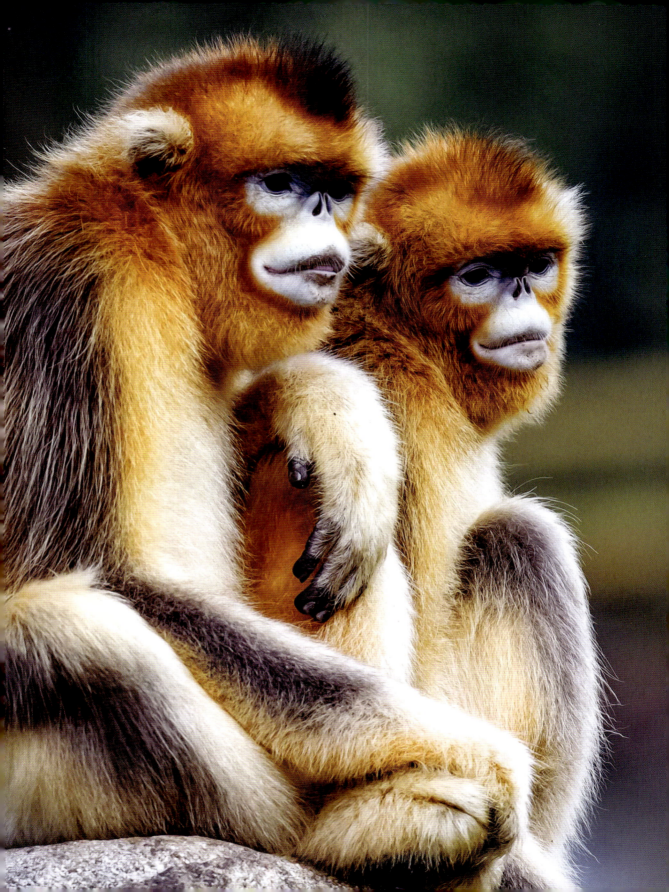

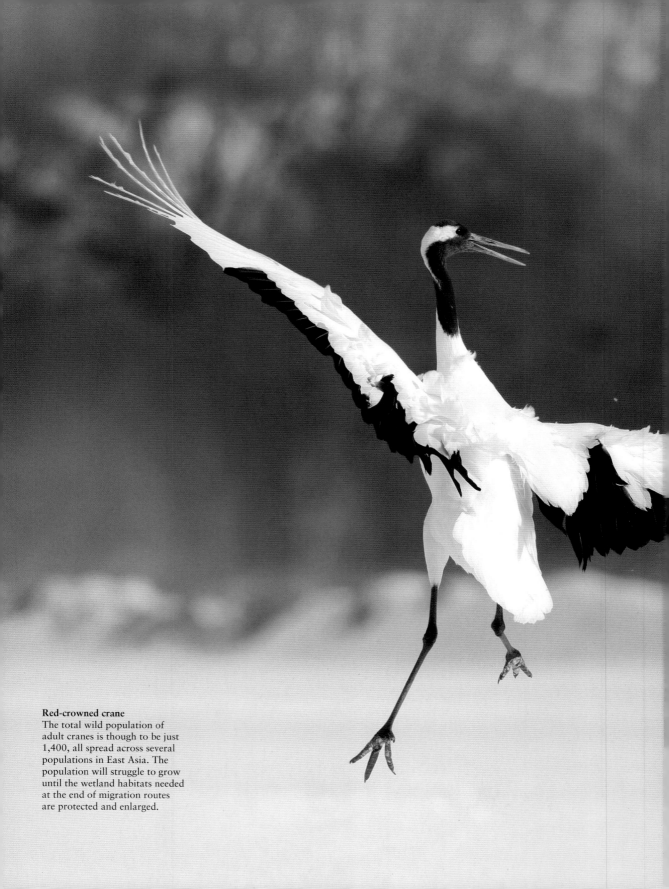

Red-crowned crane
The total wild population of adult cranes is though to be just 1,400, all spread across several populations in East Asia. The population will struggle to grow until the wetland habitats needed at the end of migration routes are protected and enlarged.

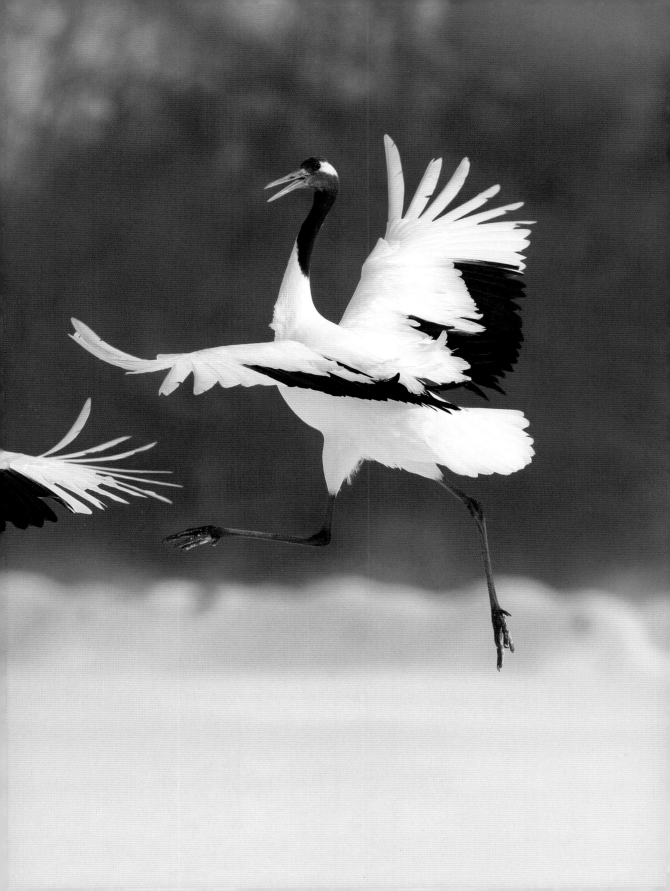

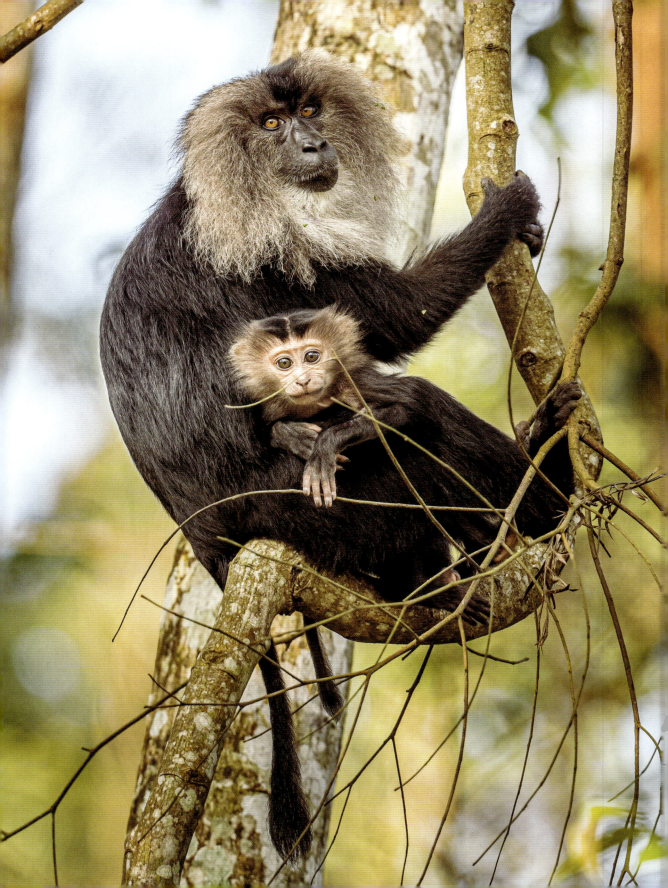

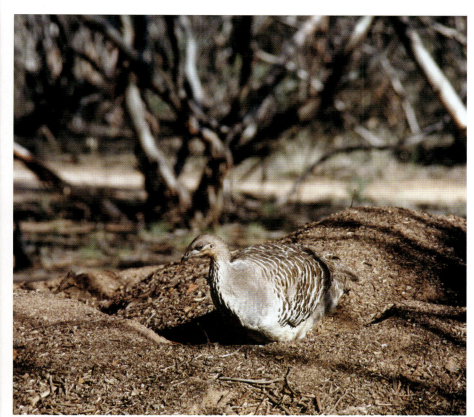

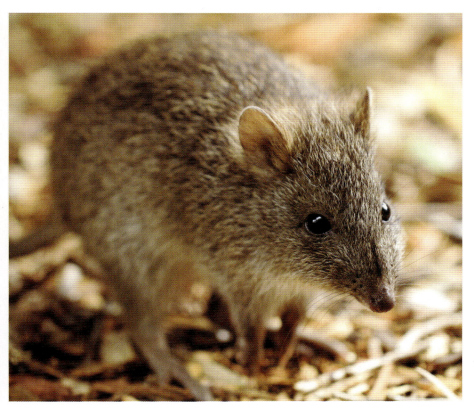

OPPOSITE:
Lion-tailed macaque
Restricted to the Indian coast of the Arabian Sea, this is one of the rarest monkey species, numbering 3,000 or so. They are threatened by agriculture destroying wild habitats.

LEFT TOP:
Malleefowl
A distant relative of the domestic chicken, this Australian bird buries its eggs in an earth mound and then leaves the chicks to their fate. Foxes introduced to Australia have decimated the malleefowl population and it is now classified as vulnerable.

LEFT BOTTOM:
Long-footed potoroo
In common with many marsupial species, the long-footed potoroo is threatened because it cannot withstand the duel onslaught of habitat loss and predation by mammals, such as foxes and cats, introduced from other parts of the world over the last few centuries.

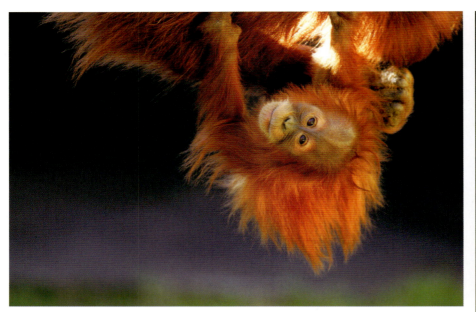

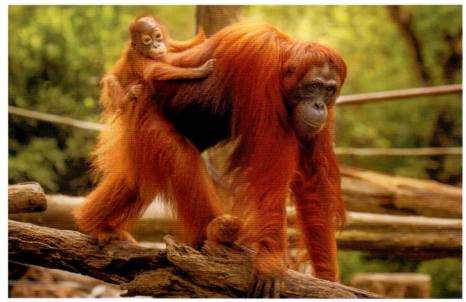

ALL PHOTOGRAPHS:
Orang-utan
The only great ape that survives in Asia (other than humans, of course), both species of orang-utan are endangered. As well as a shrinking habitat, the apes are threatened by hunters who kill the mother and take the young for sale as pets. Orang-utans breed very slowly, with babies born nine years apart, so it will take many decades for populations to recover.

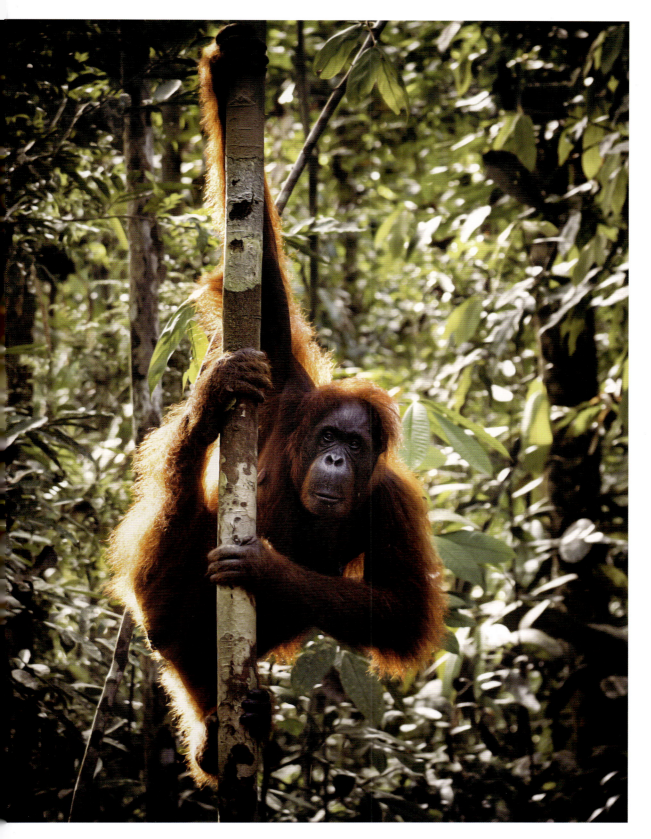

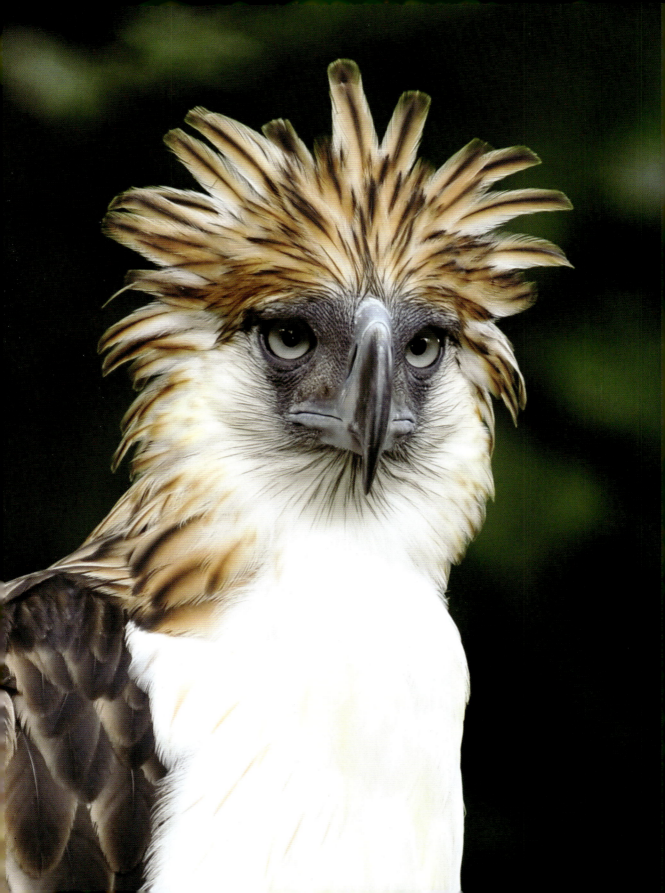

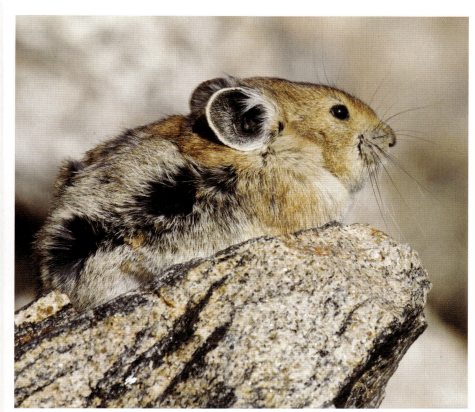

OPPOSITE:
Philippine eagle
The largest bird of prey of all, this forest hunter swoops in to snatch monkeys from the branches. They are threatened by extreme deforestation and are critically endangered. The wild population could be as low as 200.

LEFT:
Pika
These diminutive relatives of rabbits and hares live across Central Asia (and North America), often in rocky habitats. Many of them require protection.

BELOW:
Painted terrapin
Found across the forests of Indonesia and Southeast Asia, this freshwater turtle is threatened by the widespread collection of its eggs for food and for supplying the pet market. Today, its eggs are collected by rangers who ensure they hatch in captivity before returning them to the wild.

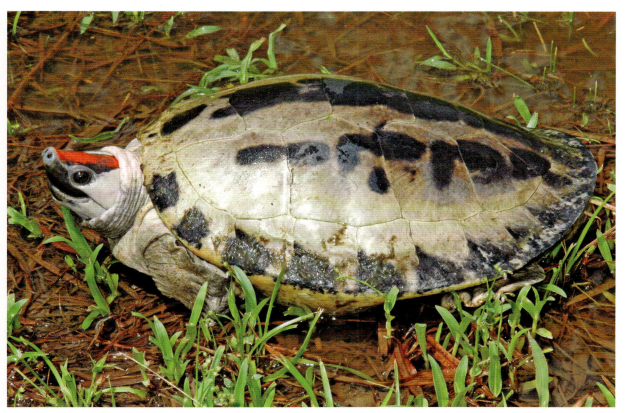

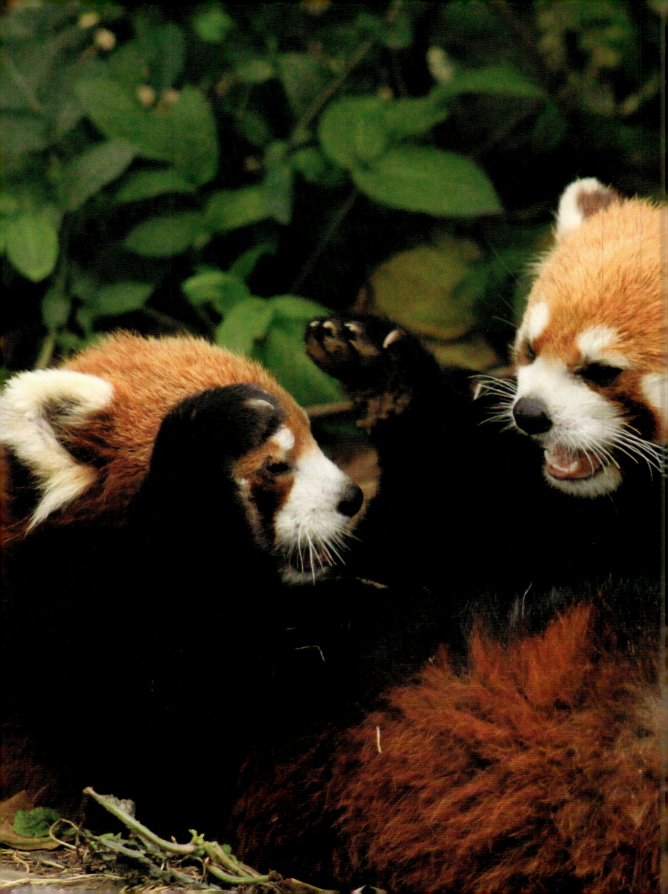

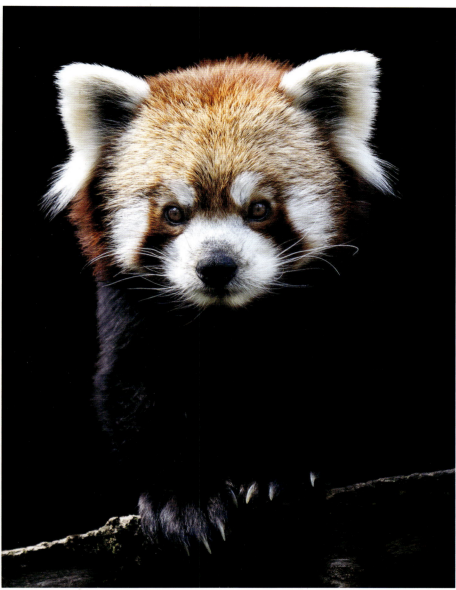

BOTH PHOTOGRAPHS:
Red panda
Earning the panda name from the cute white patches on its face, this Chinese species is not related to the giant panda. Instead it is linked to the raccoons of the Americas. Like the giant panda, the red panda relies on a similar bamboo diet. The wild population is below 10,000 due to habitat loss and hunters wanting its thick red fur. Because of this, many are kept in panda reserves such as this one in Sichuan, China.

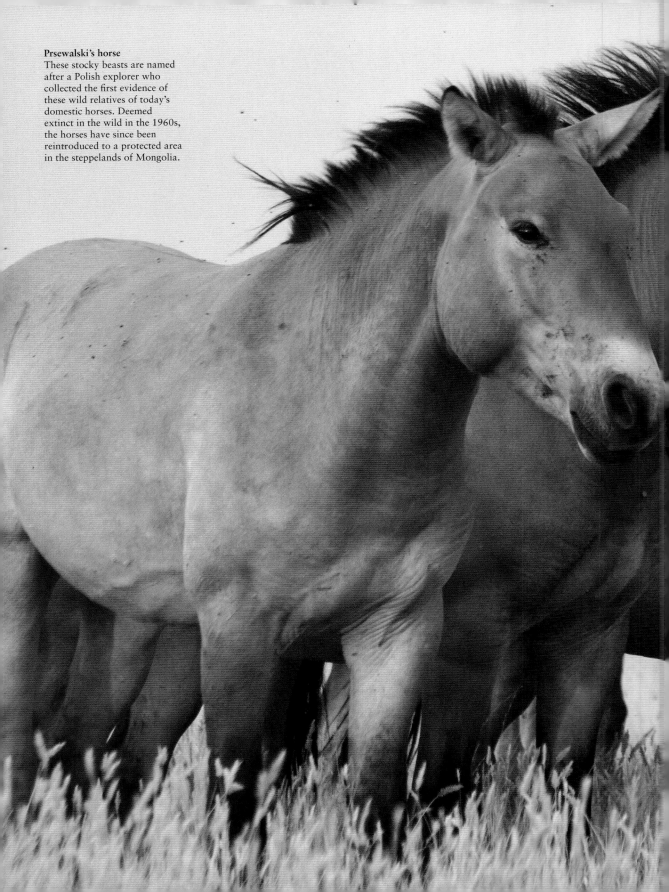

Prsewalski's horse
These stocky beasts are named after a Polish explorer who collected the first evidence of these wild relatives of today's domestic horses. Deemed extinct in the wild in the 1960s, the horses have since been reintroduced to a protected area in the steppelands of Mongolia.

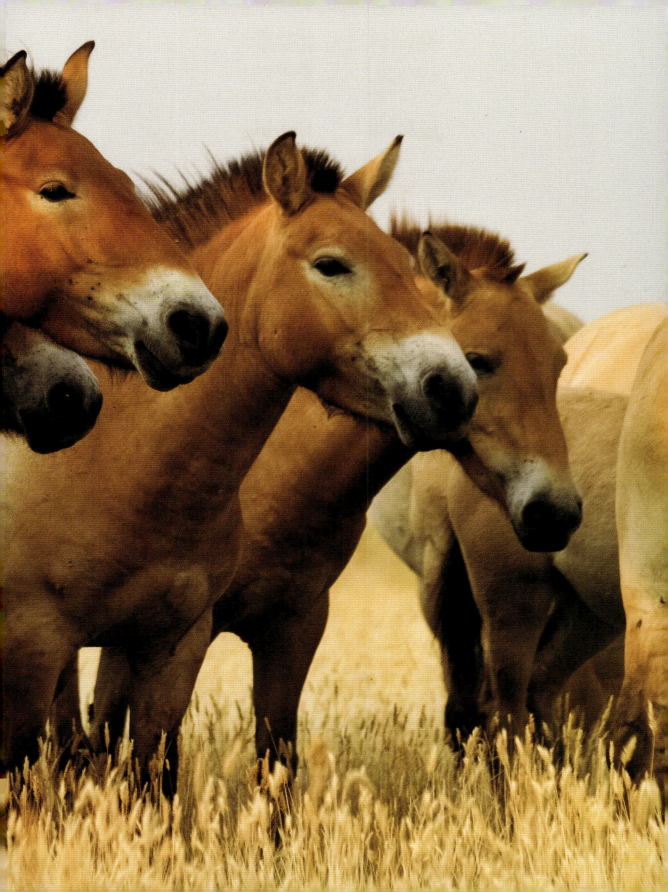

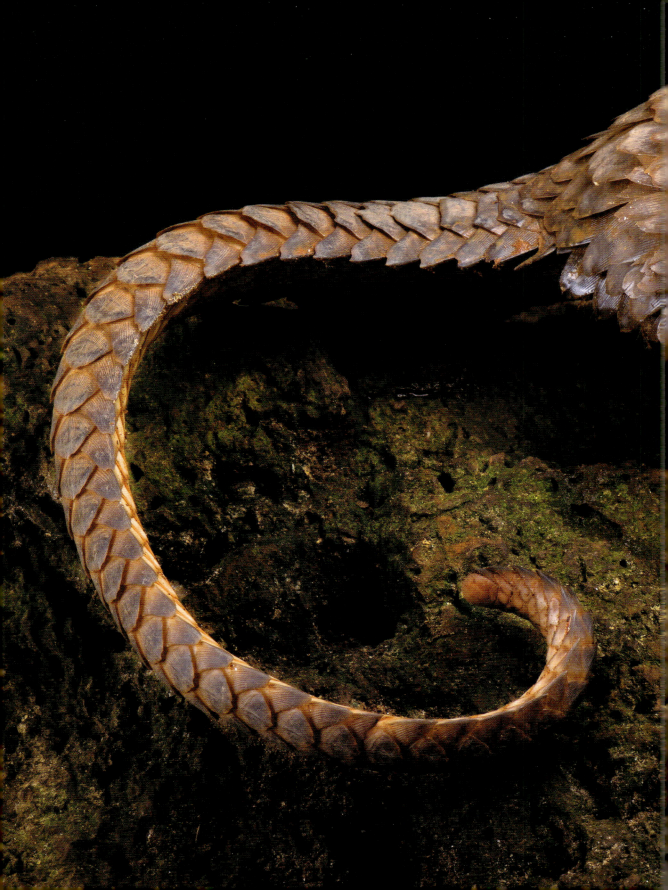

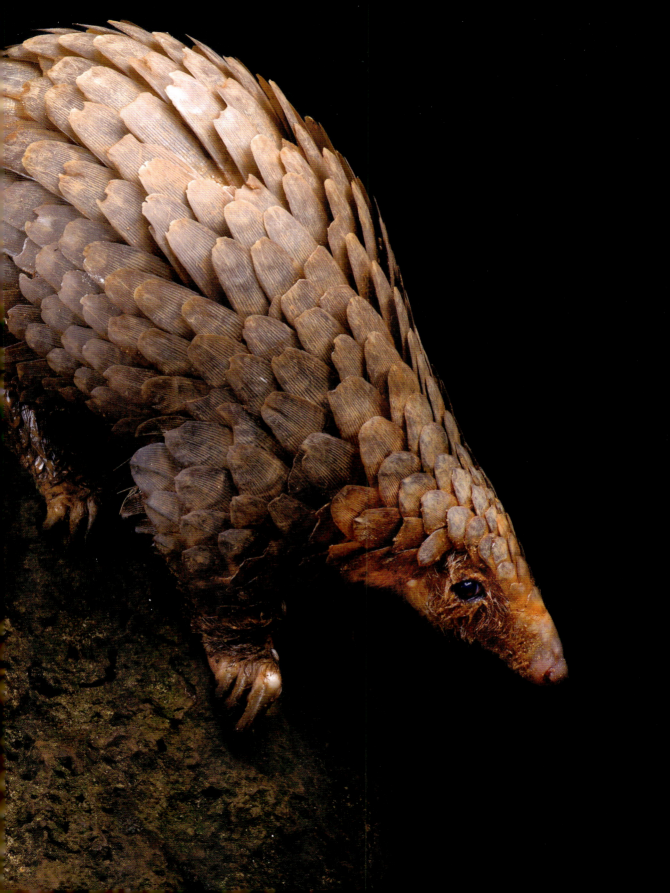

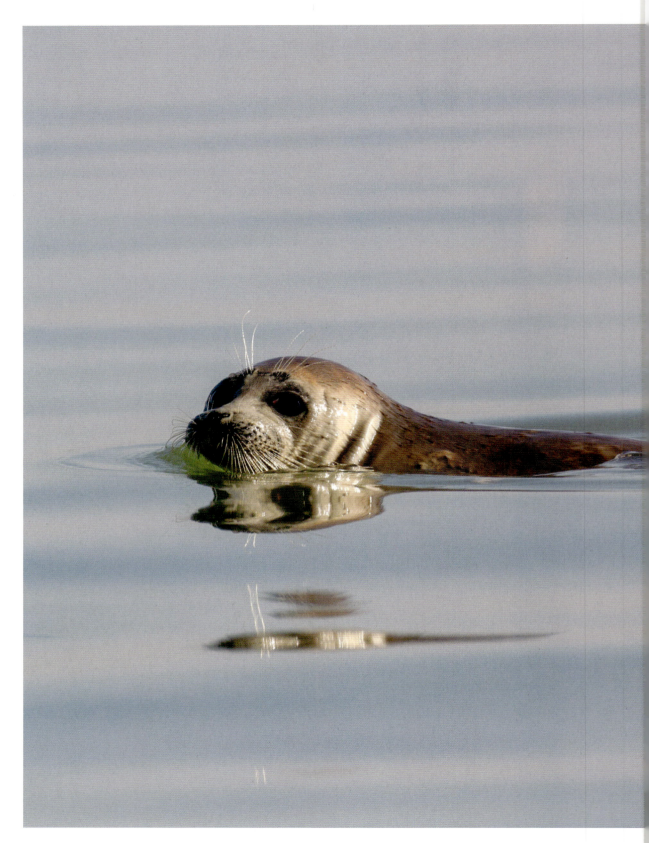

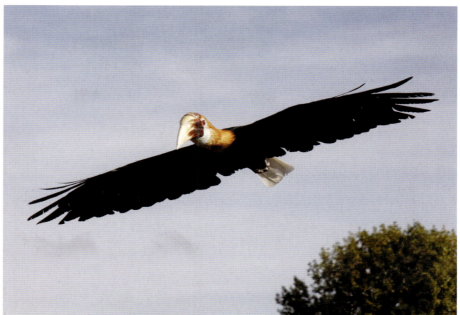

PREVIOUS PAGES:
Pangolin
Looking more like a reptile than a mammal thanks to the scales that armour its body, the pangolins of Asia are all endangered – as are their relatives in Africa. The chief threat is collection from the wild for use in spurious traditional East Asian medicines.

LEFT:
Caspian seal
This unique species from the inland Caspian Sea is the only seal to live in a freshwater habitat. The population has been in steady decline as the water has become more polluted.

ABOVE TOP AND BOTTOM:
Rufous-headed hornbill
Found only on two islands in the Philippines, their population is about 2,000 and still falling due to logging of its habitat.

RIGHT:
Andean cat
This wild mountain cat is only a little larger than a domestic pet. About 1,300 of them survive in the rocky grasslands of the Andes. Thus, many only exist in animal sanctuaries such as this one.

OPPOSITE TOP AND BOTTOM:
Black-footed ferret
As a predator of the prairie dogs of North America's great plains, this burrowing hunter has suffered as the prairies were cleared to make way for cattle and crops. Today a captive breeding programme is steadily increasing their numbers, of ferrets such as these in zoos, and there are thought to be 1,000 in the wild.

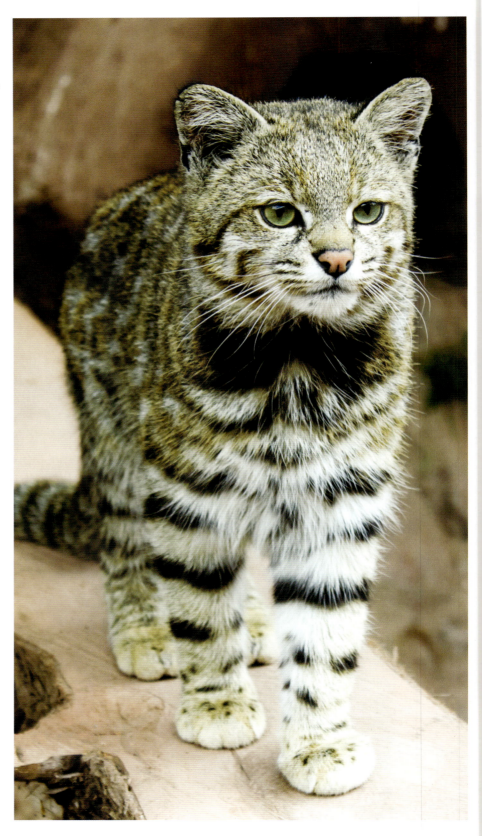

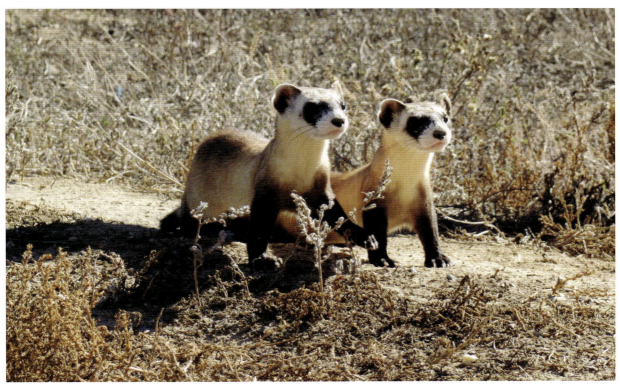

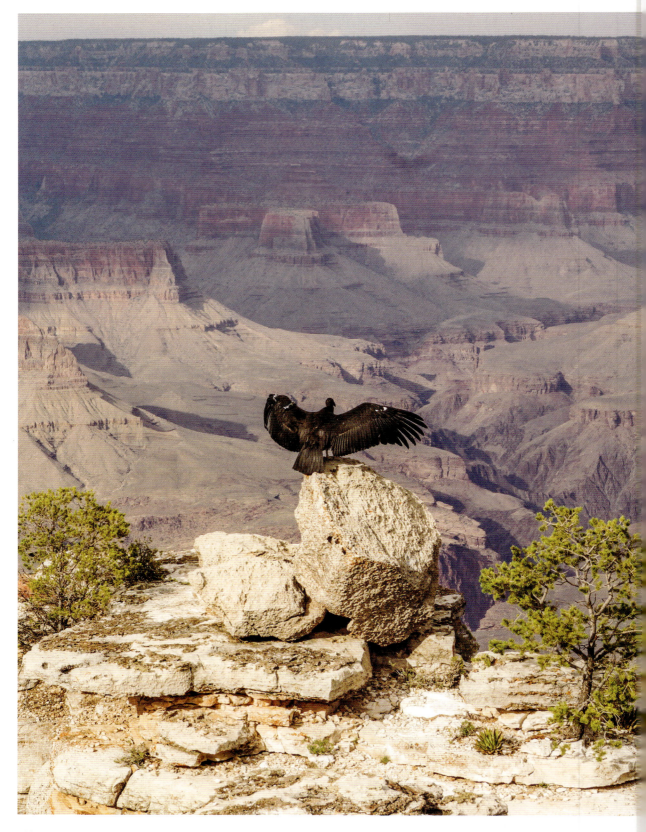

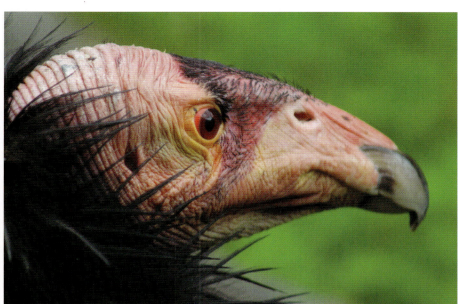
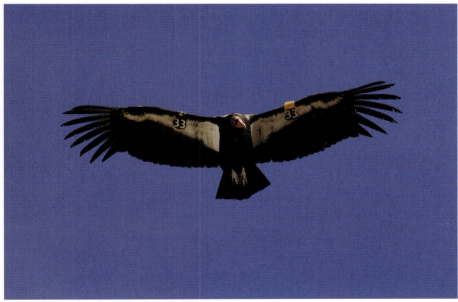

ALL PHOTOGRAPHS:
Californian condor
One of the early conservation success stories, this scavenging bird was on the brink of extinction due to habitat loss and lead poisoning, where the birds ate the remains of animals shot by sports hunters. Today numbers are on the rise again thanks to a captive breeding programme.

Chinchilla
These mountain rodents from the chilly scree habitats of the Andes are famed for having some of the thickest – and warmest – fur in the animal kingdom. As a result, their numbers have suffered at the hands of fur trappers, and today both species are highly endangered and their numbers continue to drop due to poaching.

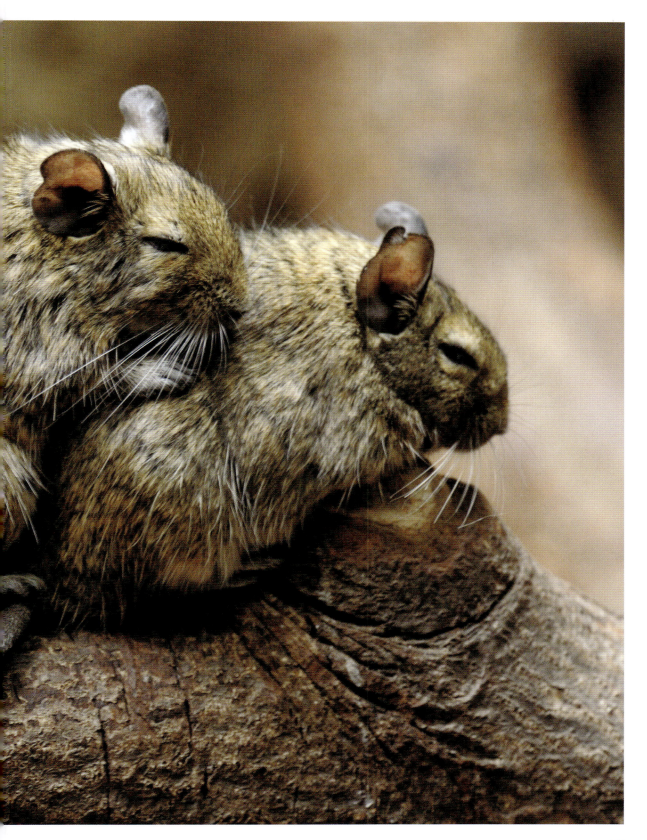

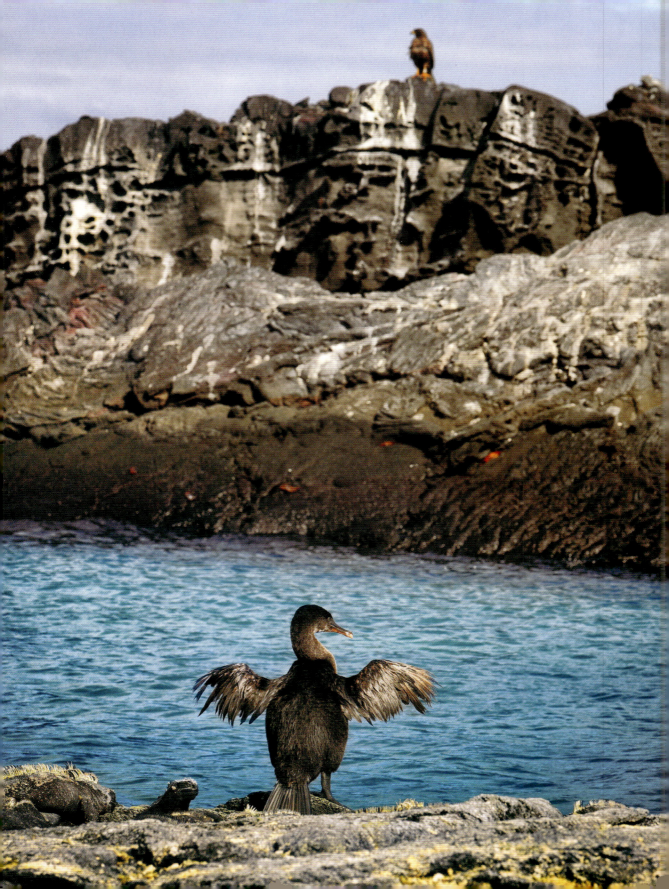

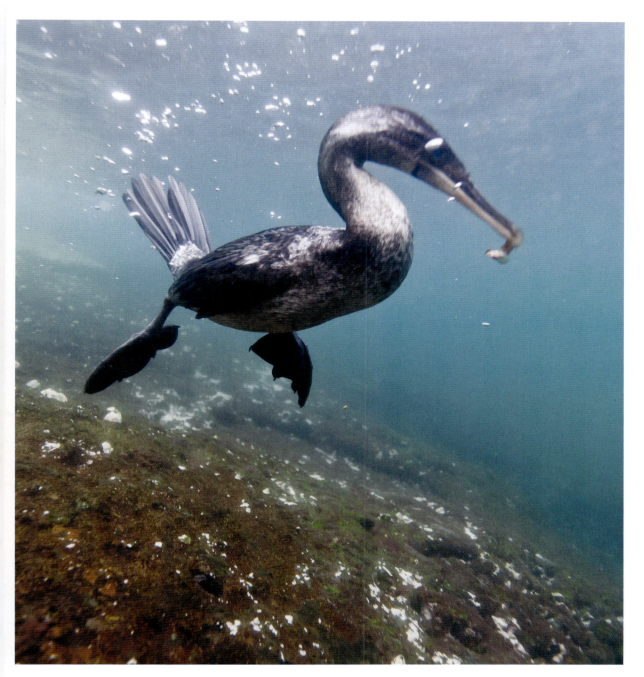

BOTH PHOTOGRAPHS:
Flightless cormorant
The cormorants are a widespread group of fish-eating birds that catch and kill prey with their diving skills. The Galápagos Islands host this unique flightless species which dives in from the rocks and has wings too small and weak to fly. The islands are highly protected but the bird is still under threat from the cats, rats and dogs introduced by people.

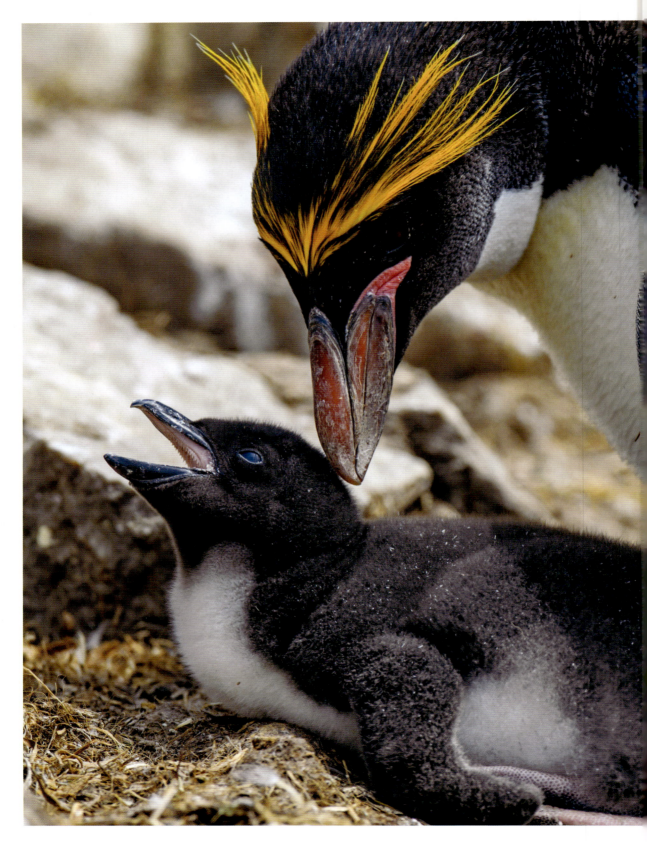

Macaroni penguin
Taking its name from a 19th-century slang word for an exuberantly dressed young man, this penguin lives around Cape Horn and islands across the Southern Ocean. Its global population is in the millions but it is in decline. There are frequent and mysterious population crashes which are a cause for concern.

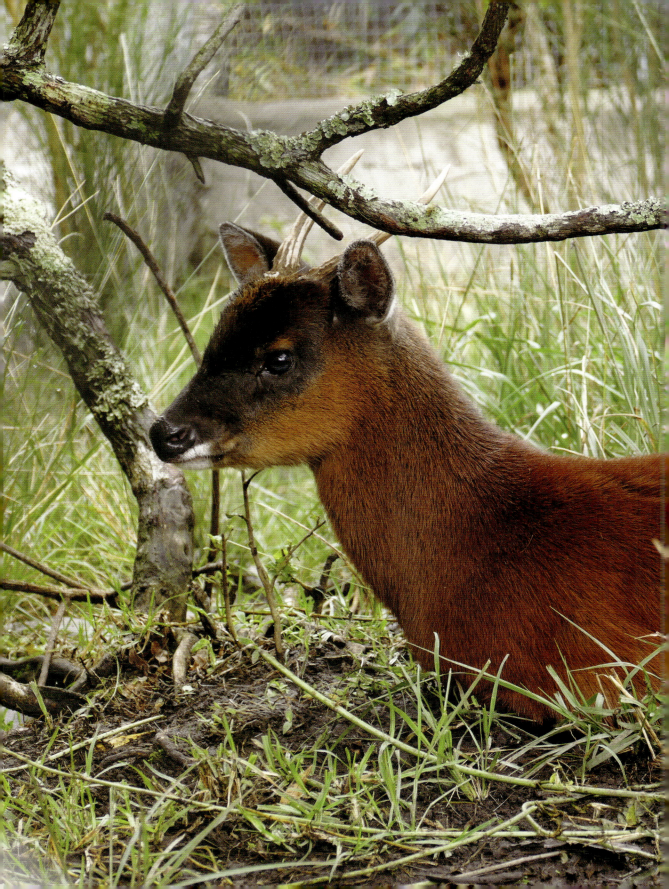

Northern pudu
The world's smallest deer, growing only 35cm (14in) to the shoulder, this little herbivore lives in the high forests of the Andes. These habitats are in decline, and no one is sure how many northern pudus remain there.

RIGHT:
Vancouver Island marmot
In the 1990s, this ground squirrel was the rarest mammal on Earth with fewer than 30 living in the wild. A breeding programme has since boosted that number to more than 200.

OPPOSITE:
Spectacled bear
The largest mammal in South America, this bear lives a solitary life in the high forests of the Andes. As well as being under pressure from habitat loss, the bear has long been persecuted by local people.

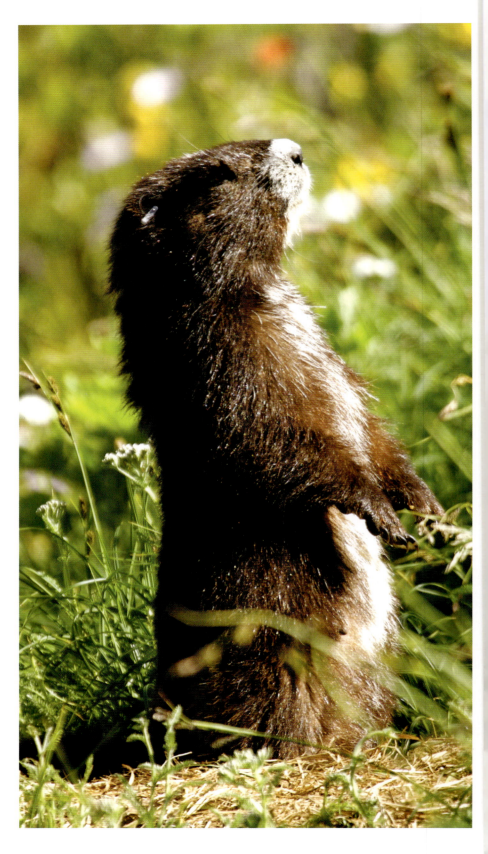

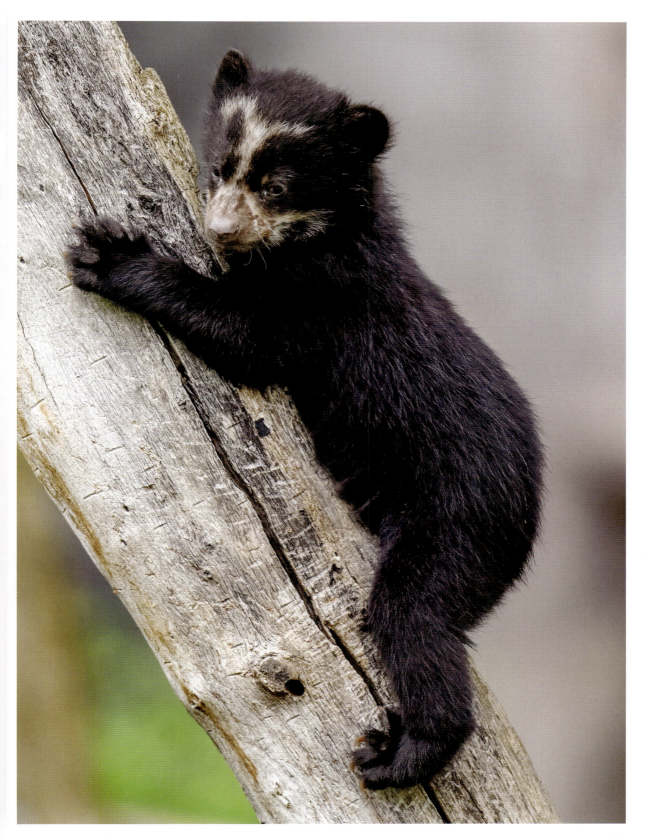

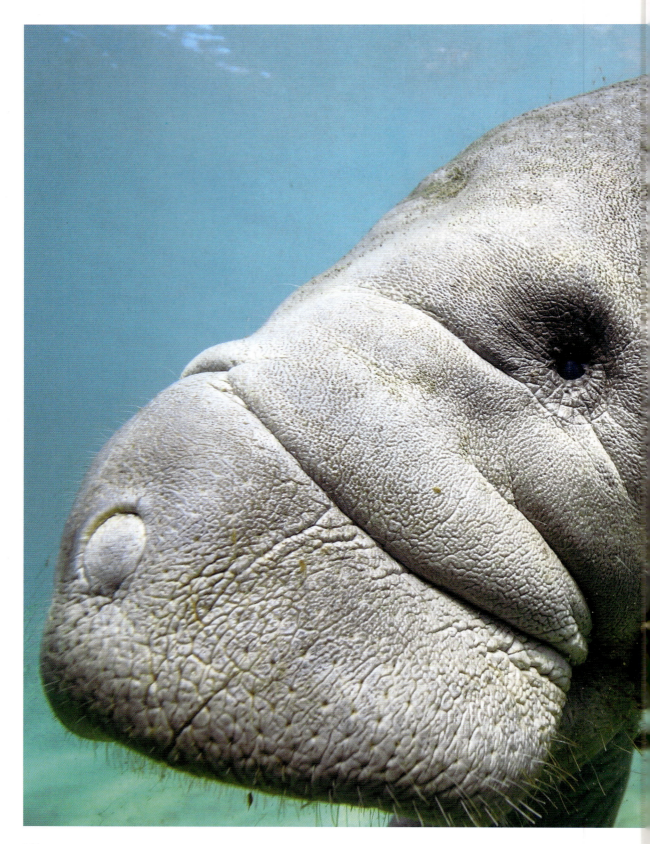

West Indian manatee
One of the three extant species of sea cow – all endangered – this species grazes on sea grasses along the Atlantic coasts of tropical America. They face many threats – the destruction of their feeding sites, poisonous algal blooms caused by pollution, and injury from watercraft that frequent the same area.

White-throated toucan
Toucans are amazing-looking birds, and this Amazon species is classed as vulnerable because it is being systematically collected from the wild for the pet trade.

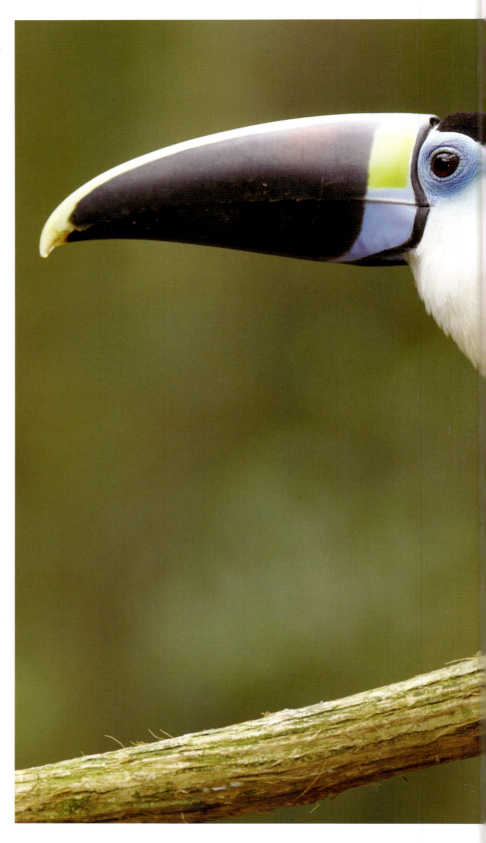

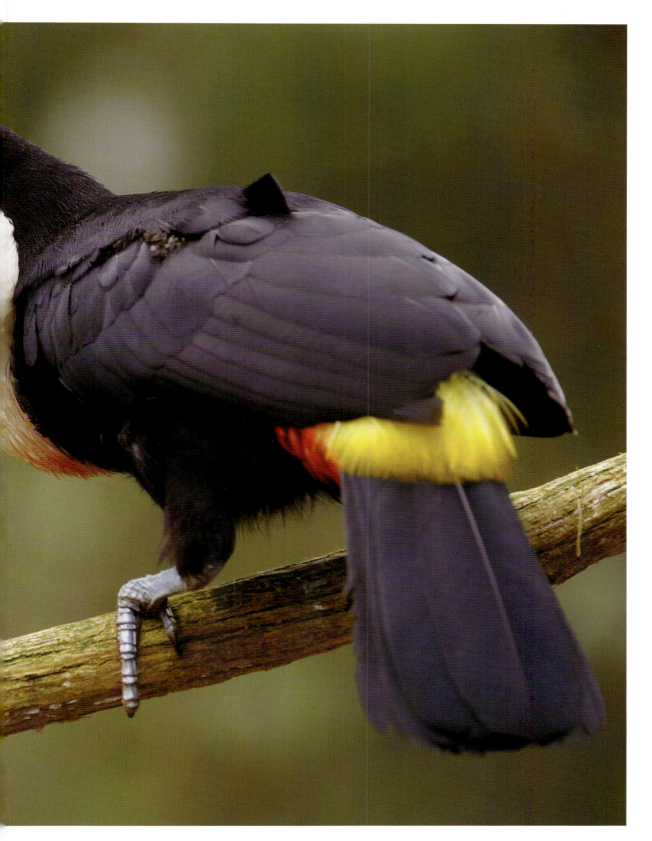

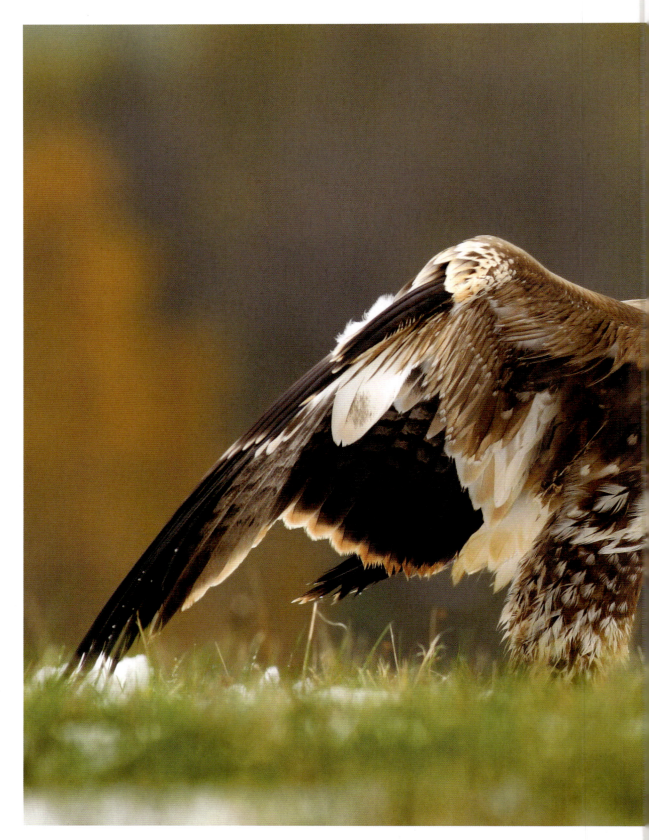

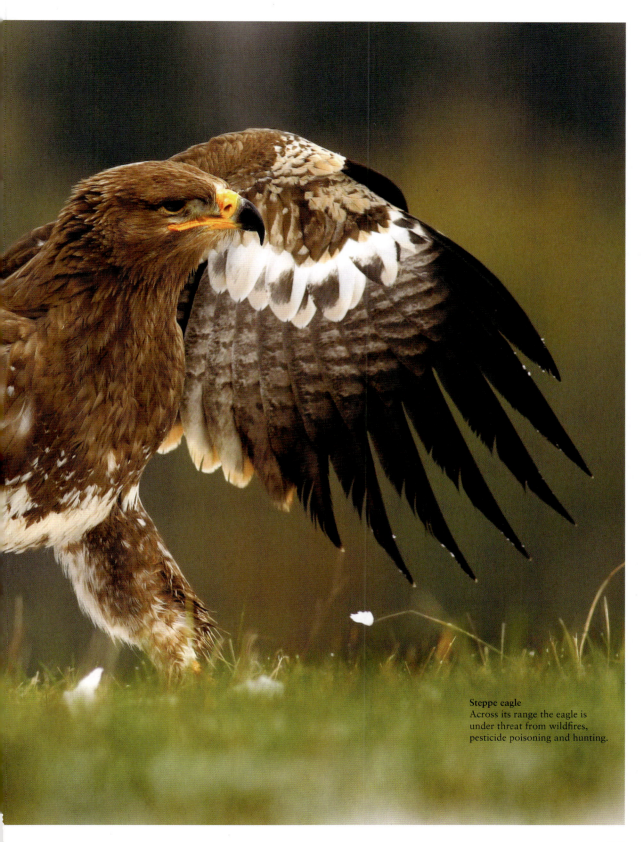

Steppe eagle
Across its range the eagle is under threat from wildfires, pesticide poisoning and hunting.

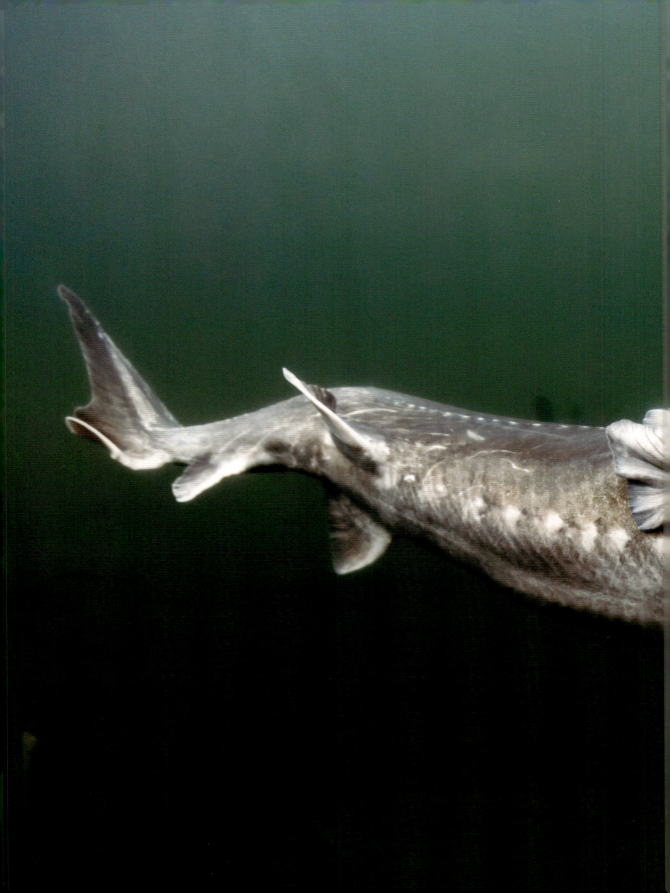

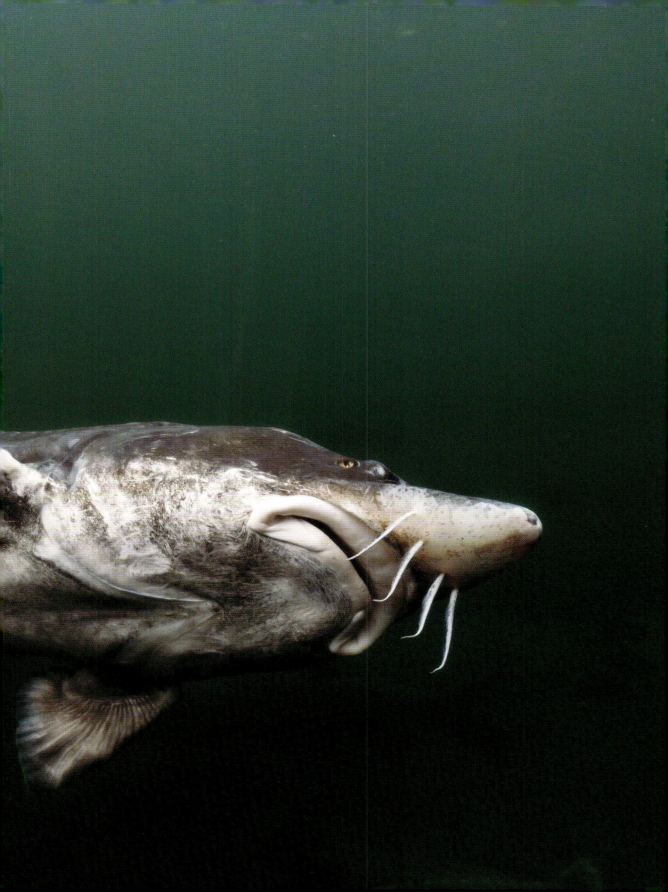

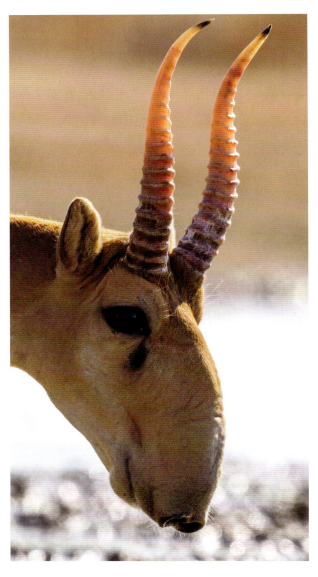
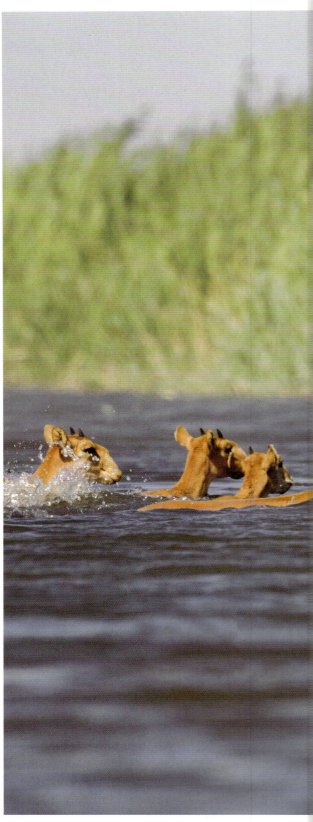

PREVIOUS PAGES:
European sturgeon
The largest river fish in Europe, and one of the biggest in the world, this fish is a source of caviar, which are its eggs. The eggs are carried internally, and the fish must be killed to extract them. As a result, the adult population of this and all sturgeon species has plunged to almost nothing and breeding is very limited.

BOTH PHOTOGRAPHS:
Saiga
Once vast herds of this odd hoofed animal paraded across the plains of Eastern Europe and Central Asia. Hunting and agriculture have destroyed the population. However, after a long decline, saiga herds appear to be growing again in Kazakhstan.

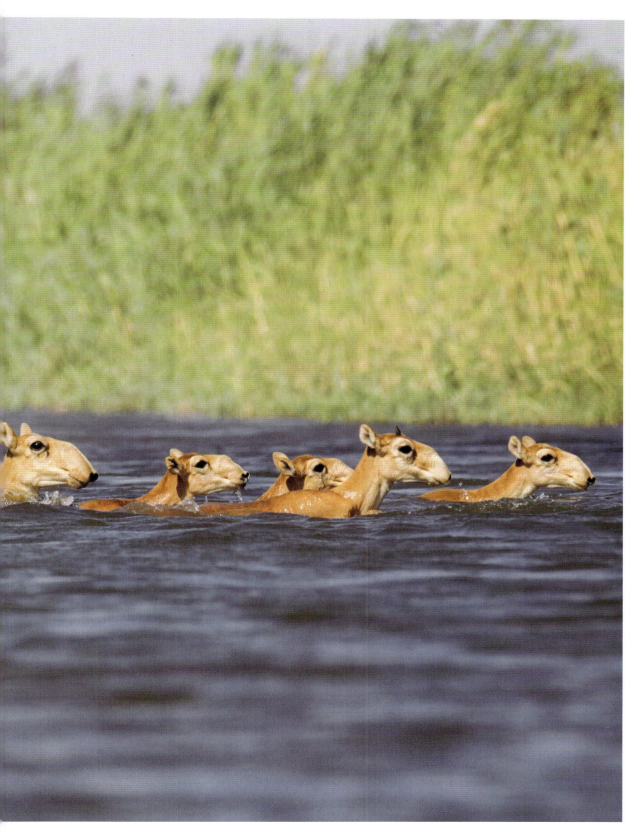

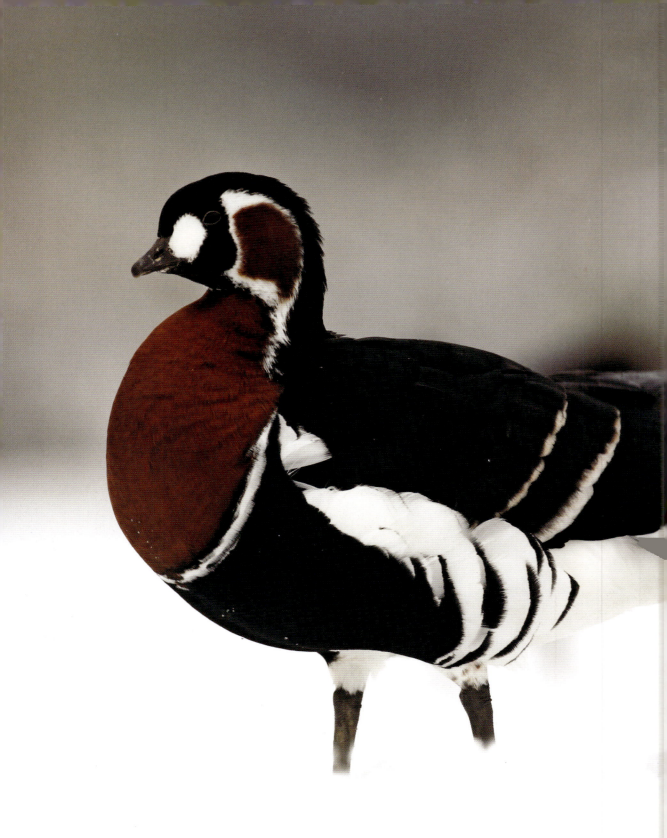

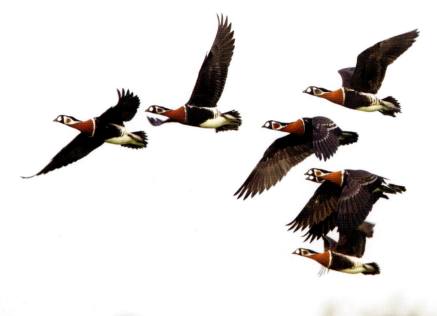

ALL PHOTOGRAPHS:
Red-breasted goose
This small but elaborately coloured goose migrates to the Arctic in western Siberia in the summer and returns to wintering grounds around the western and northern coasts of the Black Sea. The global population has recently dropped to 70,000, and the decline continues.

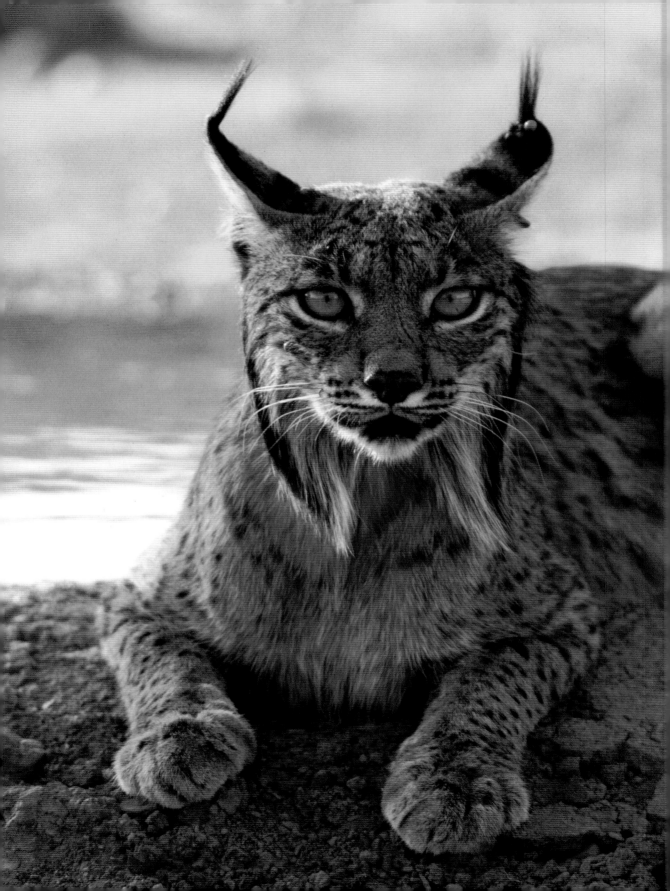

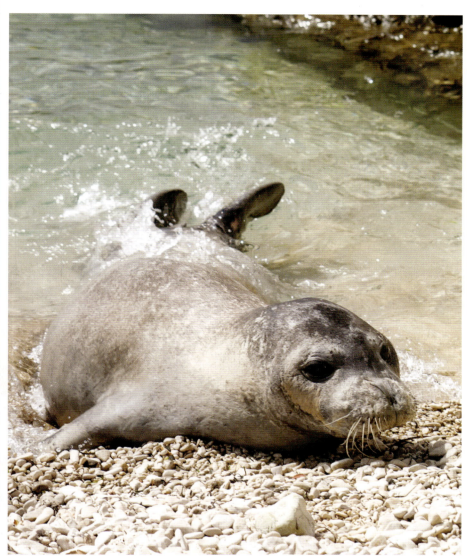

LEFT:
Iberian lynx
By the early 1990s this small hunting cat's population was reduced to just a few dozen in the wild. The cats are specialist hunters of rabbits, and the lynx's demise was due to a crash in the rabbit population in the area. A captive breeding and reintroduction programme has brought the species back from the brink.

ABOVE:
Mediterranean monk seal
It is estimated that just 400 adult seals survive in the wild, mostly in the Aegean Sea. However, conservationists have succeeded in turning the tide, and the monk seal population is rising again.

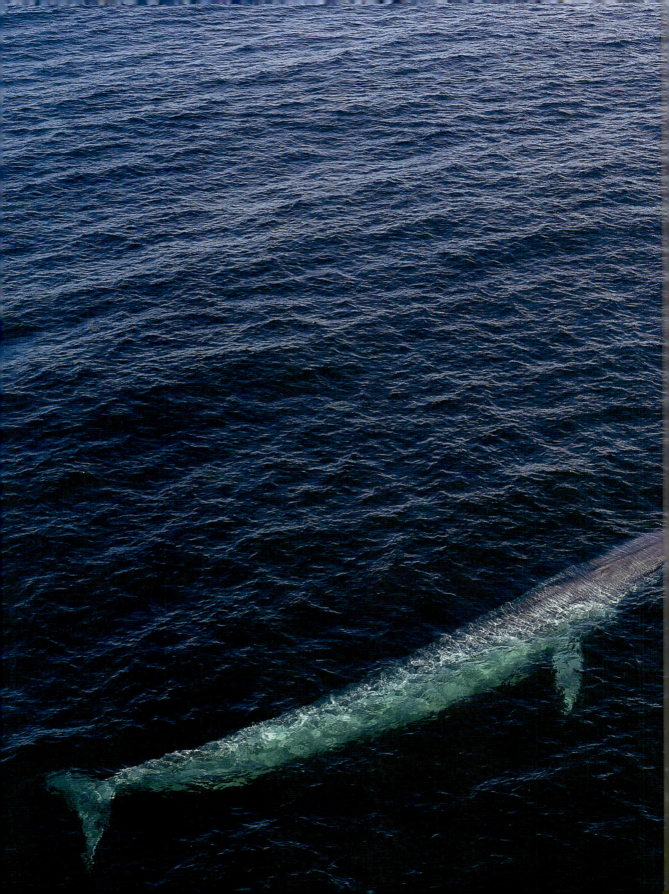

Blue whale
The mightiest creature that has ever lived on Earth, the blue whale was close to extinction as many thousands were killed each year until the 1960s. Today numbers are rising – but slowly.

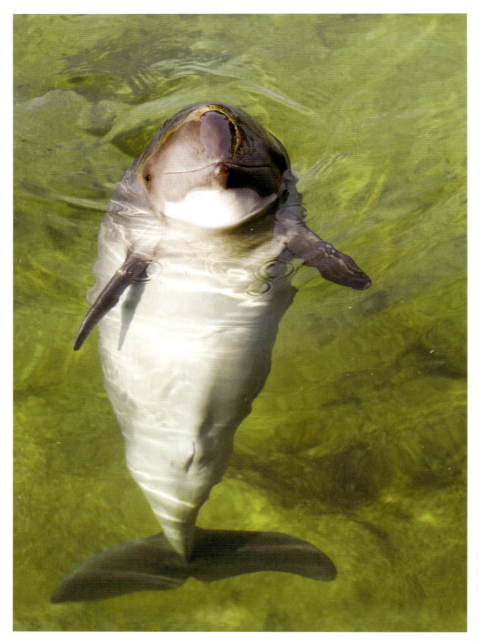

ABOVE:
Harbour porpoise
Porpoises are small relatives of the dolphins, easily spotted by the short, blunt snout. There are seven species and most of them are endangered. The harbour porpoise lives across the Northern hemisphere and is threatened, mainly by fishing nets.

RIGHT:
Hector's dolphin
Found only around the coasts of New Zealand, this species of dolphin is under threat from accidents with boats and fishing nets. The population has dropped by two-thirds in the last 40 years.

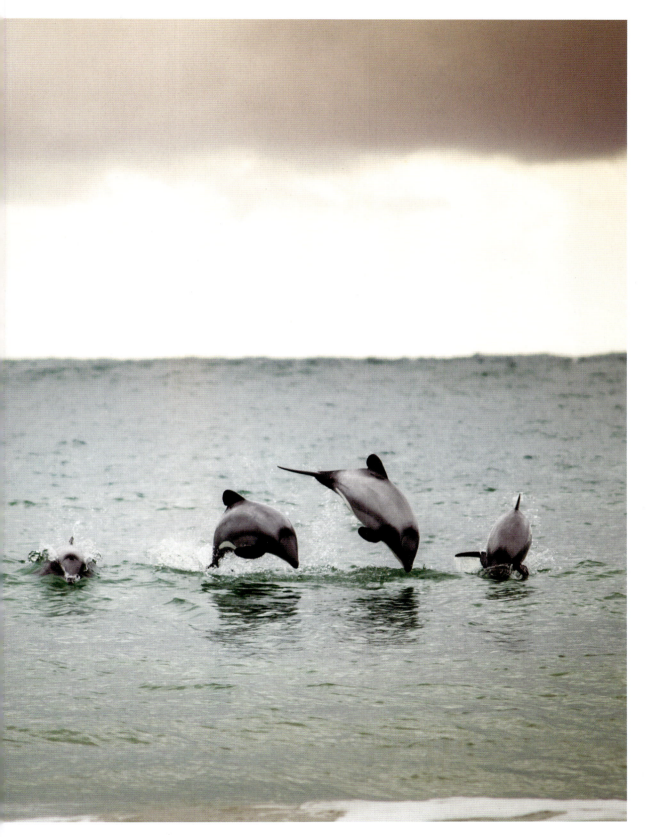

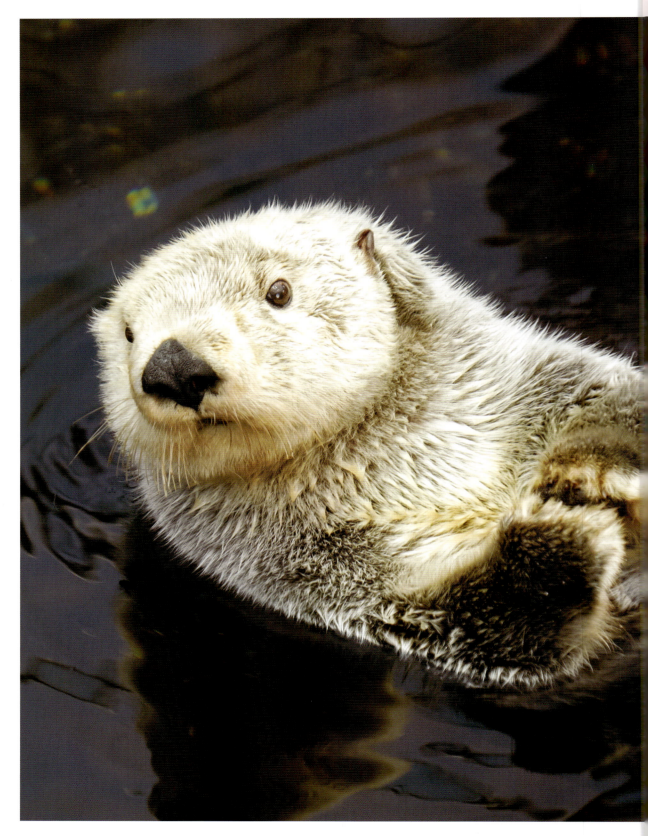

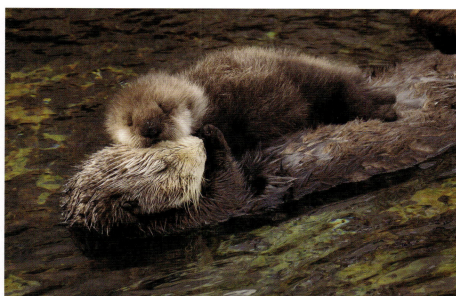

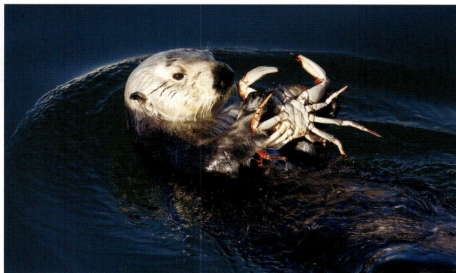

ALL PHOTOGRAPHS:
Sea otter
Rightly celebrated as one of the cutest creatures on the planet, the fur trade along the Pacific coast drove them close to extinction at the start of the 20th century. Without enough otters harvesting sea urchins from the seabed, the urchins destroyed the dense kelp forests that grow offshore. Without the forests, ocean waves accelerated coastal erosion. Today, these habitats are protected and the sea otters and ecological balance are returning.

ALL PHOTOGRAPHS:
Leatherback turtle
The largest turtle in the world, characterised by its soft leathery carapaces instead of a hard shell, the leatherback is vulnerable all over the world. Females always return to the same beach to lay eggs, the same one where they hatched themselves. Human intrusion on turtle beaches is reducing breeding opportunities.

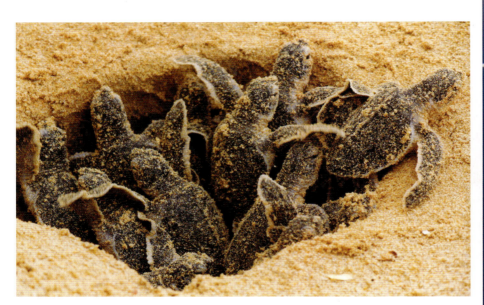

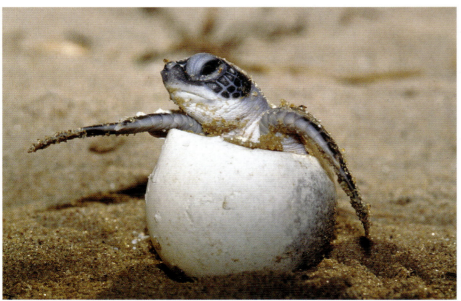

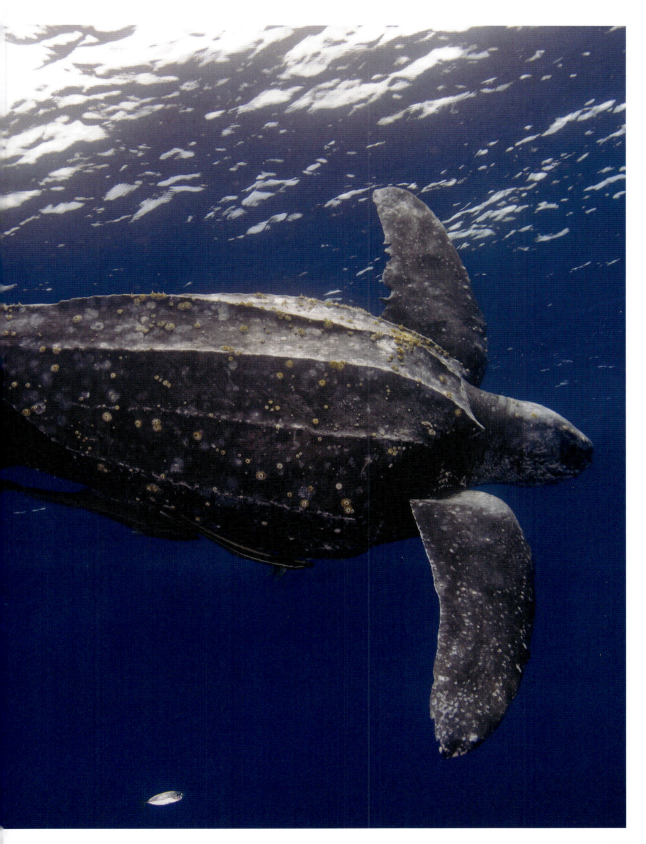

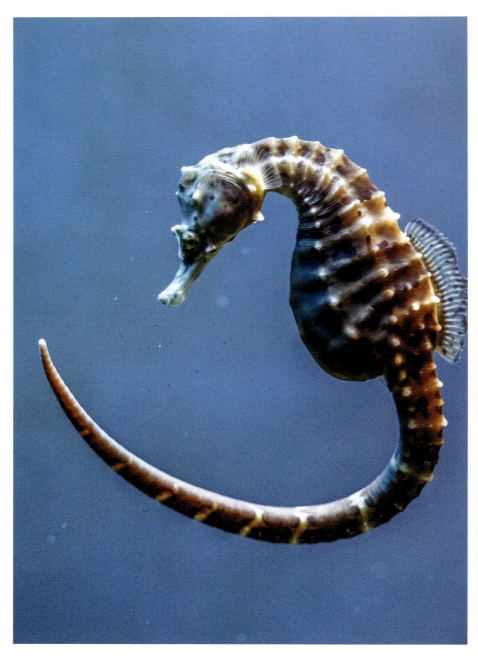

BOTH PHOTOGRAPHS:
Seahorse
There are 46 species of seahorse, mostly living in the seaweed beds of shallow seas. They cling to plants with their flexible tails and suck food particles from the water using their equine mouthparts. Being dependant on these fragile habitats means that most, if not all, seahorses are endangered.

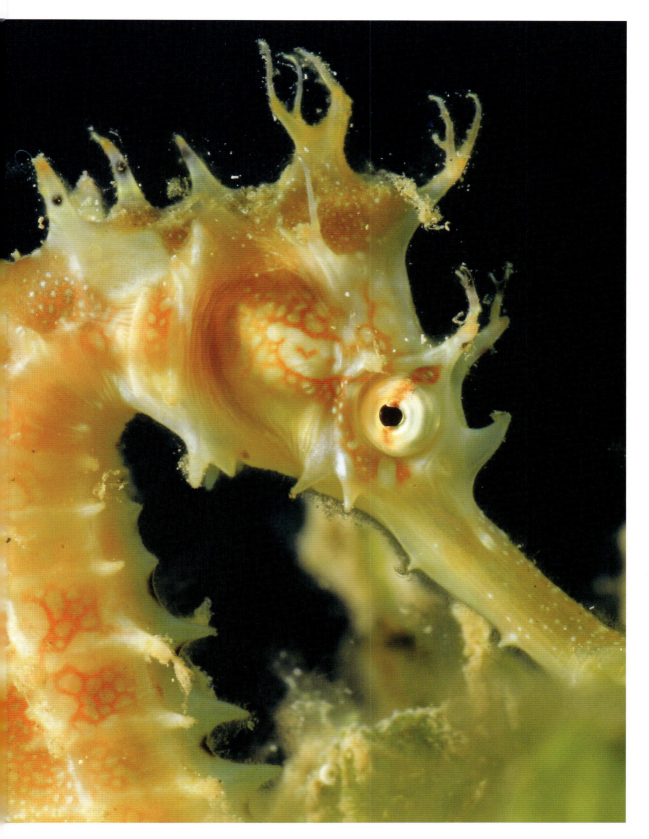

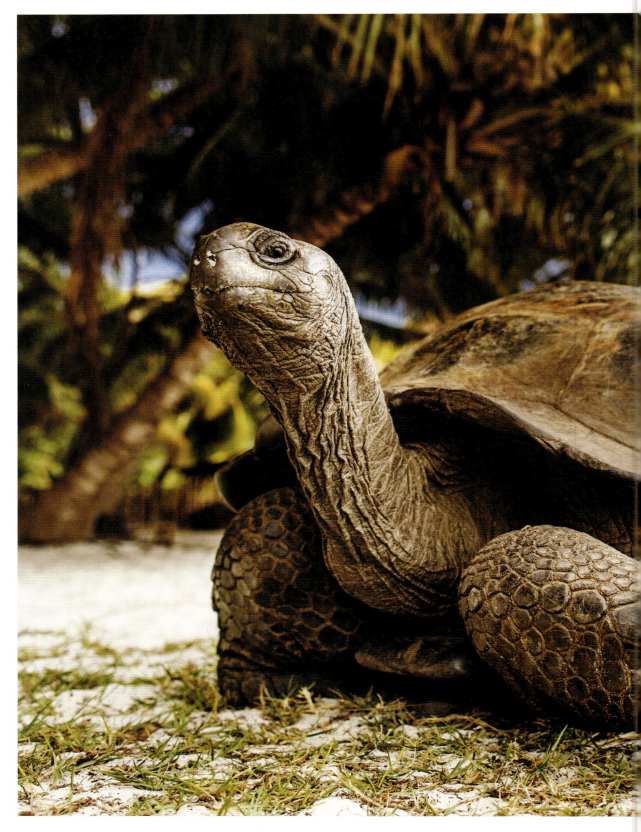

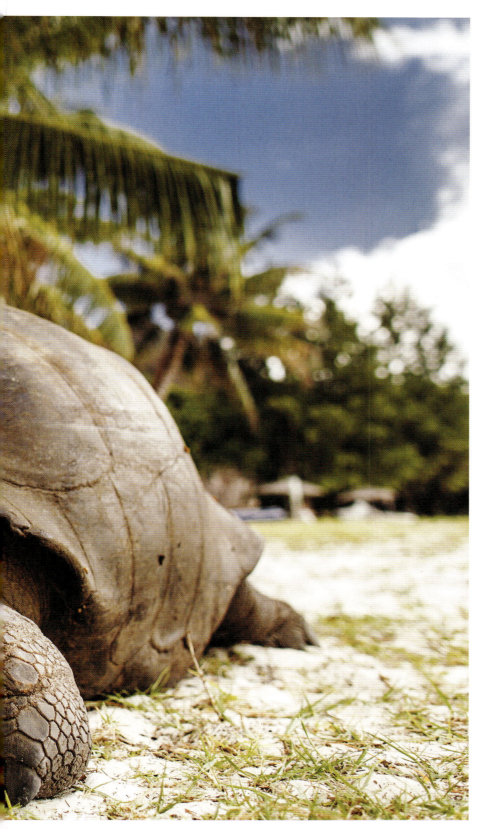

Giant tortoise
The Galápagos in the Pacific and Seychelles in the Indian Ocean, two island groups far from land, are both the last refuges of giant tortoises. In the past, these big reptiles lived on the mainland, but they now only survive in small and highly endangered island populations.

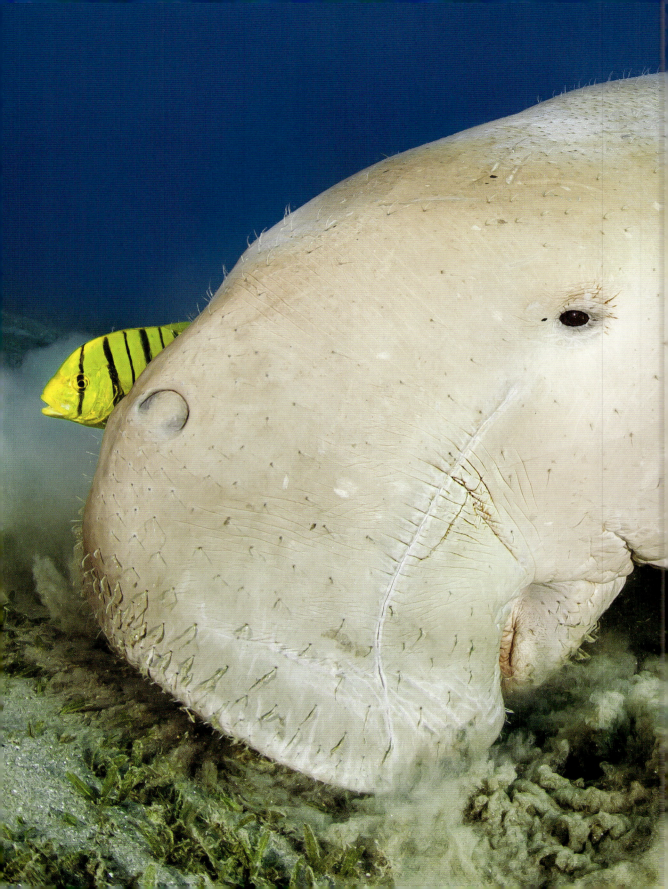

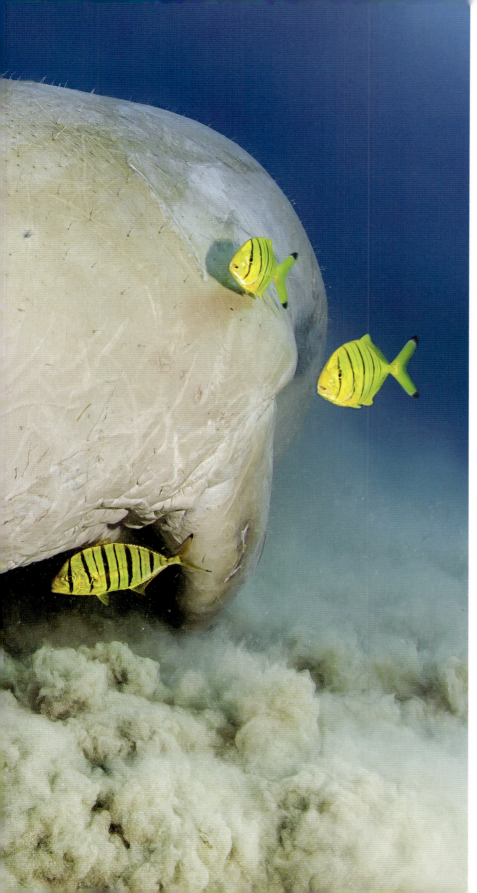

Dugong
The only sea cow species in the Indian Ocean, the dugong is threatened by pollution that kills their feeding sites in warm coastal areas. They also get entangled in fishing nets and drown.

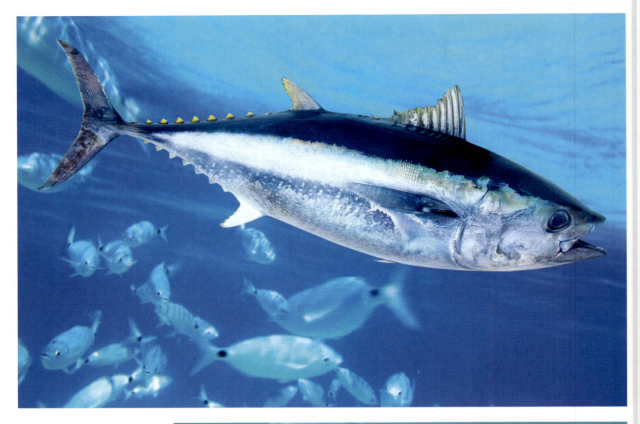

ABOVE:
Southern bluefin tuna
With meat highly prized in East Asia, the bluefin tuna of the Southern Hemisphere is critically endangered, hunted to near extinction. Most authorities ban fishing of the southern bluefin. Stocks are estimated to be at a tenth of normal levels.

RIGHT:
Ocean sunfish
The largest bony fish in the sea, the sunfish is named after the way it is often seen near the surface basking in the sunshine. They can grow to 1.8m (6ft) long and 2.5m (8.2ft) tall! Their decline from being killed in fishing nets is compounded by a slow reproduction rate.

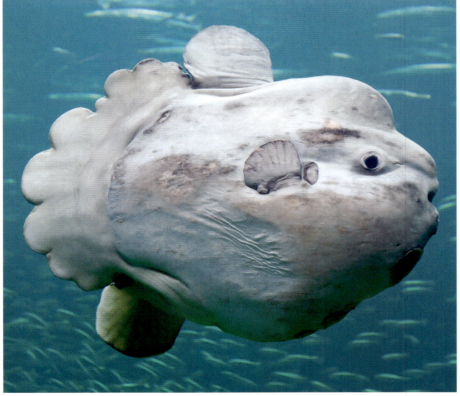

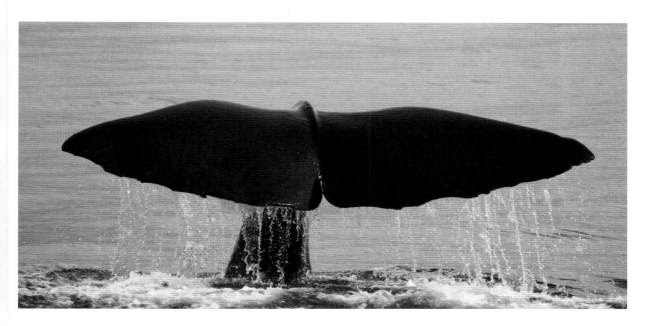

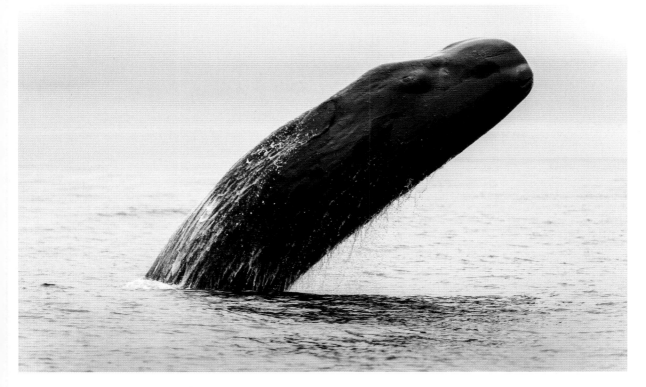

BOTH PHOTOGRAPHS ABOVE:
Sperm whale
The largest toothed whale, and by the same token Earth's biggest hunter, the sperm whale dives to incredible depths to hunt giant squids in the dark waters. They were hunted relentlessly for their oil until the 1980s, with 750,000 killed during the 20th century. Now left alone, numbers are slowly recovering.

Strange Animals

Perhaps the strangest thing about animals is that there are any of them at all! However, the natural miracle of life means there are at least 1.5 million types of animal on Earth, found everywhere from deep-sea vents to bone-dry deserts. Animals do not extract the energy and nutrients they need to survive directly from the non-living air, soil and water of the biosphere; they leave that job to other life forms, mostly plants, which animals eat – along with other animals – to stay alive.

The smallest continent of Australasia is also the one that has been most isolated from the rest of the world for longest, and as such it is home to a completely unique set of animals. Famously, Australia – a mostly arid land with large areas of a desert, dry scrub and woodlands – is home to marsupials, such as kangaroos, koalas and wombats. All are familiar, but nonetheless rather strange.

In Central and South America, the rainforest habitat is packed with life, often strange, and far too numerous to name. There are hundreds of species to be found in just one tree, making it a unique wildlife community that will be quite distinct from that found in another tree only a short walk away in the very same forest.

Strange animals are those that live in unusual ways. This chapter takes a look at the different animals groups – some cute, and some not so much – and picking out a particularly distinctive species to discover.

OPPOSITE:
Musk ox
This hairy Arctic beast looks like a buffalo or bison, but in fact this young musk ox is the largest member of the sheep family. Musk oxen spend the winter out in the open and are protected from the wind by the longest hairs in the animal kingdom.

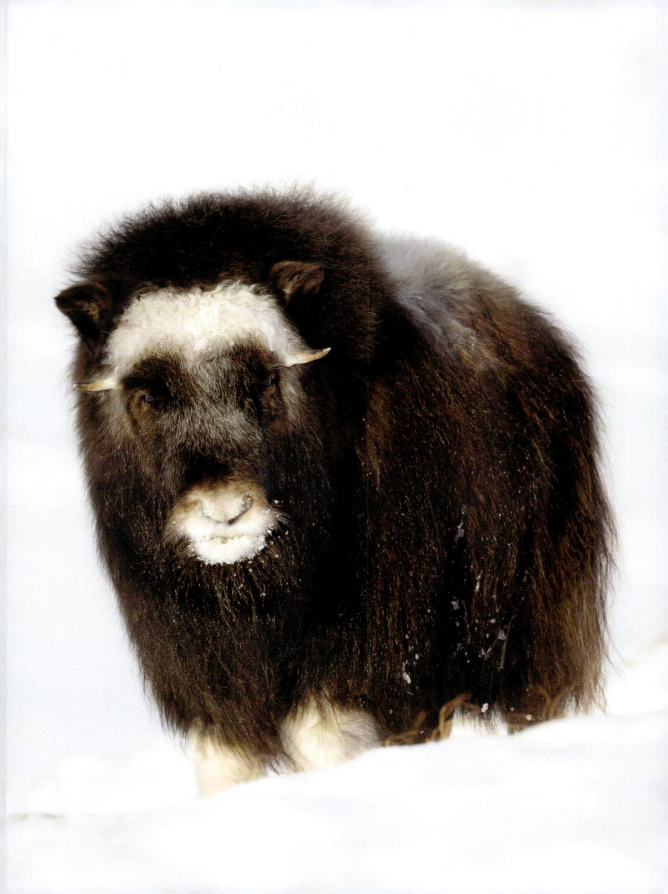

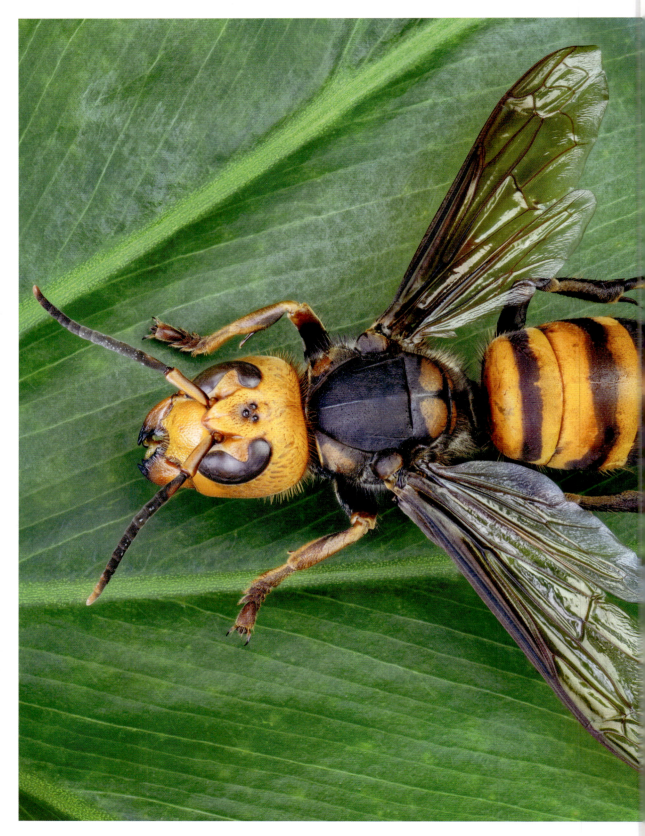

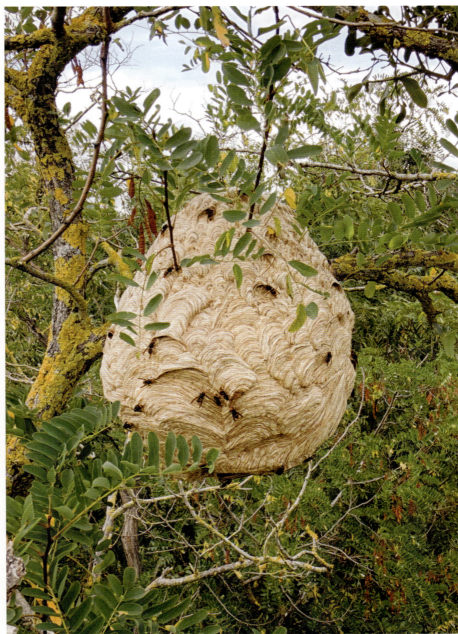

LEFT:
Giant hornet
The Asian giant hornet, which is found across East Asia and has recently spread to North America, is the world's largest hornet. It grows to 4.5 cm (1.7 in) long and has a wingspan of 7.5 cm (3 in). Its sting is 6 mm (0.2 in) long – four times the length of a honeybee's! Stings hurt but are not particularly dangerous to humans unless the recipient is allergic.

ABOVE:
Giant hornets' nest
These big insects live in relatively small colonies containing fewer than 100 workers. A new queen sets up her colony in April, raises the first generation of workers and then continues to lay eggs through the summer and into September.

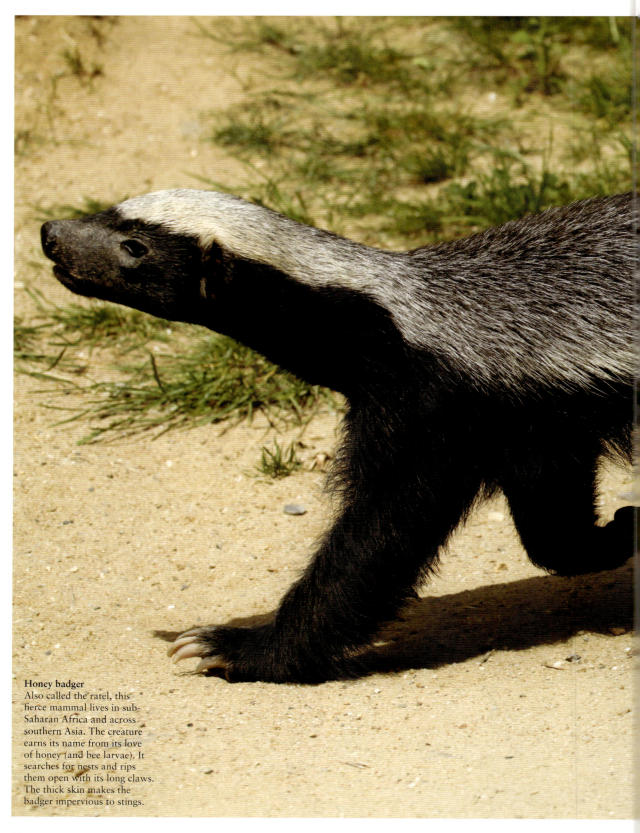

Honey badger
Also called the ratel, this fierce mammal lives in sub-Saharan Africa and across southern Asia. The creature earns its name from its love of honey (and bee larvae). It searches for nests and rips them open with its long claws. The thick skin makes the badger impervious to stings.

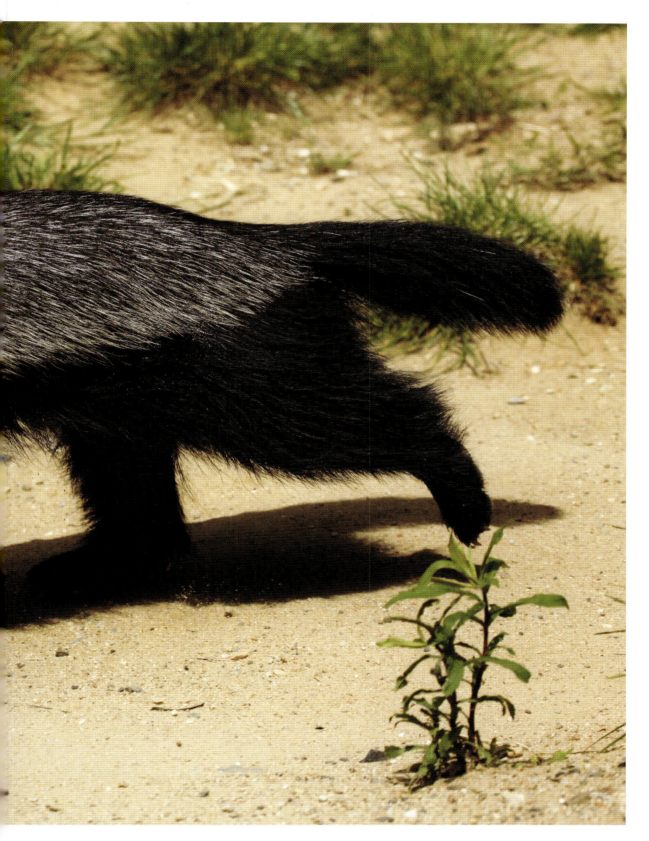

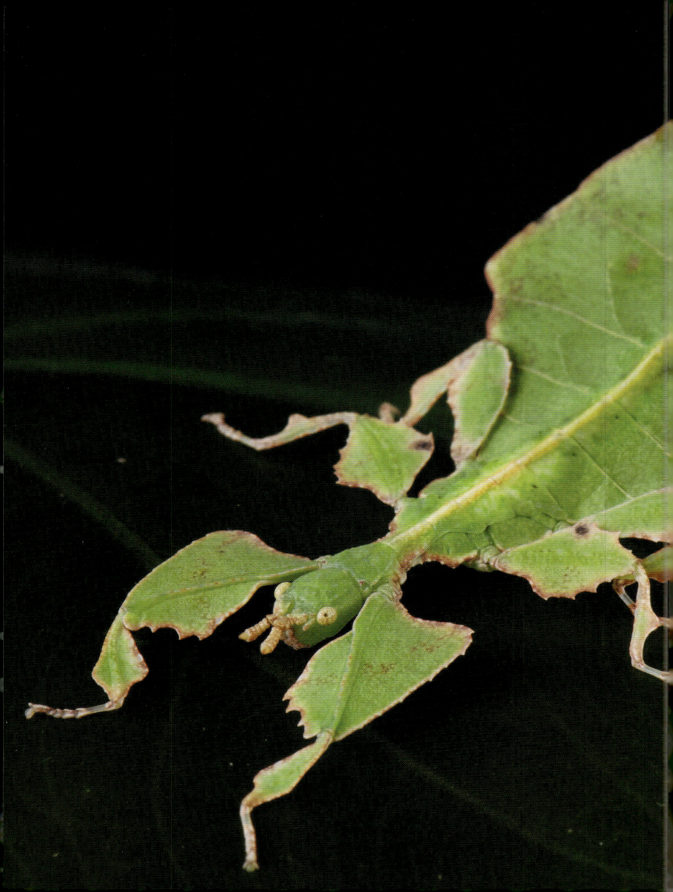

Leaf insect
On closer inspection, this ragged leaf is in fact a camouflaged insect with six legs and a head with a pair of eyes and small, stubby antennae. Leaf insects are found in forested areas from South Asia to Australia. Those that live in the branches of living trees are green, while those on the forest floor match the darker colours of rotting leaves.

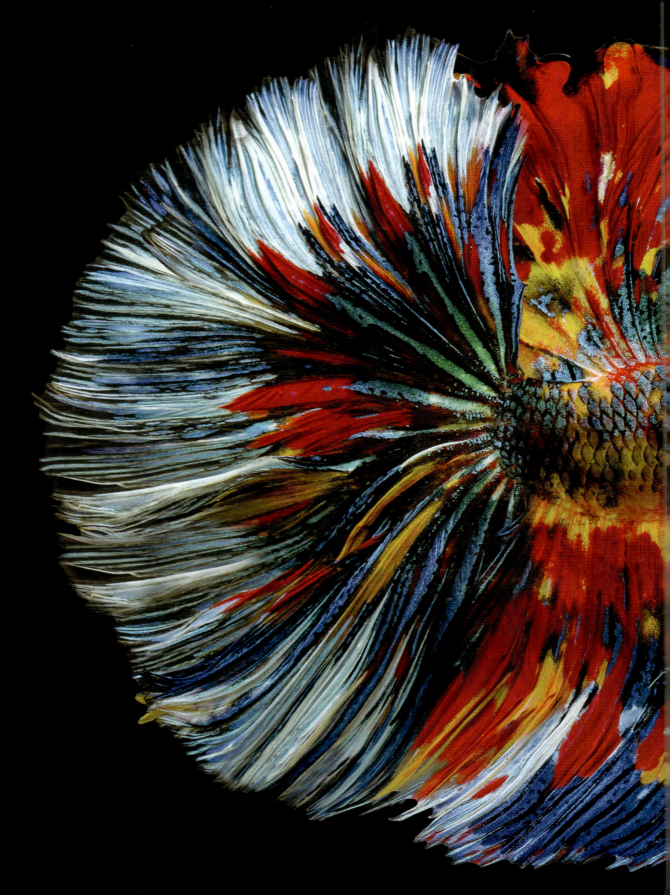

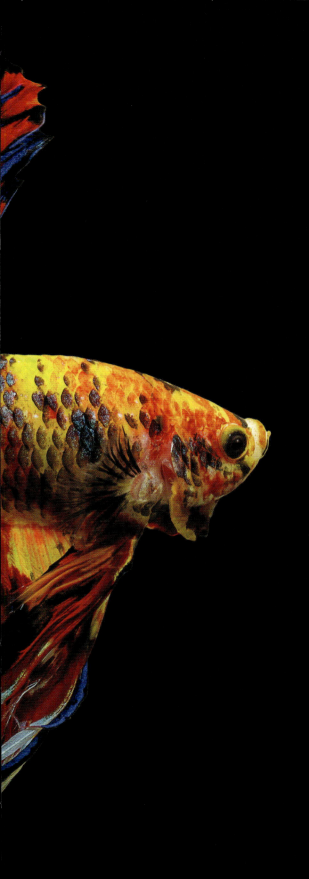
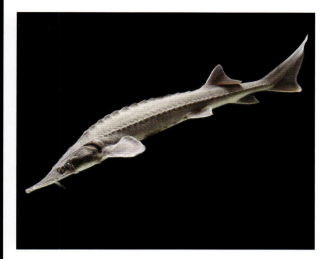
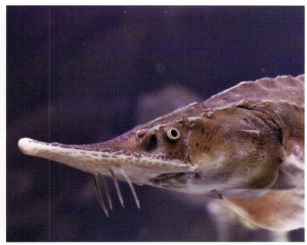

LEFT:
Siamese fighting fish
This freshwater fish is a type of betta that is found in the wild across eastern Asia. It lives in slow-flowing water and can survive in low-oxygen environments. The wild types lack the colouring of captive fish. The long fins allow them to orientate themselves in still water as they slowly patrol a territory. The fish will always fight when two of them end up in one territory – hence the name.

ABOVE TOP AND BOTTOM:
Siberian sturgeon
This type of fish, which is found in the Lena, Yenisei and Ob river systems, is exceptional for living for up to 60 years. Along with all species of sturgeon, this massive river fish is in grave peril of extinction since it is killed for its roe, or eggs, which grow internally. These eggs are cut out of the dead adult and made into caviar.

ALL PHOTOGRAPHS:
Tokay
This is the world's largest gecko species. It grows to around 35 cm (14 in) from snout to tail tip. That large size does not stop the gecko from using adhesive pads on its clawed toes to stick to smooth surfaces as it climbs. The predatory gecko is named after the sound of its distinctive call.

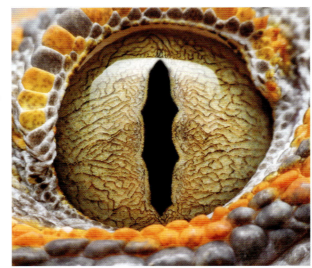

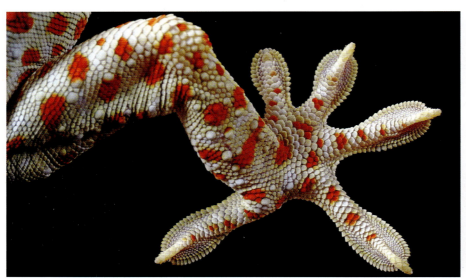

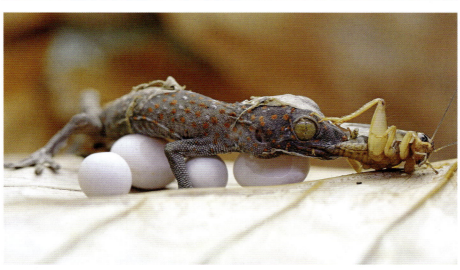

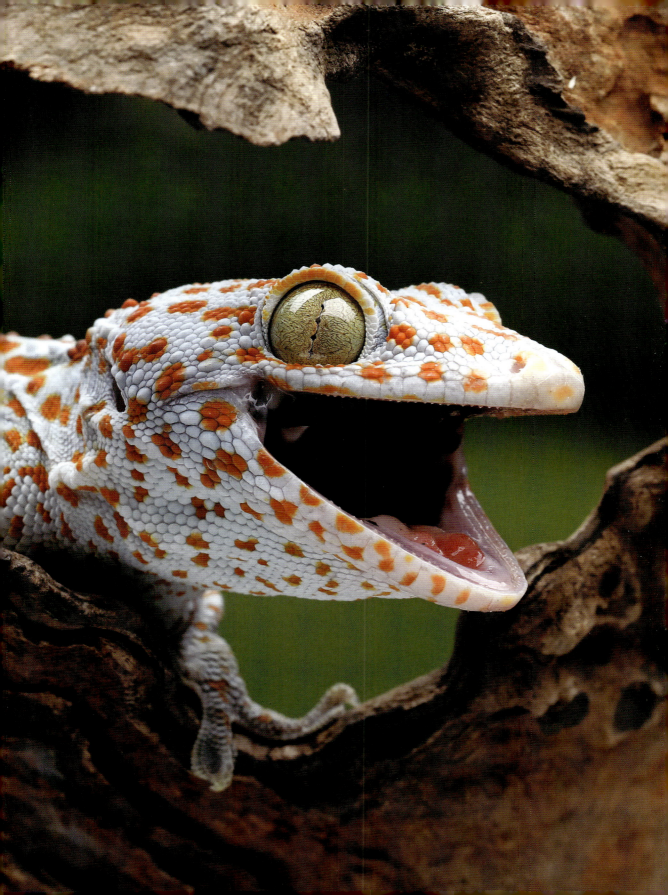

ALL PHOTOGRAPHS:
Mudskipper
A fish that breathes air is nothing if not strange. The mudskippers, which live around the coasts of the Indian Ocean and western Pacific, breathe underwater with the usual arrangement of gills. However, since they prey on small crustaceans that are found in mud, the fish haul themselves on to mudflats – or leap and skip up the shore – and breathe oxygen directly through the skin while out of the water.

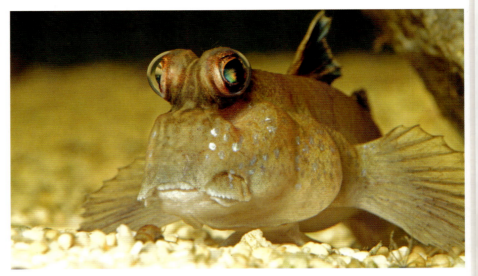

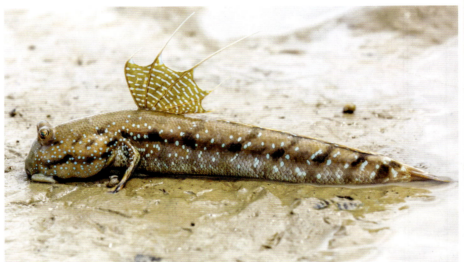

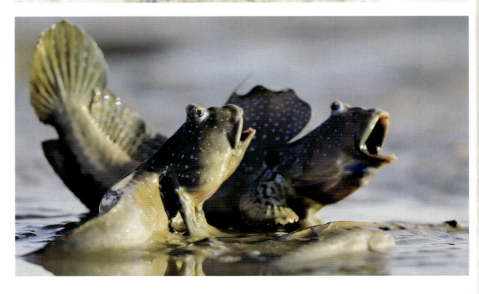

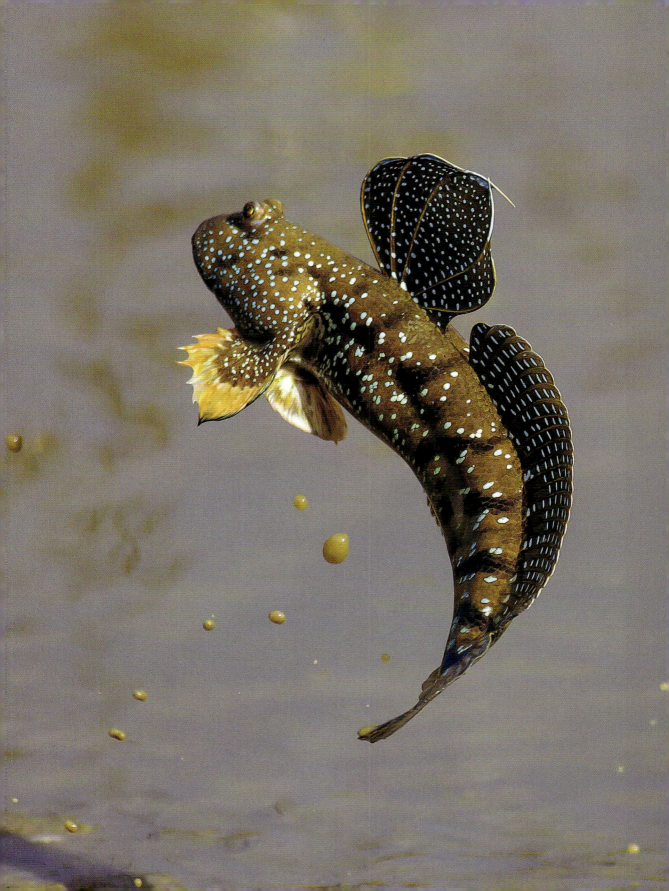

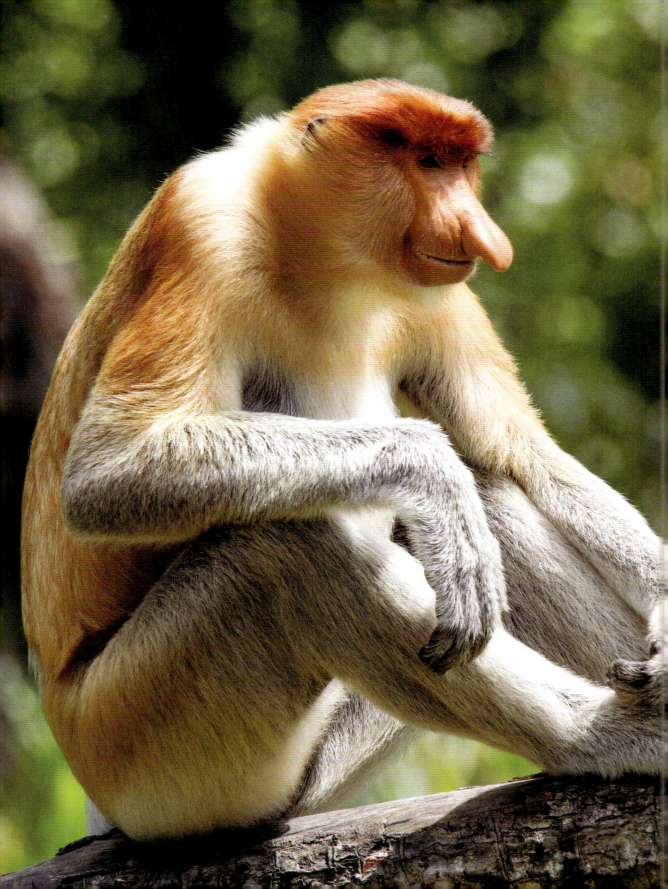

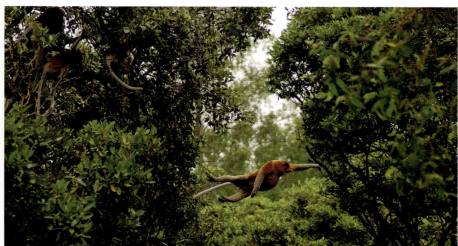
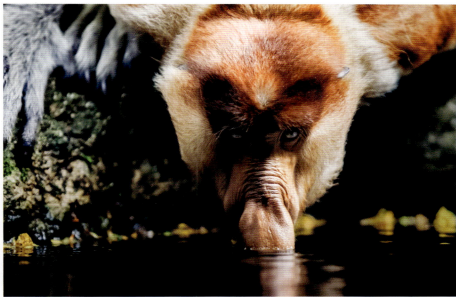

ALL PHOTOGRAPHS:
Proboscis monkey
Borneo's famous big-nosed monkey lives in the coastal mangrove swamps. It is the adult males that are blessed with large noses, which serve as a signal of their virility and general health. There is no other species that looks anything like it. Some are kept in monkey sanctuaries such as this one.

OVERLEAF LEFT:
Giraffe weevil
This Malagasy insect looks too strange to be true but it is an example of extreme sexual dimorphism. Only the males have such a long neck – which is three times the length of that of the females. The neck is a signal of its health and status and is used in fights over mates.

OVERLEAF RIGHT:
Hammer-headed bat
This species is the largest bat living on the African mainland. It has a wingspan of just under 1 m (3.3 ft). The fruit-eater is said to be a 'hammer-headed' because the male has a highly enlarged snout housing a cavity that is used to amplify mating calls.

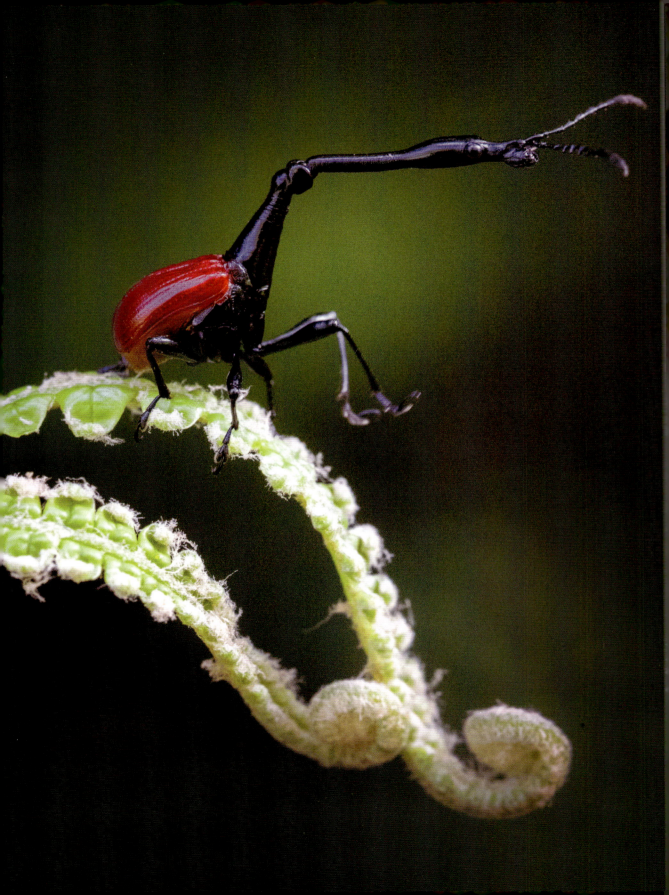

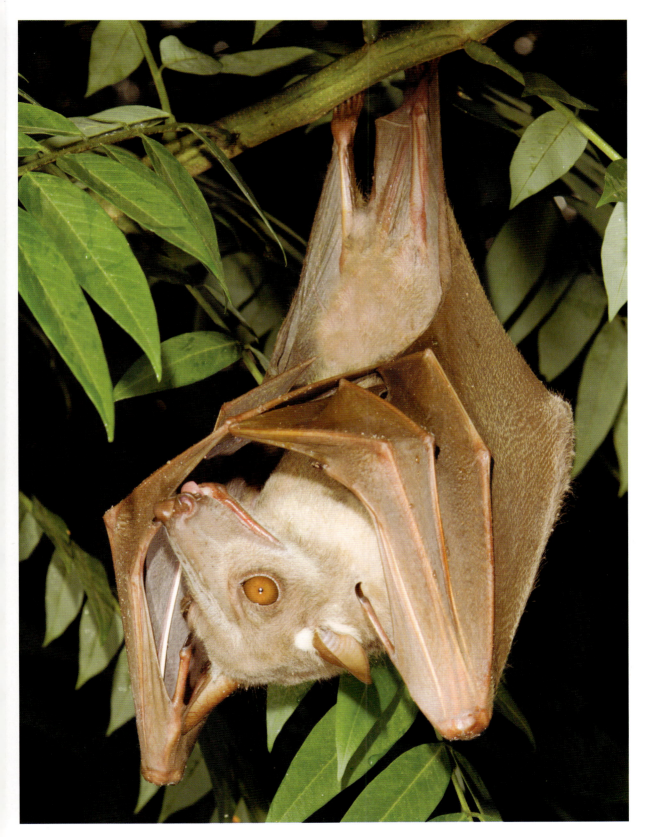

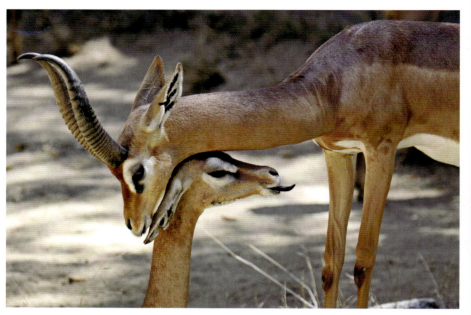

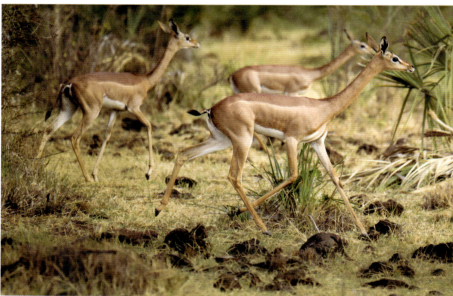

ALL PHOTOGRAPHS:
Gerenuk
Confined to the arid grasslands of the Horn of Africa, this gazelle seems too slender for its own good. The long legs and neck make the gerenuks fast runners but also agile enough to stand up on their back legs (and lean on the forelegs), so they can reach up to eat fresh leaves and fruits.

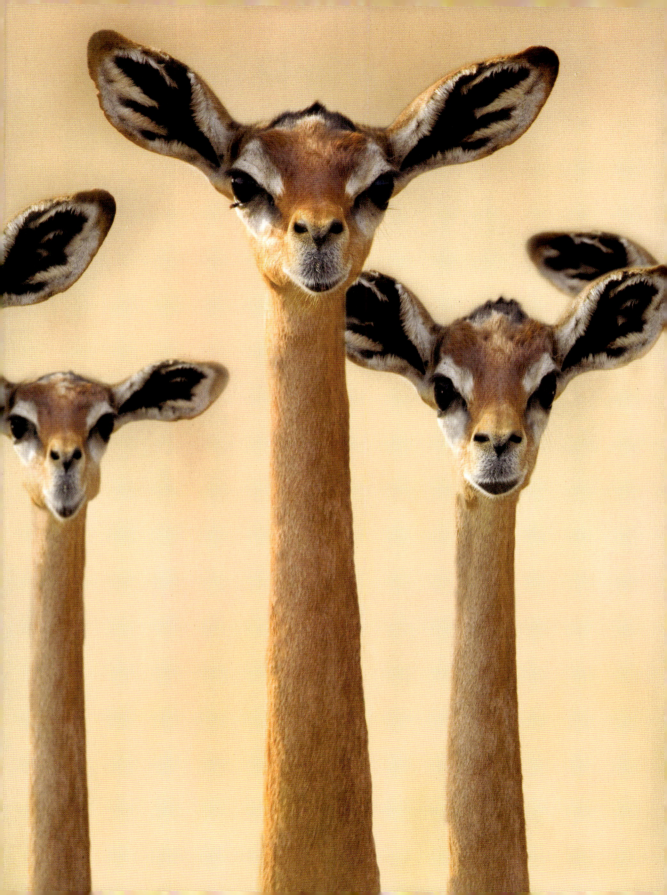

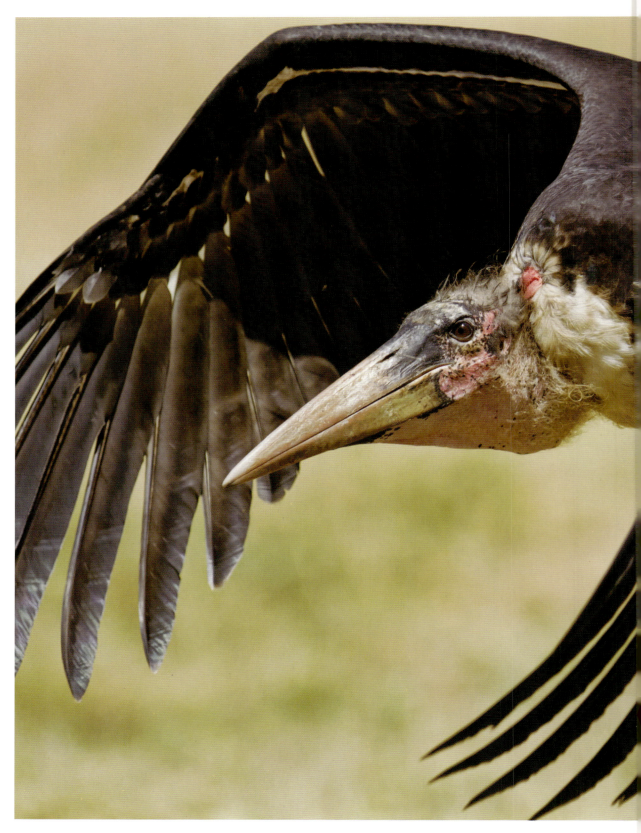

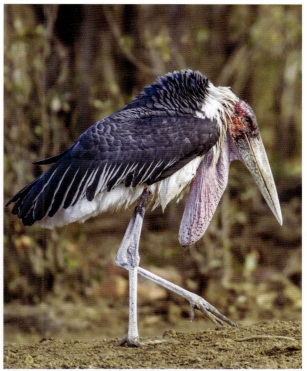
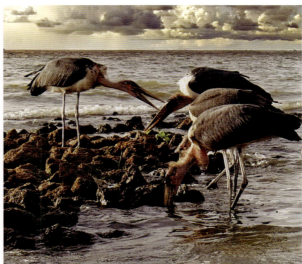

ALL PHOTOGRAPHS:
Marabou stork
This large, lumbering wading bird is a scavenger. Its dark, cloak-like plumage and hunched demeanour have earned it the nickname the 'undertaker bird'. It stalks the grasslands of Africa, especially areas close to rivers and lakes, searching for carrion. It will also catch live prey, such as fish and lizards.

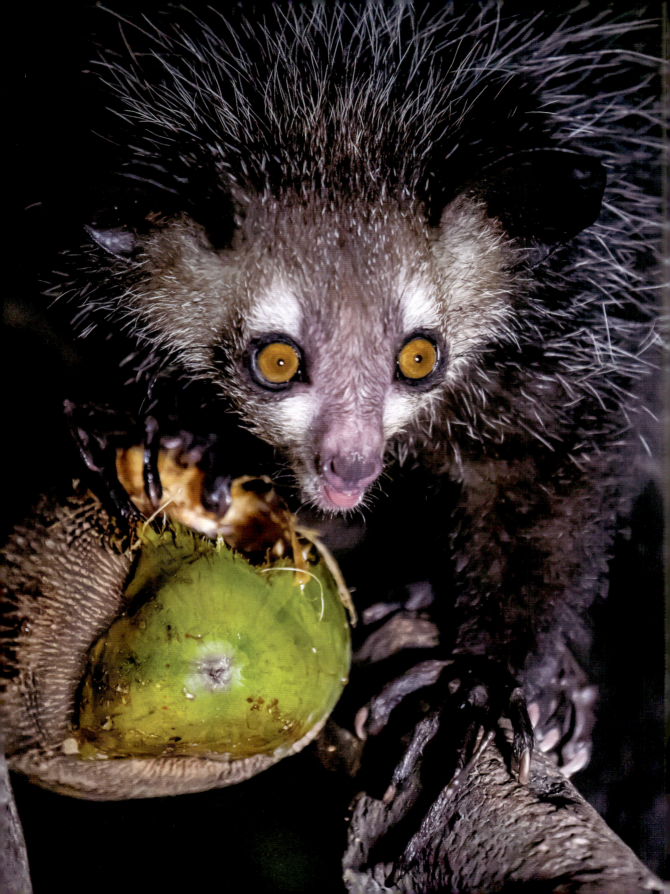

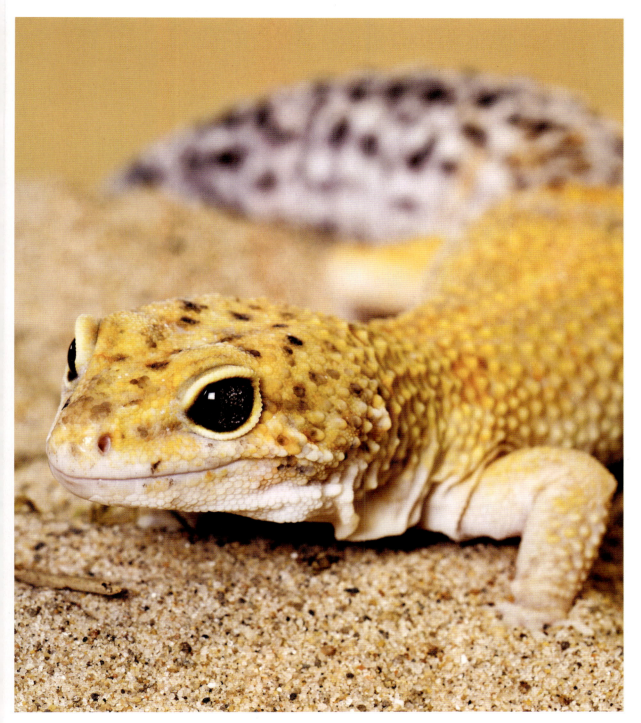

OPPOSITE:
Aye-aye
In the dead of night, this bizarre lemur is hard at work. It taps branches with its long ring finger. It is listening for sounds of hollows under the bark, which would indicate a chubby woodworm or grub is burrowing there. It then digs out the treat with its long claws.

ABOVE:
African fat-tailed gecko
A camel has a hump, whereas the fat-tailed gecko uses its tail. In times of plenty, this desert lizard stocks up on fat in its tail as a store of nutrients and energy for the lean times. After periods of scarcity, the tail has slimmed back down.

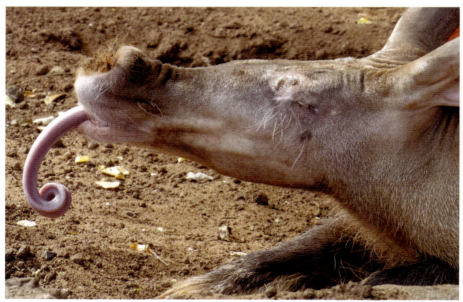

ALL PHOTOGRAPHS:
Aardvark
The first animal to appear in the dictionary, the name aardvark translates from the Afrikaans term 'earth pig'. The animal spends the day underground, and snuffles around by night using its nose and ears to find ants and termites. It uses long claws to dig into their mounds and nests, and then slurps them up with its long tongue.

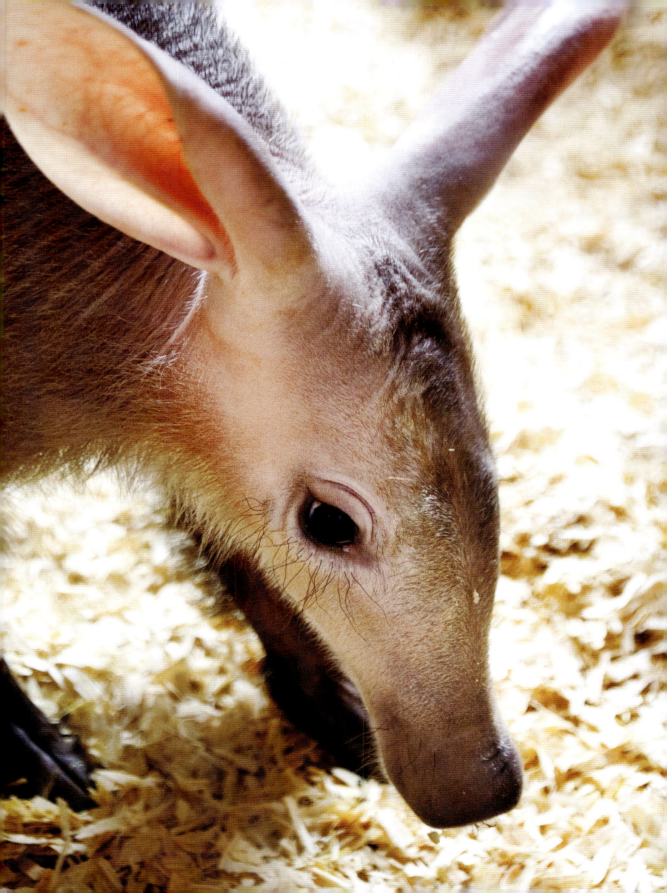

ALL PHOTOGRAPHS:
Emu
Standing proud as the second tallest bird in the world (reaching up to 1.9 m/6.2 ft), the emu is Australia's largest bird and fastest runner. It is a distant cousin of the ostrich, and it too lacks the sturdy breast muscles needed for flight, though the birds do flap their wings while running to help with balance. Their three-toed feet are built for running, with soft pads underneath and thick claws that are used to deliver a dangerous defensive kick. Female emus are bigger than the males, and they fight each other for mates.

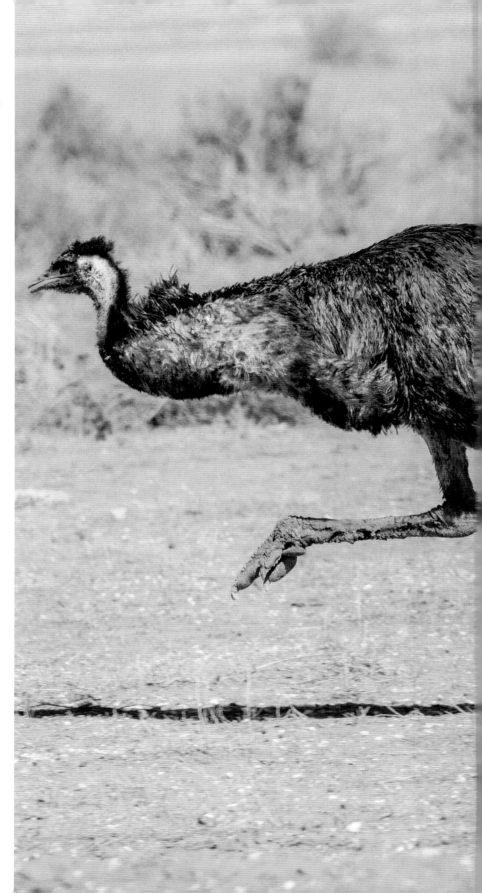

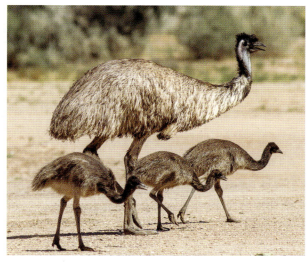
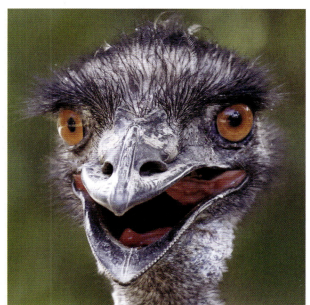
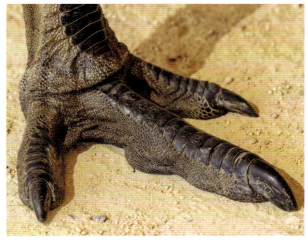

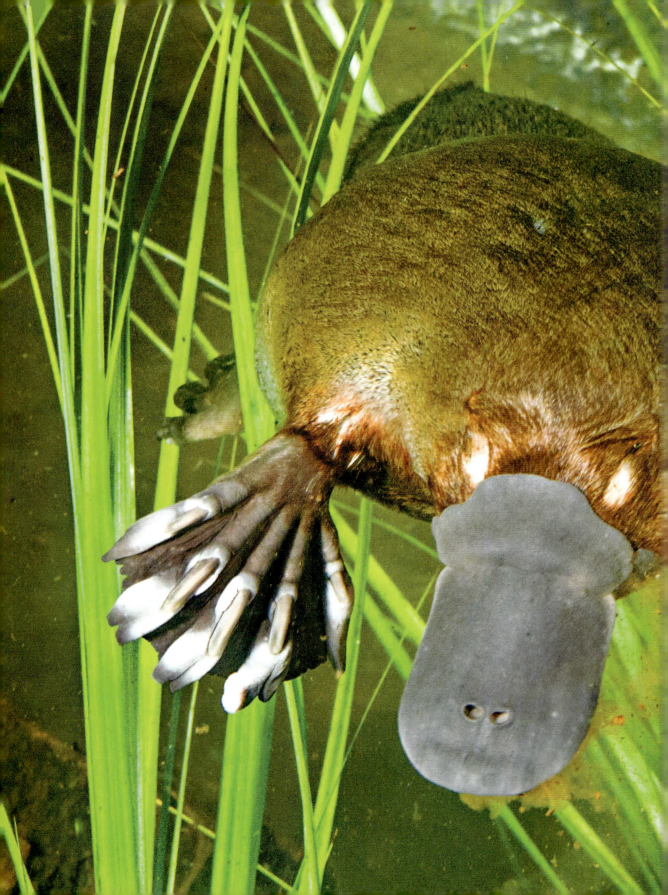

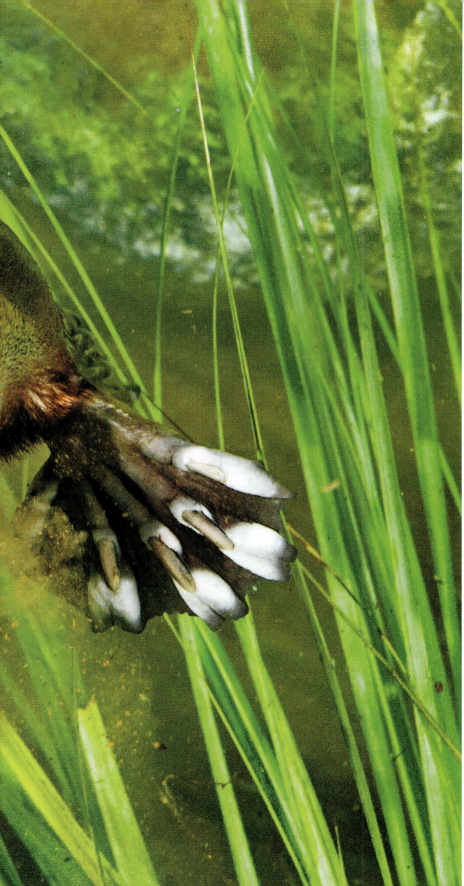

Duck-billed platypus
Few animals are stranger than this aquatic hunter. The famed duck bill is actually a detector that picks up the electrical currents produced by freshwater crustaceans and other prey in dark, muddy water. Back on land, the strangeness continues. Instead of giving birth, the platypus lays small, leathery eggs from which its young hatch.

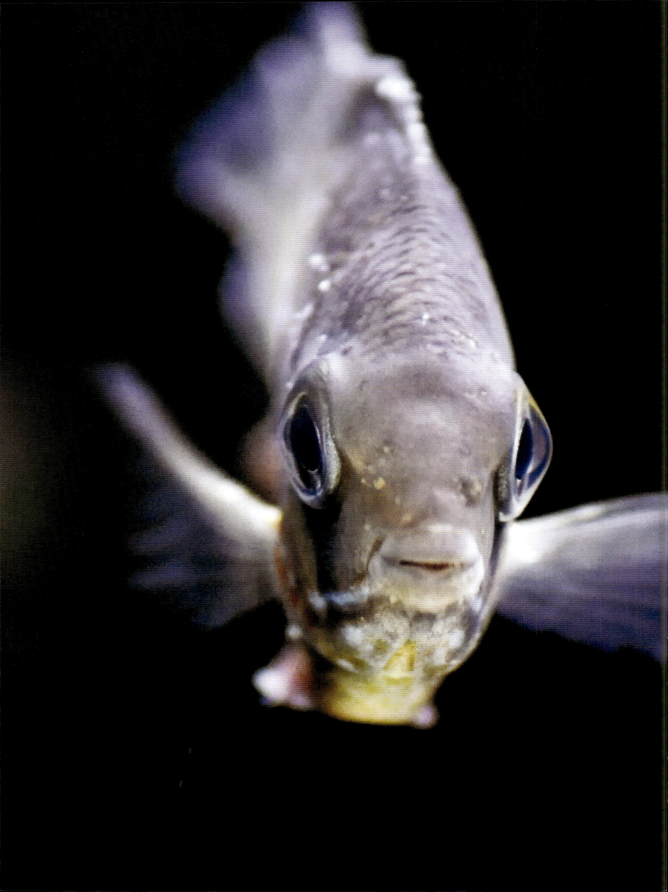

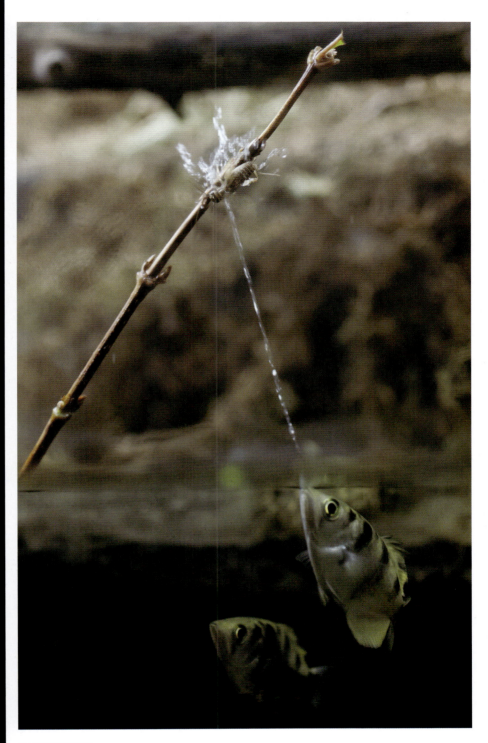

ALL PHOTOGRAPHS:
Archerfish
These sharp-shooting fish can bring down an insect perched on branches hanging some 3 m (9.8 ft) above with a jet of water spat from the surface.

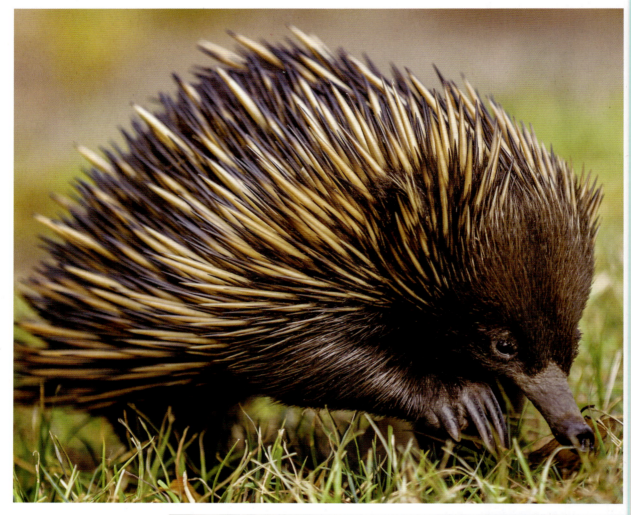

ABOVE AND RIGHT:
Echidna
Also called a spiny anteater, the spikes covering these little creatures are thickened hair shafts. The echidna is related to the platypus. It too lay eggs, and the pointed snout is sensitive to electricity given out by insect prey.

OPPOSITE:
Kea
New Zealand is a land of birds, and the kea is a parrot from the mountains of the South Island. It has evolved to live as a spirited scavenger, grabbing food from tourists and feasting on the carcasses of sheep, and is thus more akin to a gull or crow than a macaw chattering in a forest tree.

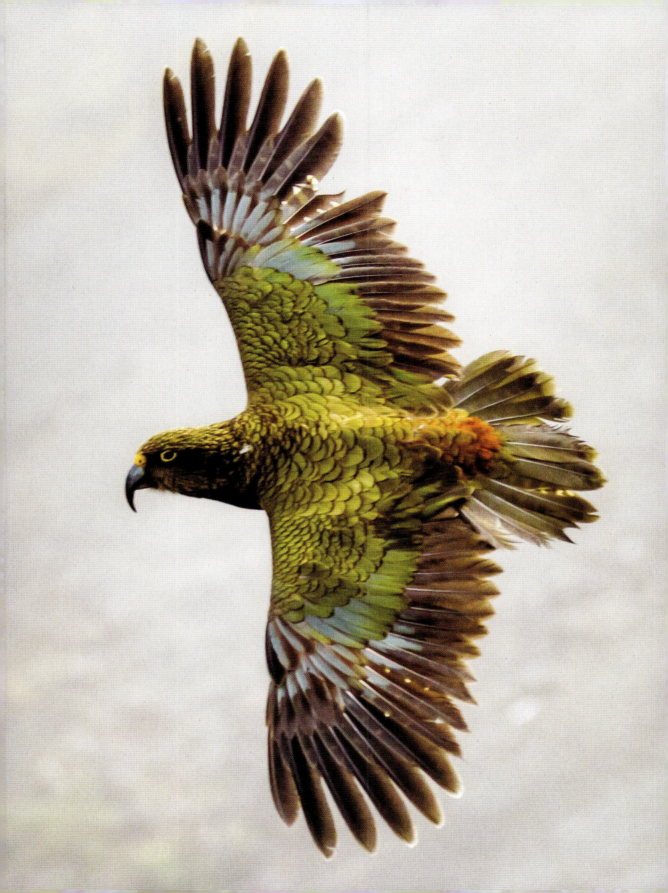

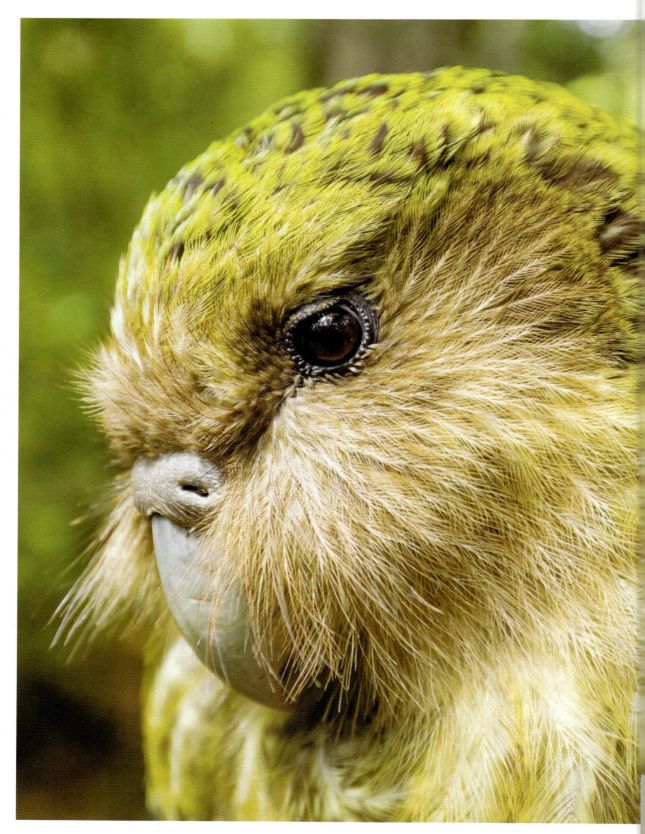

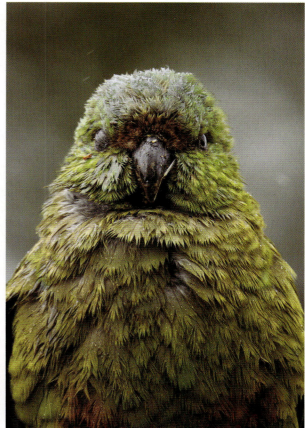

ALL PHOTOGRAPHS:
Kākāpō
The kākāpō is the world's largest parrot, growing to 64 cm (25 in) long, not including the tail. It is too heavy and fat to fly and has only small wings. The bird, now extremely rare, lives on the forest floor, often clambering around inside bushes to find leaves, fruits and seeds to eat. The kākāpō also has the world's loudest bird call – the males make deep booming calls that can be heard 5 km (3.1 miles) away.

PREVIOUS PAGES:
Heavy insects
Wētās are flightless; they lack even vestigial wings. This is because they are far too heavy to get off the ground. The heaviest weighs in at 70 g (2.5 oz).

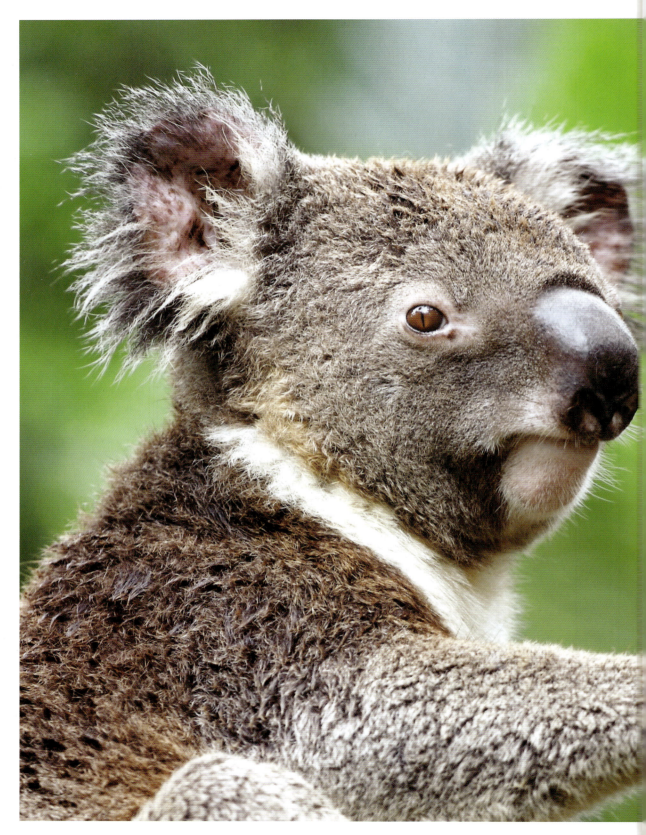

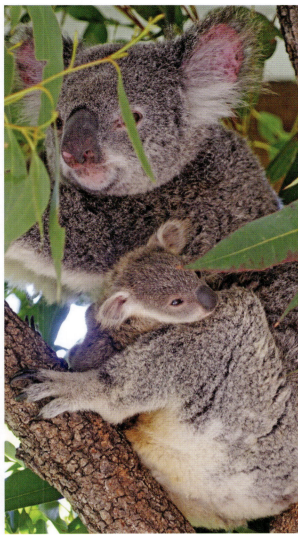

BOTH PHOTOGRAPHS:
Koala
Frequently referred to as a koala 'bear', this Australian icon is obviously a marsupial, and not related to true bears. The sluggish koala eats a diet composed almost exclusively of eucalyptus leaves. These are filled with pungent oils that turn the stomach of most herbivores, but the koala is immune to the toxins and slowly digests the food using a host of gut bacteria. Some koalas are kept in zoos such as this one in Queensland.

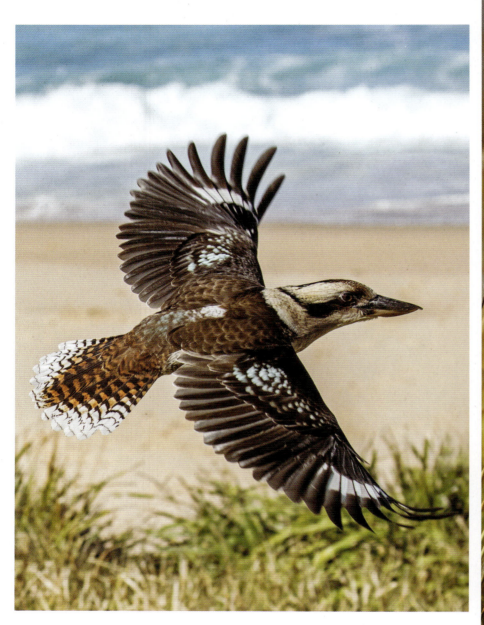

ABOVE:
A mate for life
The laughing kookaburra is a big bird, growing to about 45 cm (18 in) long. It mates for life, and builds its nest in a tree hollow.

RIGHT:
Kiwi
The namesake of all New Zealanders, this medium-sized flightless bird is a nocturnal forager. It has nostrils on the tip of its long beak and uses them to sniff out grubs and worms in the soil. It then plunges its beak into the earth to grab its prey.

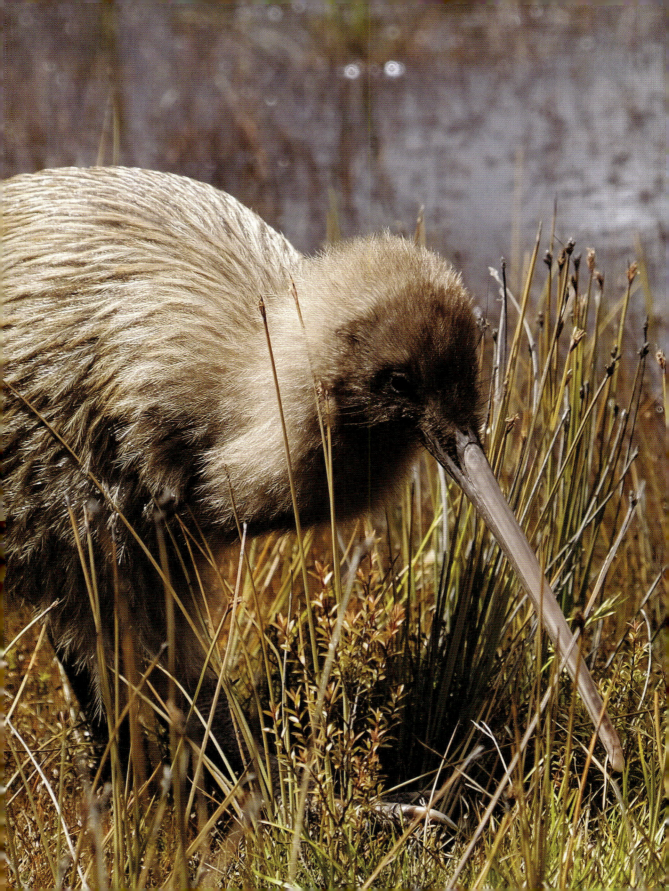

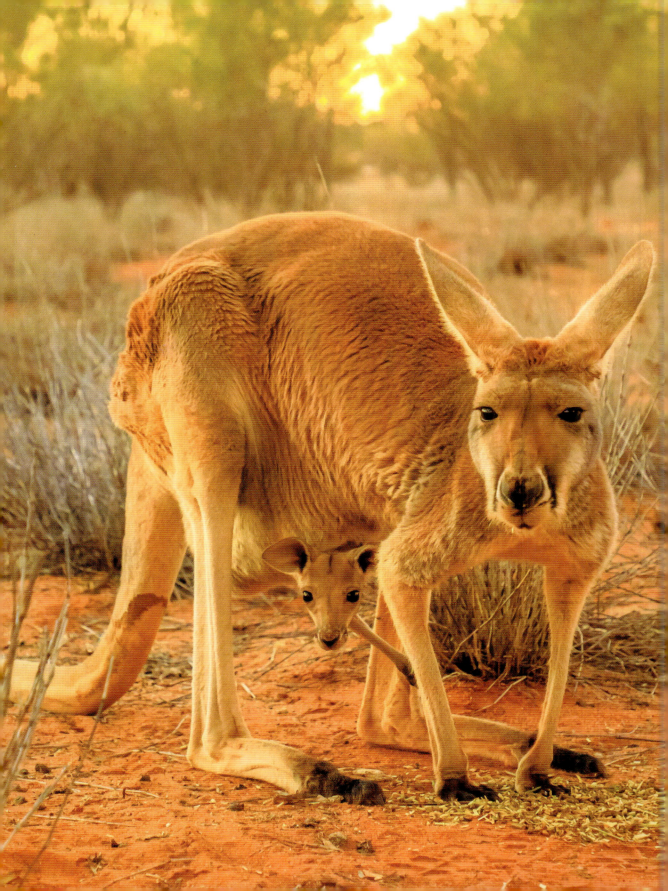

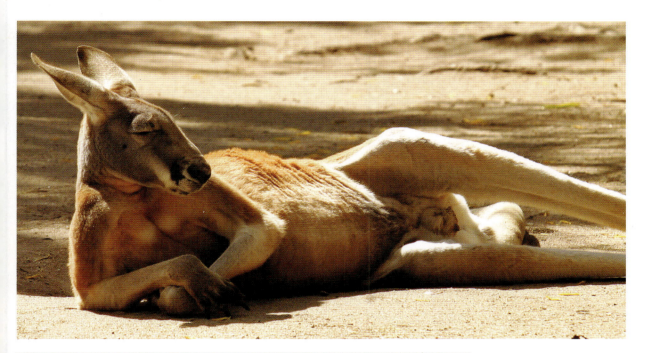

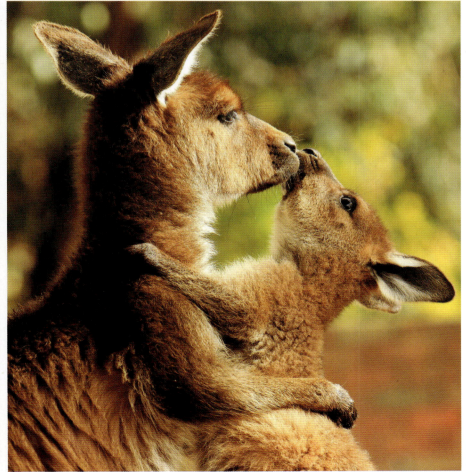

ALL PHOTOGRAPHS:
Red kangaroo
The largest wild land animal in Australia, the red kangaroo stands at about 1.5 m (4.9 ft) tall and weighs in at a maximum of 90 kg (198 lb). The kangaroo famously hops along on long, elastic back feet. The thick, 1.2 m (3.9 ft)-long tail helps balance out the body as the beast bounces along, and is used to provide a third point of support when the kangaroo is standing still. In line with all marsupials, the kangaroo gives birth to a very undeveloped baby, or joey, which then lives inside a pouch on the mother's belly to complete its development.

RIGHT:
Sugar glider
It might look like a flying squirrel but that is the power of convergent evolution. This nocturnal marsupial, which lives in the treetops of Australia and New Guinea, has a membrane of skin running between its front and back legs, which acts as a gliding surface. This extends the distances – up to 50 m (164 ft) – the little creature can leap from tree to tree.

OPPOSITE TOP AND BOTTOM:
Thorny devil
The fleshy spines on this terrifying desert lizard (although never fear, it is only 20 cm/8 in long) have two functions. First, they offer an obvious defence, but they also collect droplets of morning dew, and this water trickles along grooves between the spines all the way to the mouth.

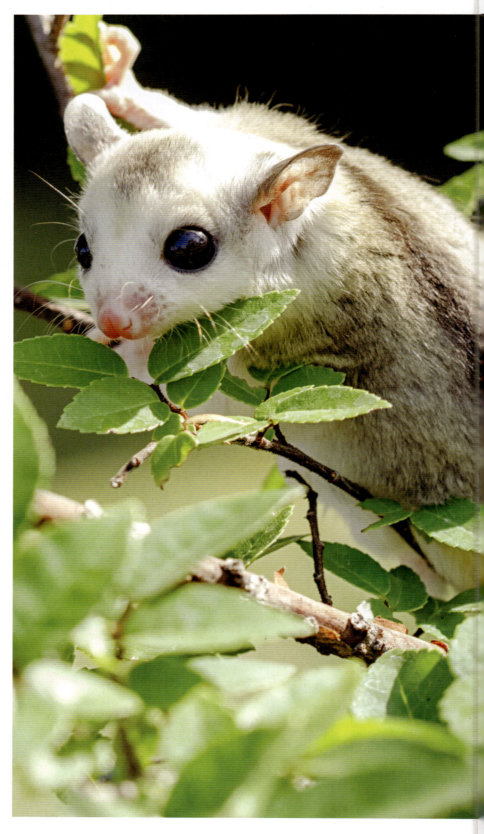

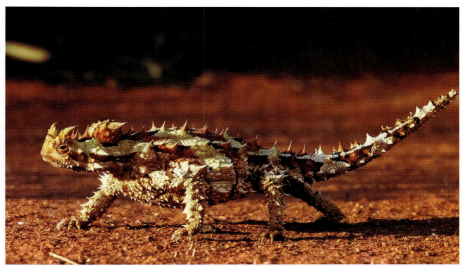
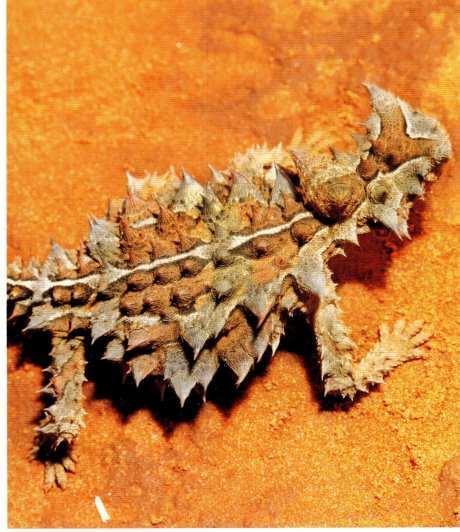

241

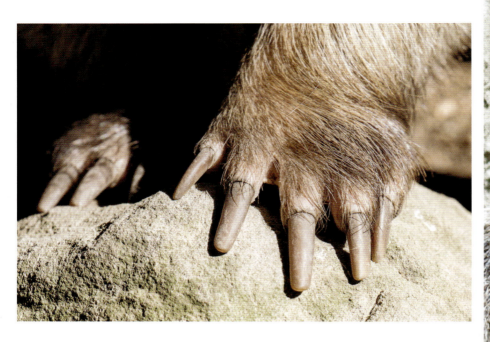

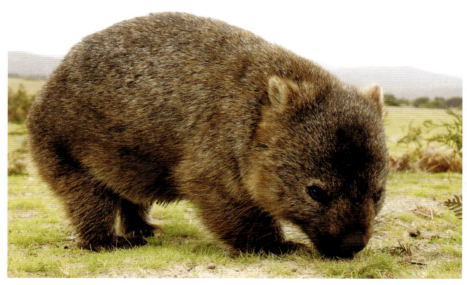

ALL PHOTOGRAPHS:
Wombat
These hefty burrowing grass-eaters have an odd claim to fame: they are the world's most dangerous marsupial. When threatened, they turn tail and present a rock-hard rear that is impervious to bites. Next, they reverse charge, and a bash from the butt can crush a foe's skull – in theory. Wombats also use their rumps to knock down mating rivals and curious humans who come too close – and then bash them repeatedly.

In addition, wombats have a powerful bite and a sturdy set of claws for digging burrows, which are also a threat to life and limb, although there are no reports of fatalities. They generally produce one joey at a time. And a final strangeness: wombats do cube-shaped droppings!

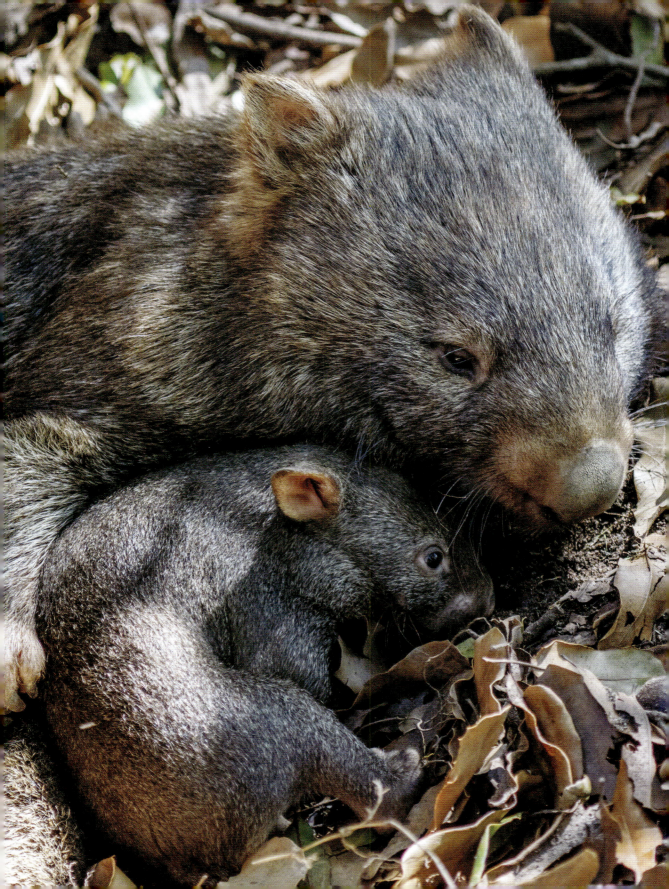

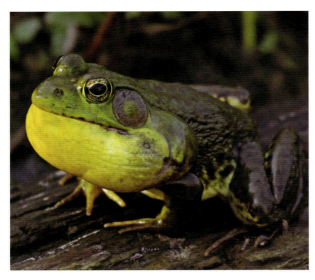

ALL PHOTOGRAPHS THIS PAGE:
Down in one
Big and noisy, the bullfrog is an all-American amphibian. It is supremely adapted to life in swamps and rivers – anywhere that is wet enough. It can grow to 15 cm (6 in) long, and is much bigger when its limbs are outstretched. It will eat whatever animal it can swallow. Food is swallowed whole, the big eyes on top of the bullfrog's head being pulled down to give meals an extra push down the throat.

RIGHT:
Beaver
Few animals are as iconic as this semi-aquatic rodent. It is famed for felling trees with its powerful gnawing teeth, and using the logs to dam rivers. The reason for doing so is to create a lush wetland upstream, where the beaver can feed on grasses. In winter, it survives on wood left to soak in water. Beaver dams are a nuisance in intensively managed landscapes, but if they are given space, landowners are beginning to realize their benefits in controlling flooding and boosting biodiversity.

OVERLEAF:
American white pelican
With a wingspan of nearly 3 m (9.8 ft) and weighing in at 13 kg (28.7 lb), this is one of the biggest flying birds in the world. It makes short flights over water, searching for fish. It then lands on the surface and scoops up the food in its sac-like beak. The lower part of the beak is a flexible bag of skin. The bird drains the water from the bag, trapping the fish inside – which is then swallowed whole.

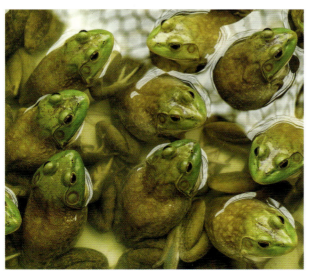

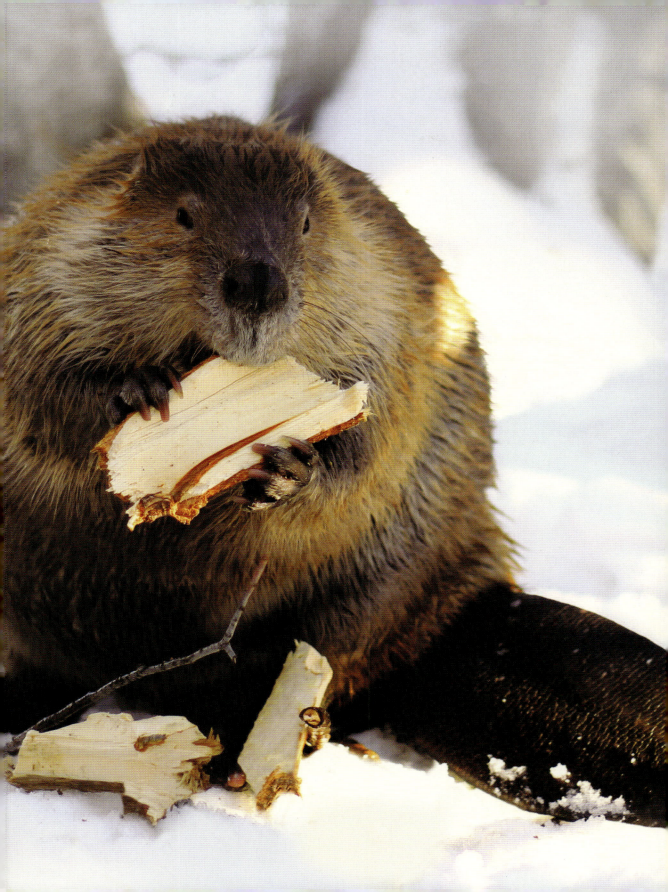

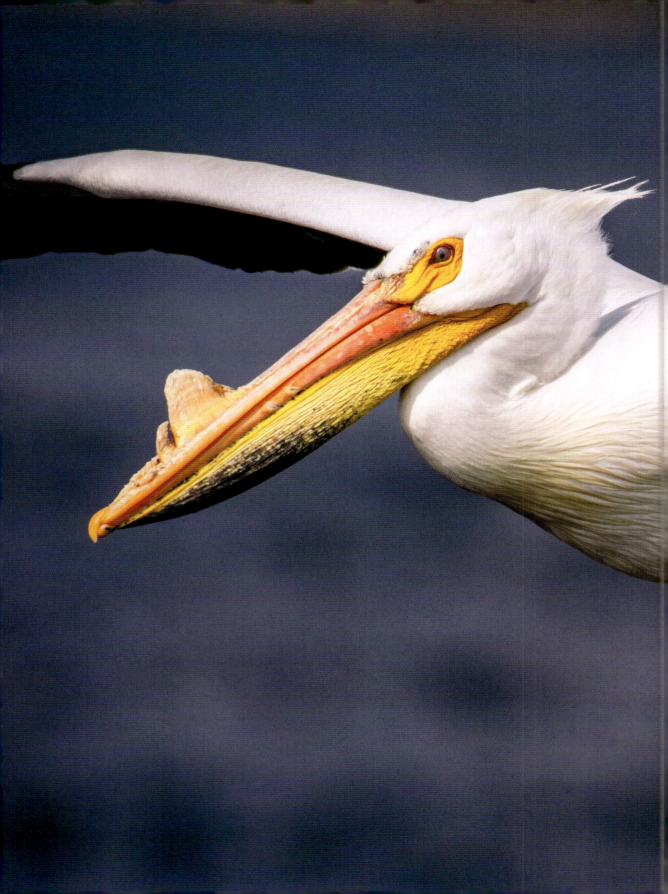

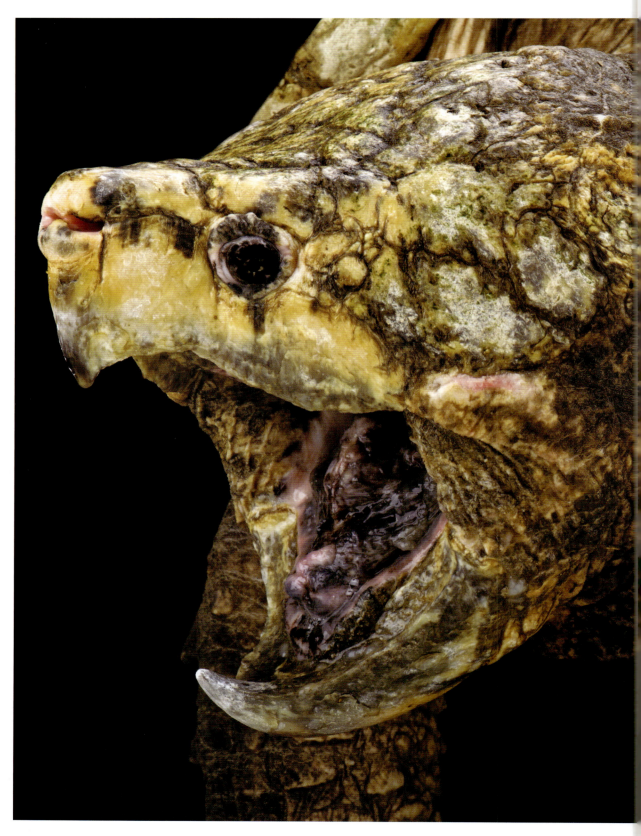

ALL PHOTOGRAPHS:
Alligator snapping turtle
This monstrous river turtle is the biggest freshwater turtle in North America, and the most feared. The beak may be toothless but it is sharp enough to slice off a finger with a single snap. Thankfully, the snapping turtle is mostly found at the bottom of the rivers and lakes in the southeast of the United States. Down there, it uses a bright worm-shaped flash of red on its tongue to lure in fish, which are gobbled up and never seen again.

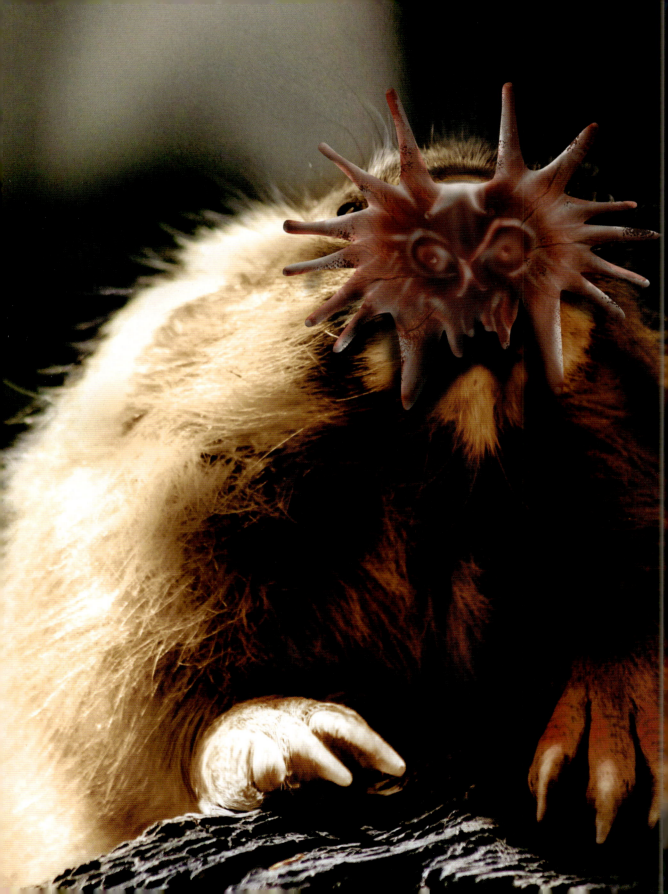

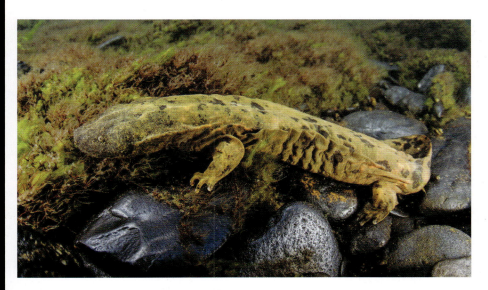

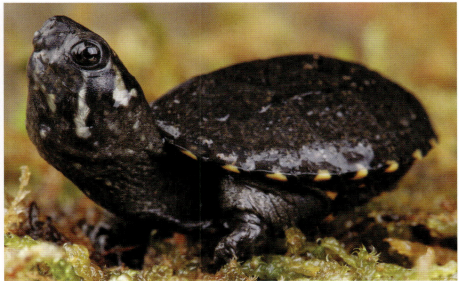

LEFT:
Star-nosed mole
The fingered snout of this small burrowing animal is a touch and electrical sensor, not a smelling organ. It is covered with 25,000 receptors in total, which pick up the electricity given out by the muscles and nerves of worms and other prey in the soil.

ABOVE TOP:
Hellbender
This is the largest amphibian in North America. The giant salamander spends its days in fast-flowing mountain streams, preying on crayfish and other small water animals. The cold, clear water is full of oxygen, so the big hellbender can absorb the oxygen it needs directly through its wrinkled skin.

ABOVE BOTTOM:
Stinkpot
Also called the common musk turtle, this freshwater reptile is named after the way it releases a foul-smelling liquid from glands around the edge of the shell. Few predators proceed with an attack after encountering this.

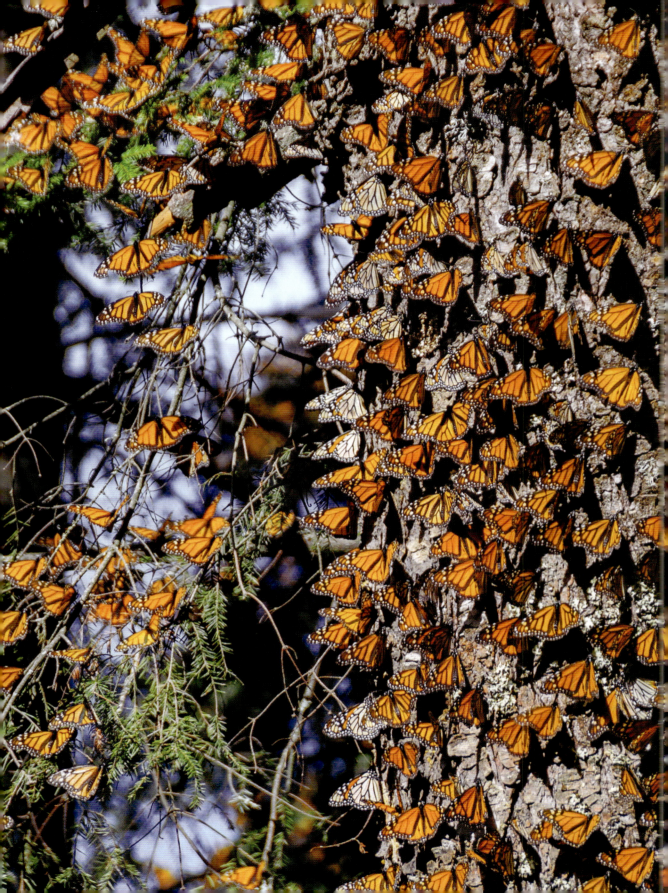

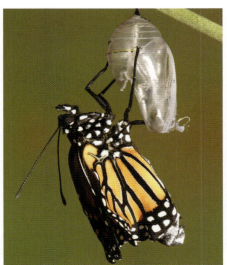
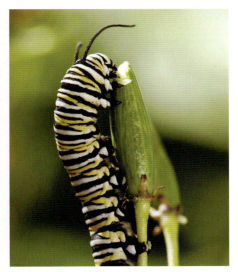
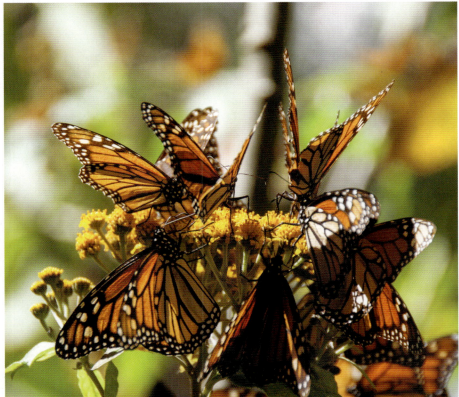

ALL PHOTOGRAPHS:
Monarch butterfly
This large American butterfly is famed for making an epic migration from the meadows and forests of North America as far north as the Great Lakes, to wintering grounds in Mexico and California. There, it perches in trees, where it avoids the frost. Birds know not to eat them – the bright orange colours are a signal that the insect does not taste very nice. This is because as a caterpillar, the monarch feasts on milkweed, which has a toxic sap. These toxins are stored in the body and passed on to the adult as it emerges from the chrysalis.

253

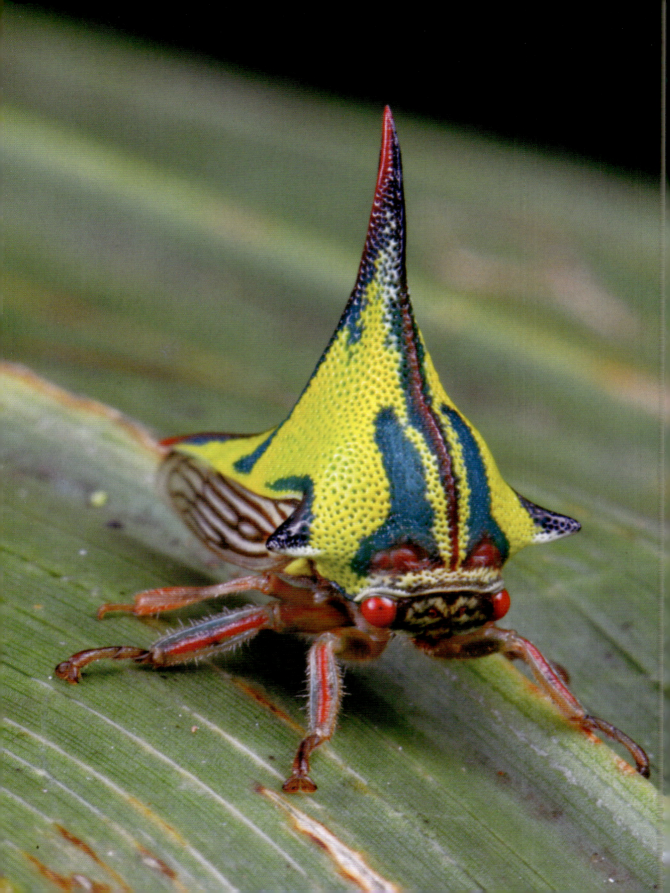

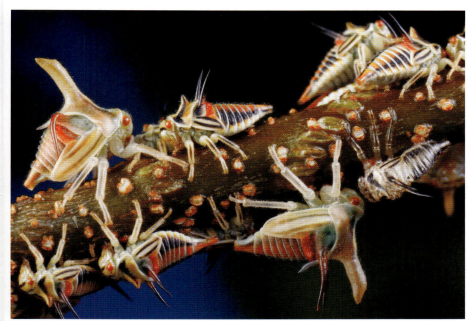

OPPOSITE AND LEFT:
Thorn bug
This sap-sucking insect belongs to a group called the treehoppers. It sits on a twig and jabs it pointed mouthpart into plants. The insect has to sit still as it drinks the low-quality food. To defend against attack, its thorax does a very good job of looking like a sturdy thorn.

BELOW BOTH PHOTOGRAPHS:
Alligator gar
This long fish from the Mississippi Basin is a so-called 'living fossil'. It evolved at least 100 million years ago and has a body system that is very different to the ones used by the great majority of fish today.
It grows to 1.8 m (5.9 ft) long and weighs up to 50 kg (110 lb). It earns its name from the wide, square jaw, which holds many small but sharp teeth.

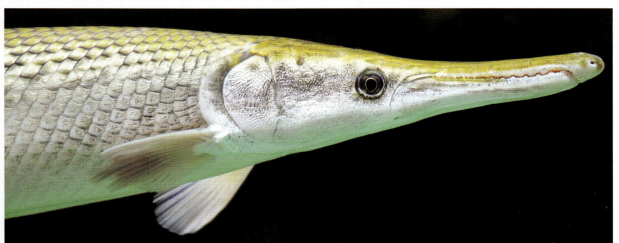

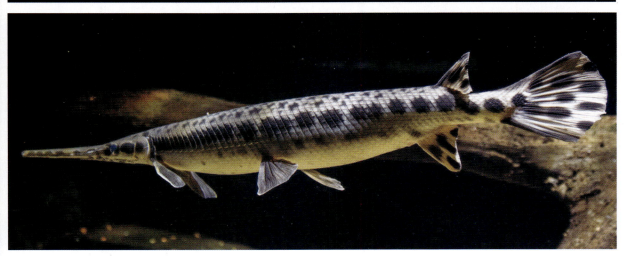

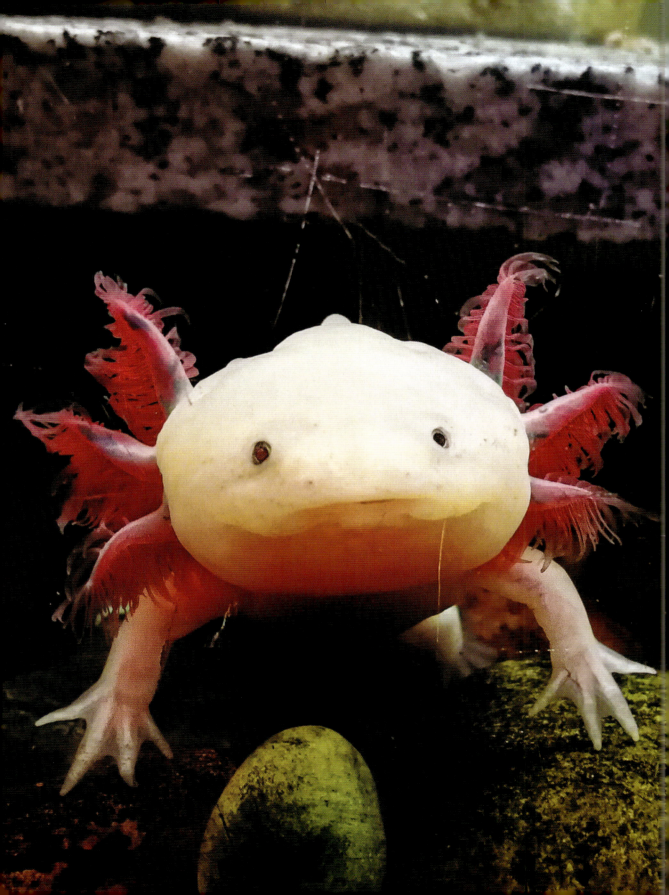

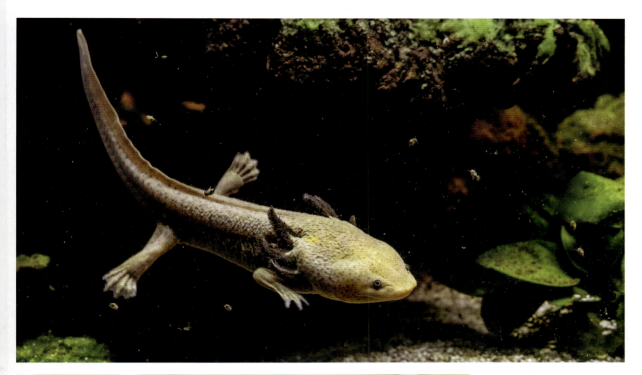

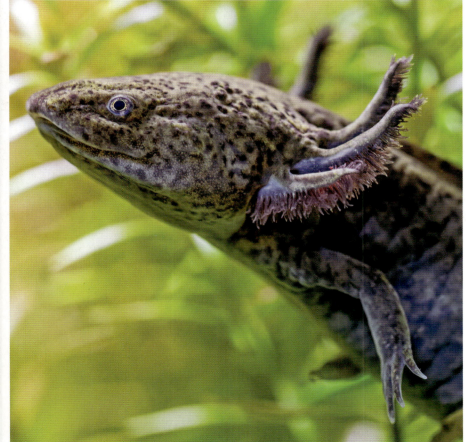

ALL PHOTOGRAPHS:
Axolotl
This unique amphibian is named after the Aztec god of fire and lightning. During Aztec times the axolotl lived wild in the lakes and waterways of Tenochtitlan, the old imperial capital. Today, that is the site of Mexico city, and the axolotl's wetland habitat has been considerably shrunk. They can also be kept as aquarium pets as pictured on the far left. The amphibian spends all of its life in water, unlike almost all other amphibians, which transform from a young aquatic form with gills into an air-breathing adult.

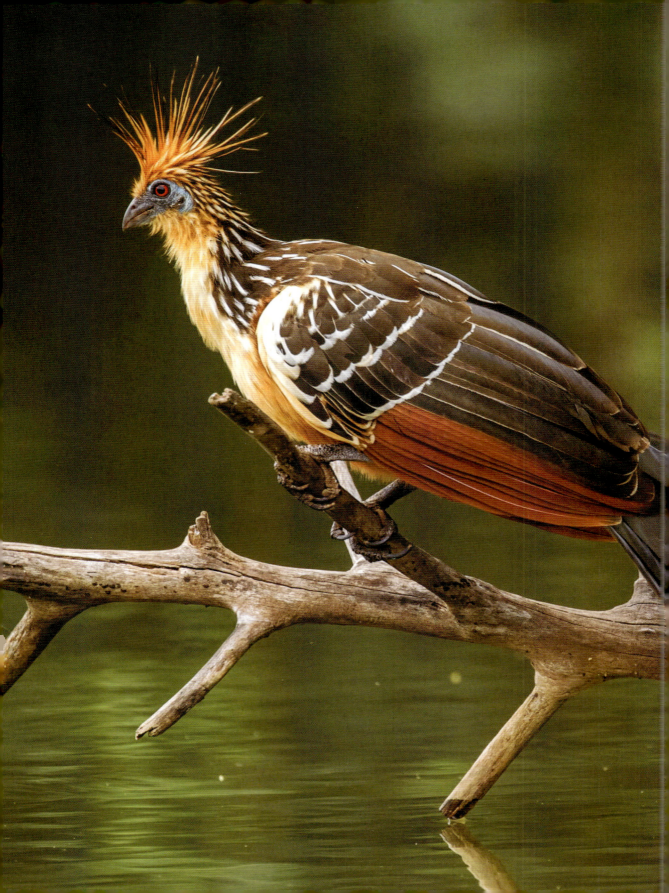

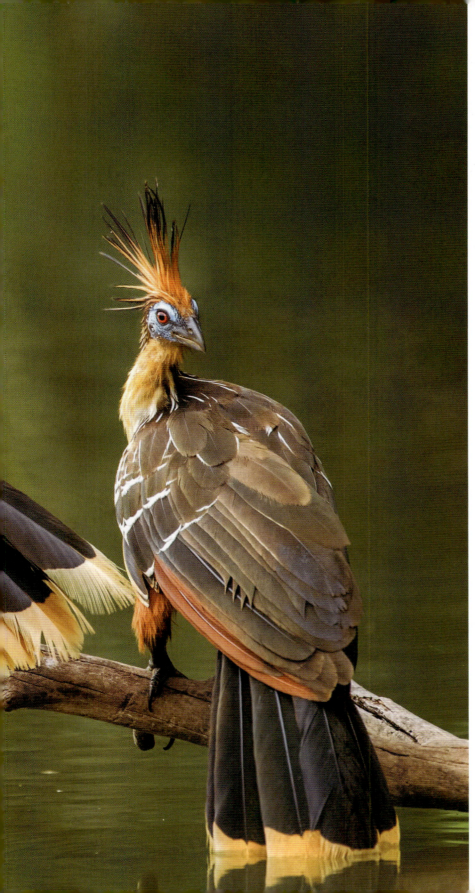

Hoatzin
This strange Amazonian bird defies simple classification and has no close relatives. Experts now think the hoatzin, or 'stinky turkey' as the locals might call it, is a distant cousin of wading birds. The species lives close to water, mostly eating the leaves in trees that grow above swamps. It has two claws in the middle of its wings – a very primitive feature of birds – which are used to grip branches as the bird clambers around inside a tree.

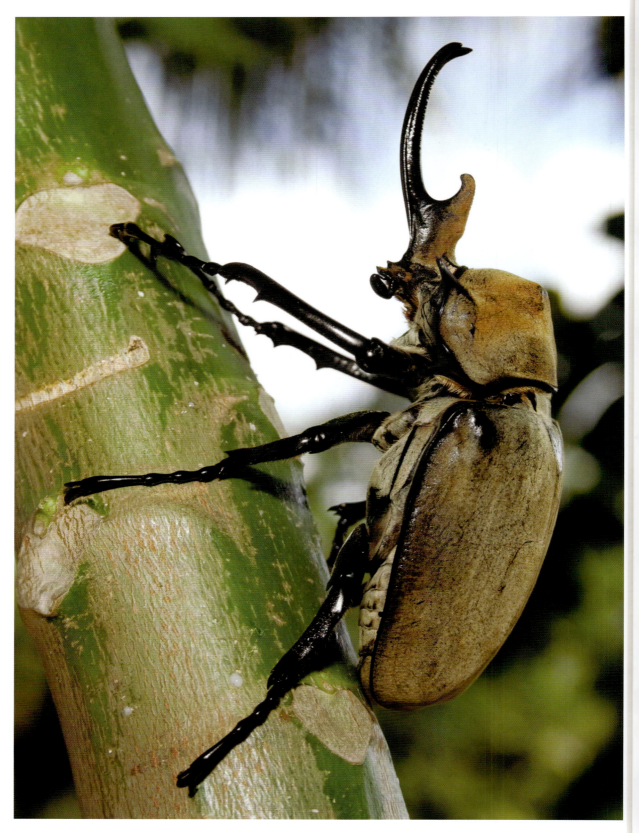

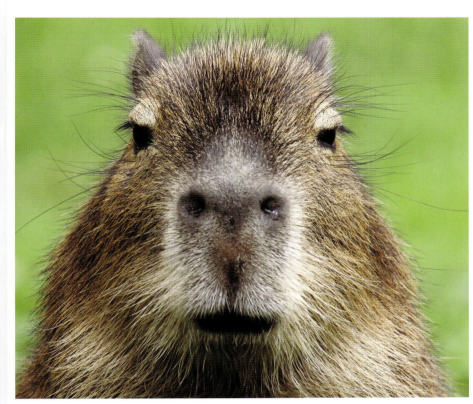

OPPOSITE:
Elephant beetle
The trunk-like horn that earns this forest insect its name grows from the face of the males only. It is used as a symbol of status during the battle for mates. The bigger horn wins conflicts, and when it is too close to call, the males will use their horn to push a rival off the branch. Some of these beetles can grow to 15 cm (6 in).

LEFT AND BELOW:
Capybara
Known by locals as a water pig, this is actually the world's largest rodent. It is a giant relative of the guinea pig that grows to 130 cm (51 in) long and can weigh as much as 60 kg (132 lb). Capybara herds graze in lush meadows beside rivers, and the animals dash into the shallows when they feel threatened.

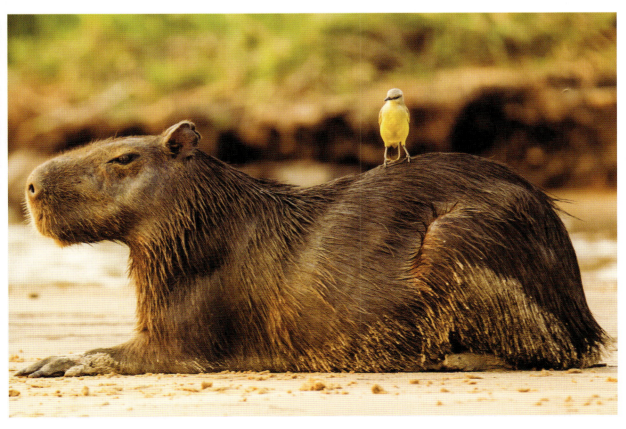

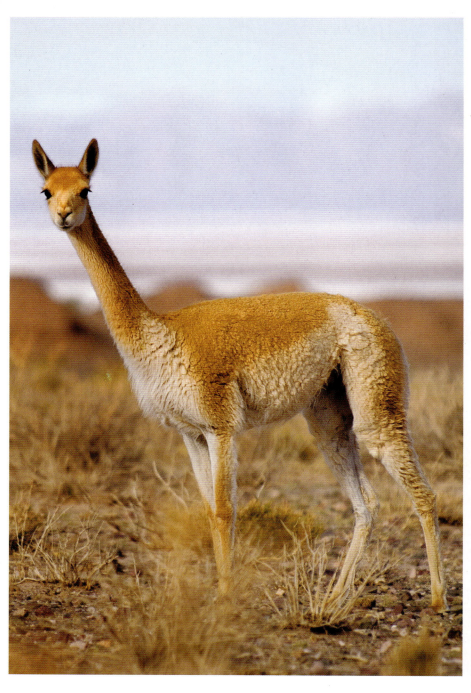

ABOVE:
Vicuña
This is the wild relative of the alpaca, and shares South America's high and dry habitats with the guanaco, which is the wild relative of the llama. The vicuña, a type of humpless camel, lives on the high slopes of the Andes. It grows a thick fleece of wool to keep out the cold air.

RIGHT:
Three-toed sloth
There are four species of sloth with three claws on the forelegs. They live across the forested regions of South and Central America. Famously slow, sloths eat large quantities of leaves and hang about digesting much of the time. They sleep, mate and give birth upside down.

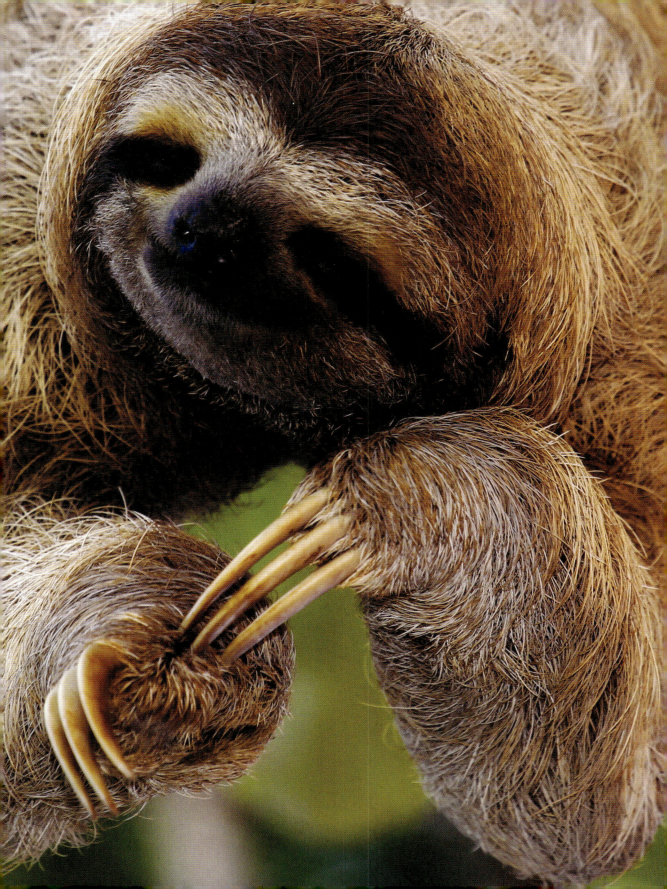

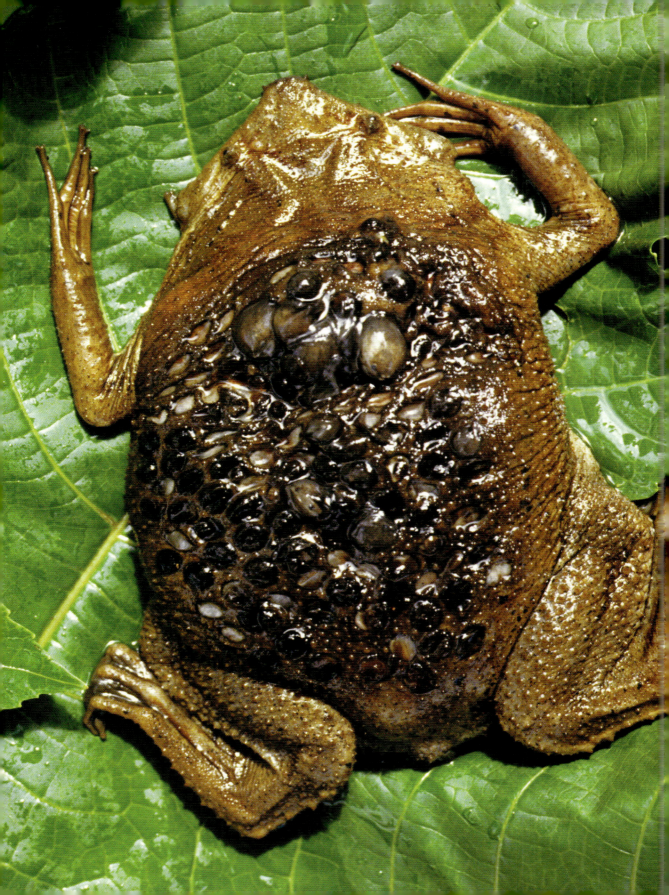

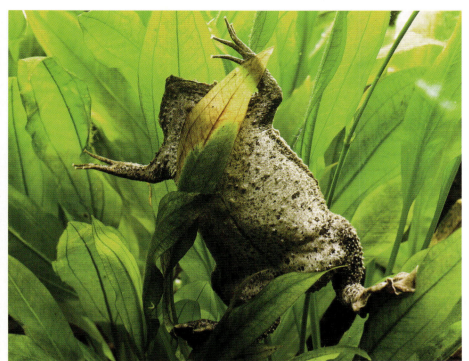

ALL PHOTOGRAPHS:
Surinam toad
This rainforest frog spends it whole life in water. It has a very flattened body and lies in the mud on the bottom of forest rivers, looking like a fallen leaf as it waits to ambush small fish, shrimps or worms. During mating, the male shoves the sticky fertilized eggs on to the female's back. The skin grows around them, and the eggs develop inside fleshy capsules.

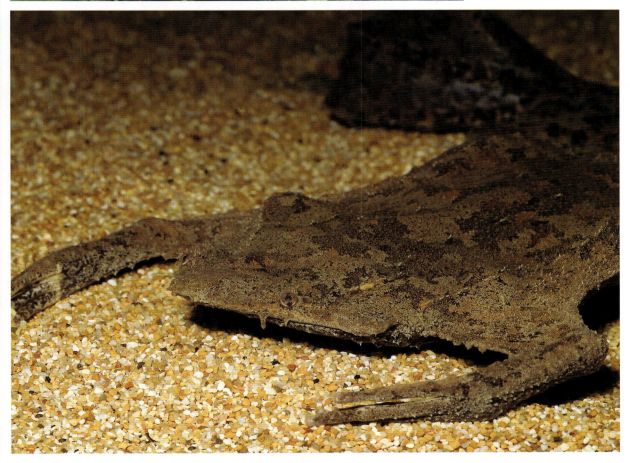

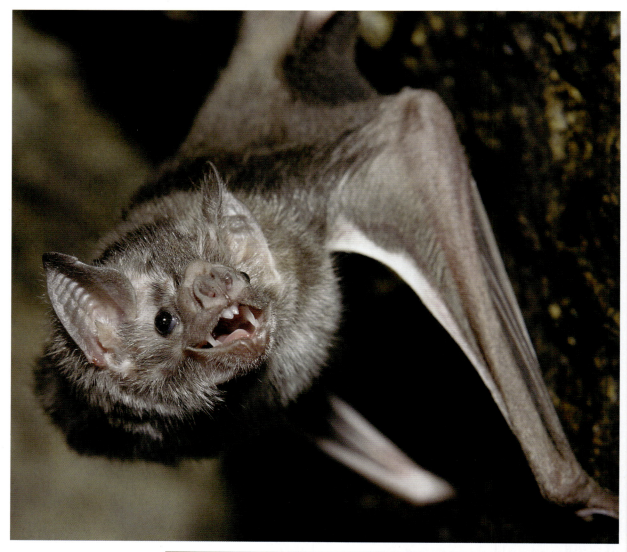

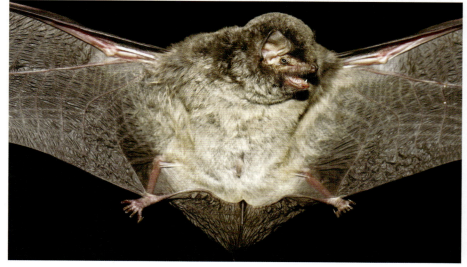

ABOVE AND RIGHT:
Vampire bat
It may be a surprise to hear that it is very strange for bats to drink blood, but that is exactly how these long-fanged flyers get their food. Vampire bats rarely target humans, preferring larger beasts such as horses and cattle. They attack sleeping victims, making a small bite on some warm skin and licking up the blood that flows.

OPPOSITE:
Red howler monkey
At dawn, these big, leaf-eating monkeys stand up in their nests at the tops of the tallest forest trees and give out loud howls. The chorus travels some 5 km (3.1 miles) into the forest and reinforces territorial claims.

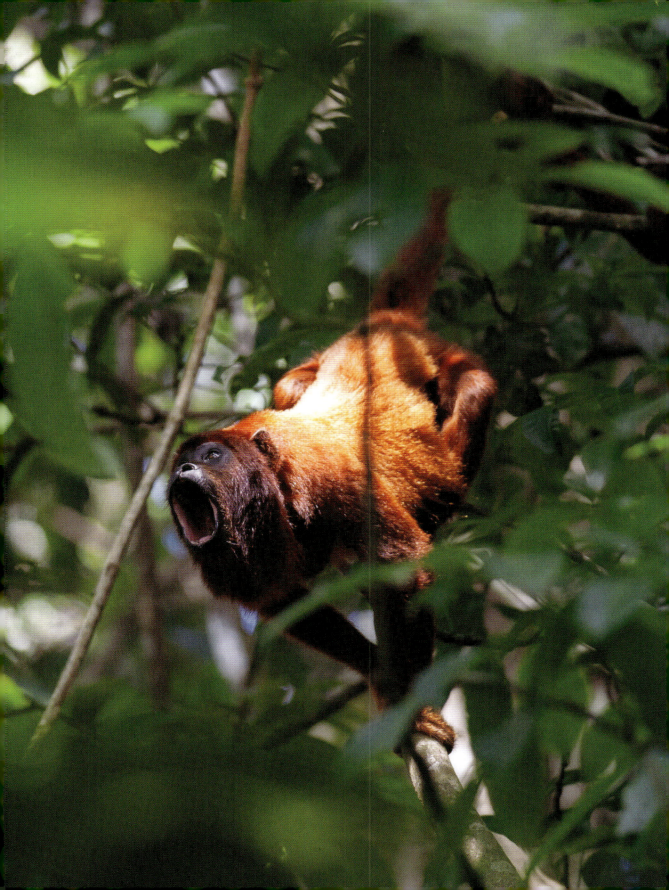

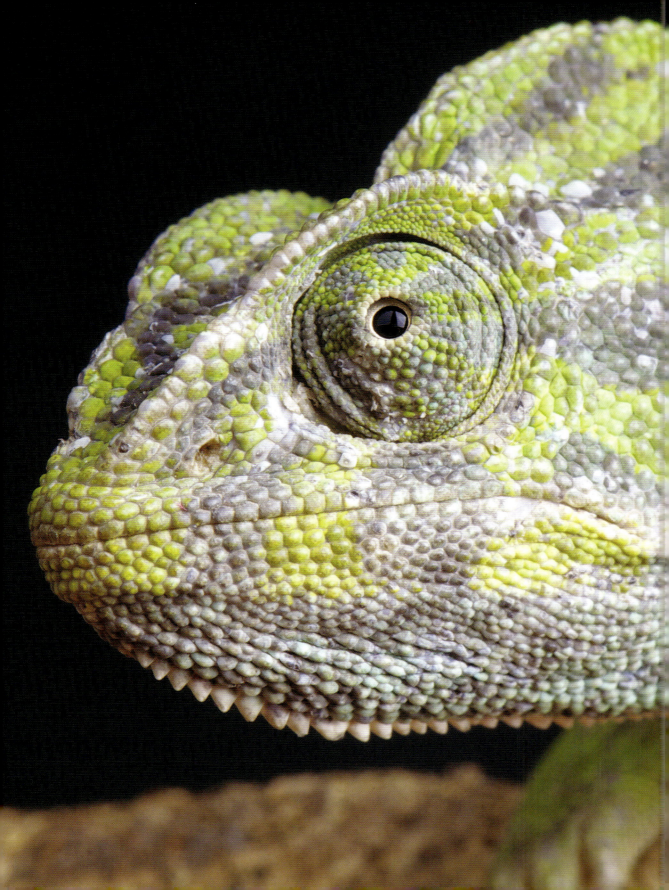

Common chameleon
This is the only chameleon species to live in Europe. It clings on in patches of forest along the southern coast and islands of the Mediterranean. Chameleons are obviously famed for their ability to change colour, although this is much more limited than in the popular imagination. Another strange feature is that the eyes move independently, searching in all directions for insect prey. It then splats them with a strike of its long tongue.

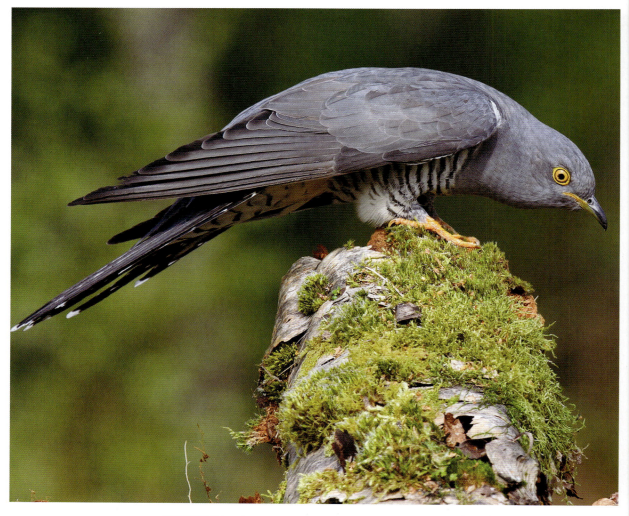

ABOVE AND RIGHT:
Common cuckoo
Arriving from Africa in spring, Eurasian cuckoos sound off their distinctive call to find a mate. The female then makes the most of her passing resemblance to a sparrow hawk to scare off warblers or other songbirds from their nests. Next, she lays a single egg among the hosts', and leaves. The interloper hatches first and shoves out all the other eggs. The tricked parents will feed their guest even as it grows much bigger than them.

OPPOSITE:
Badger
This chunky black-and-white beast is the toughest predator around in many parts of Europe, now that bears, wolves and lynxes are all but gone. It is no larger than a spaniel but potentially much fiercer.

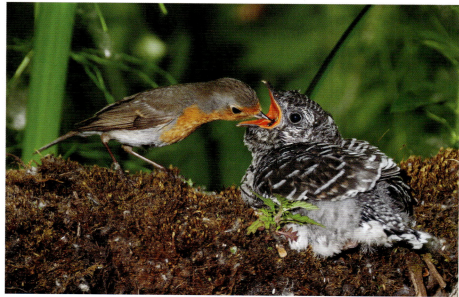

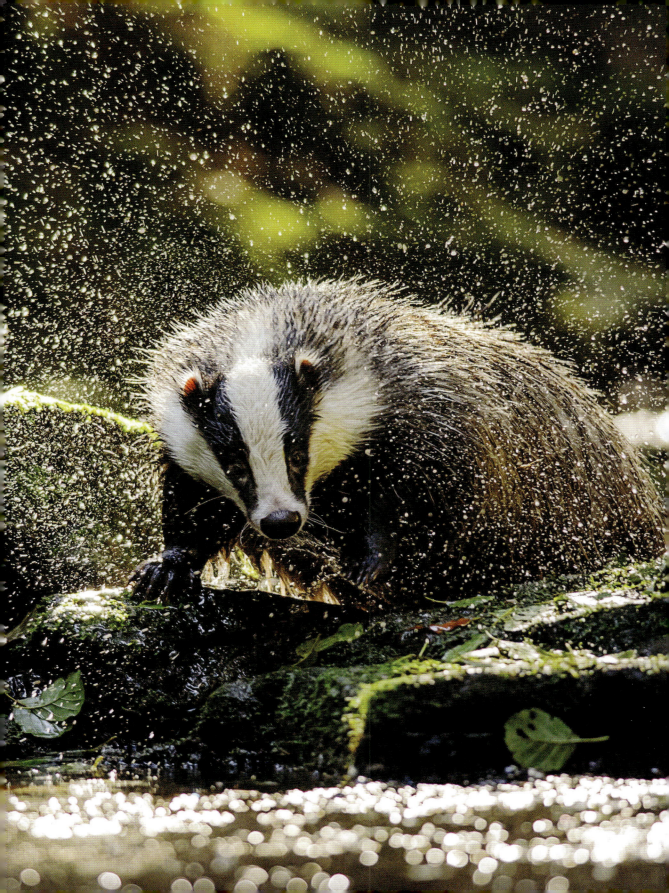

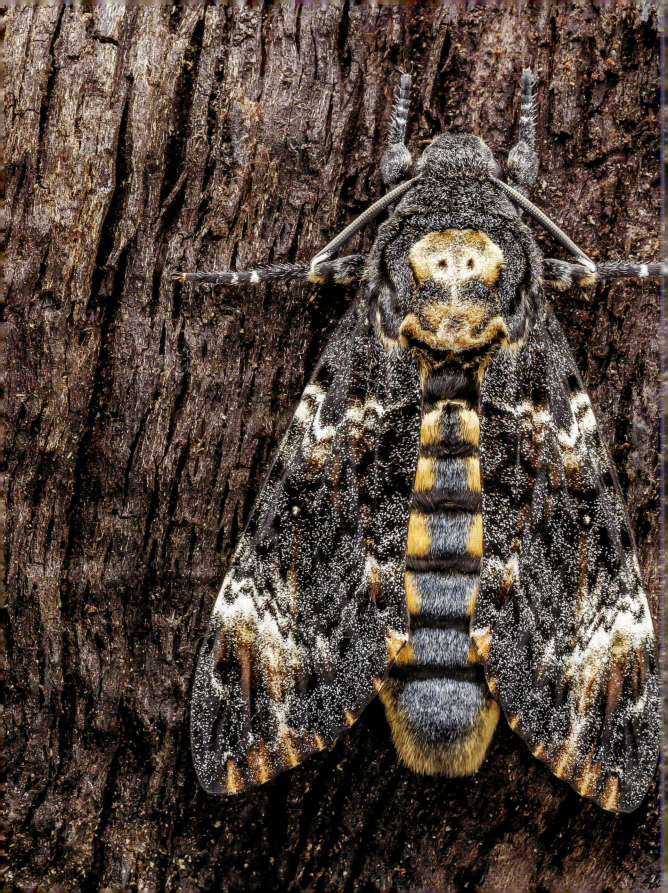

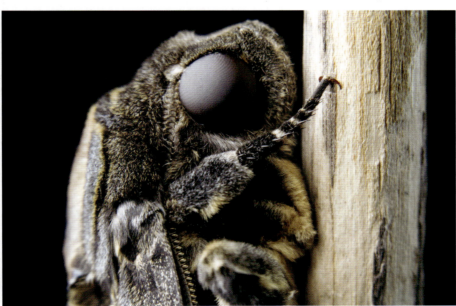

ALL PHOTOGRAPHS:
Death's-head hawkmoth
This fast-flying, delta-winged moth migrates into Europe from Africa in summer. It is famed for the skull-shaped pattern on its thorax, which has led people to assume that the insect brings bad luck. It is certainly a bad omen for honeybees, because the yellow and black stripes on the abdomen are a rough disguise that enables it to invade nests. The moth also mimics the smell of the bees as it raids the supplies of honey and nectar. If spotted, the moth gives out a squeak, which is thought to sound like the piping noises issued by the queen bee as commands. This offers some respite, and the moth's thick skin protects it from stings as it makes its escape.

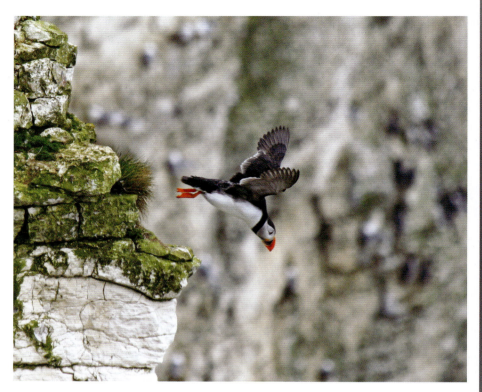

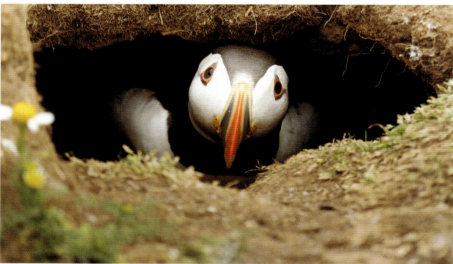

ALL PHOTOGRAPHS:
Atlantic puffin
After spending the winter out at sea, these distinctive sea birds congregate at breeding grounds in spring. The mature birds arrive with a brightly coloured bill to act as a sign of fertility and dominance. They nest in deep burrows in muddy cliffs, with pairs returning to the same nest year after year. Puffins eat nothing but fish, which they collect during short dives. They are able to collect several fish at once, holding them against the roofs of their mouths with their tongues as they snatch additional ones.

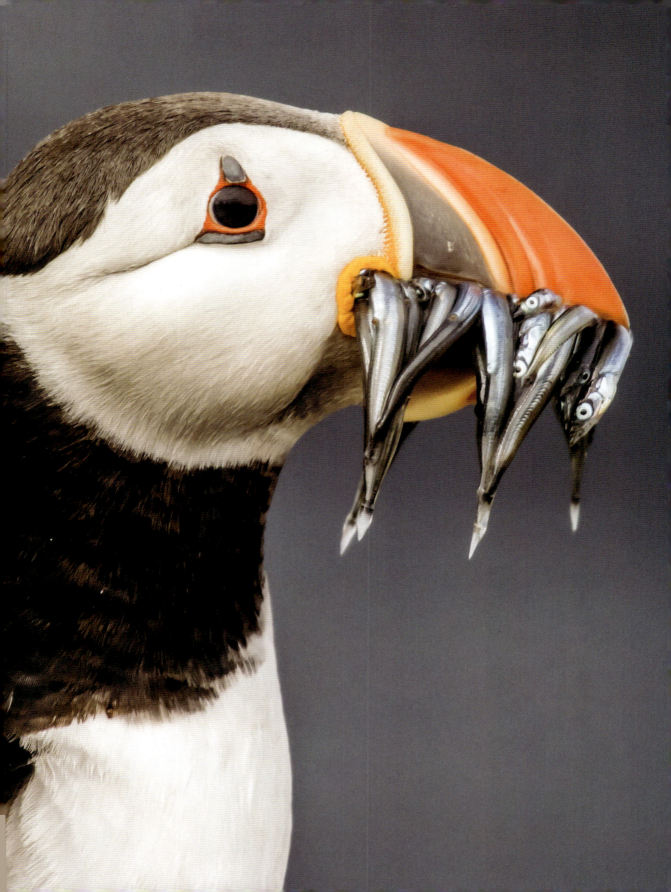

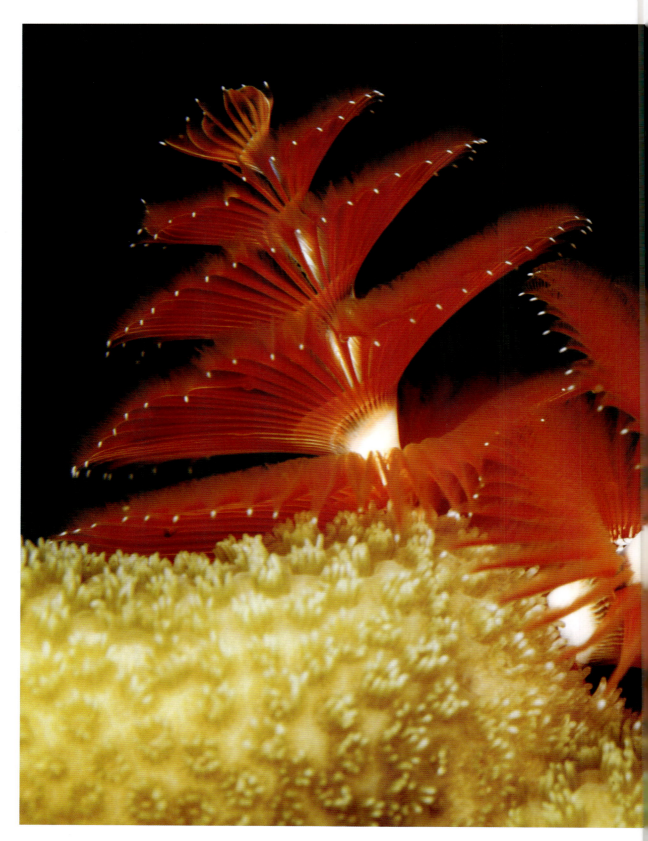

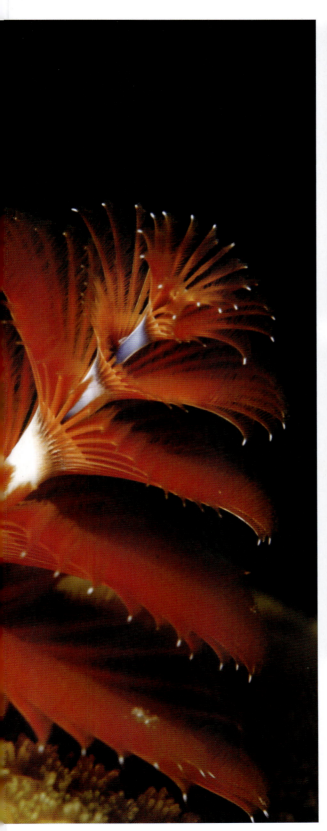

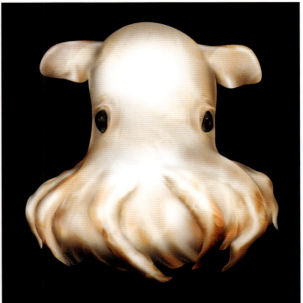

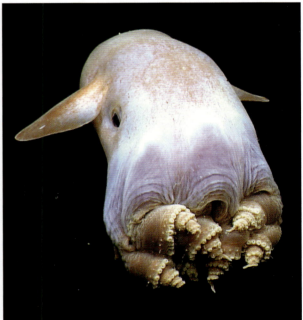

LEFT:
Christmas tree worm
Is it a seaweed? Is it an anemone? The clue is of course in the name, and it is in fact a worm, which grows on coral reefs around the world. The feathery tree-shaped appendages are used to collect food and oxygen from the water.

ABOVE TOP AND BOTTOM:
Dumbo octopus
Named after the big-eared flying elephant from the Disney movie, this deep-sea umbrella octopus searches the dark seabed for crustaceans and other prey. The ear-like fins are used for swimming in open water.

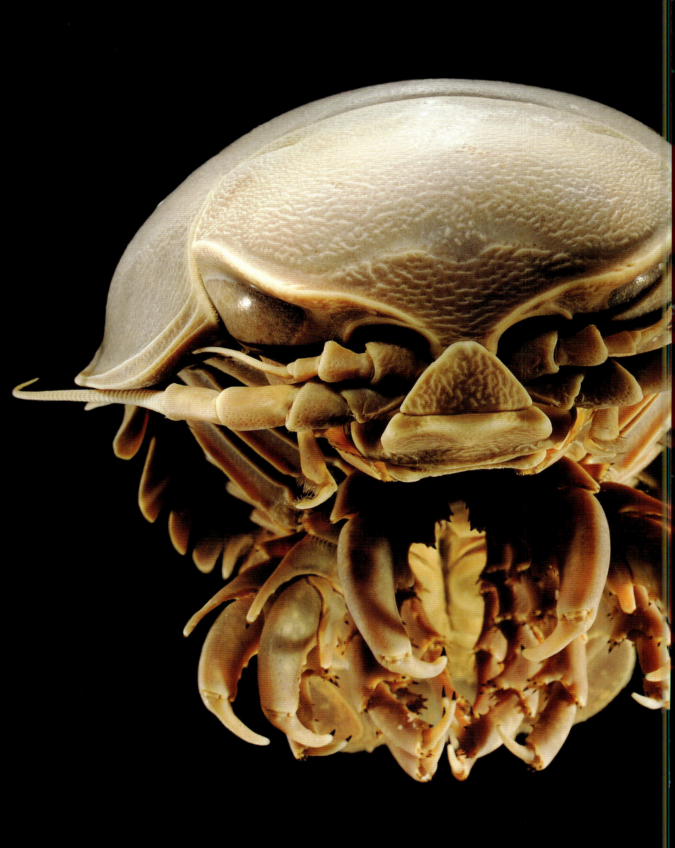

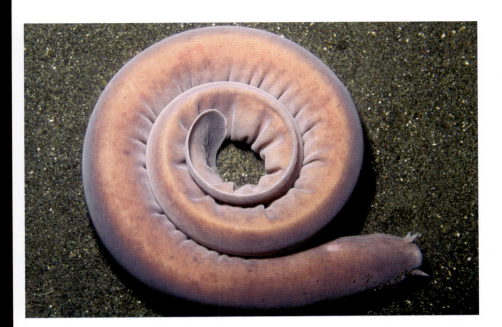

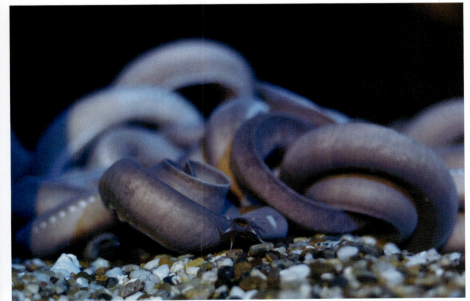

LEFT:
Giant isopod
This is a deep-sea crustacean that has many features in common with its terrestrial cousin, the woodlouse. However, growing to 15 cm (6 in) long, it is truly giant. The isopod lives on the sea floor, scavenging for the remains of animals such as whales that have fallen from above.

ABOVE TOP AND BOTTOM:
Pacific hagfish
Primitive tubular fish like this have been living on the sea floor for hundreds of millions of years. They are chiefly scavengers. Hagfish have no jaw, but instead have a spiral of teeth that they twist into corpses to drill out a cylinder of flesh.

Leafy seadragon
This relative of the seahorses lives along the southern coast of Australia. Its fins and appendages resemble seaweeds and it lingers in weedy spots sucking up microscopic foods through its tubular snout. This way of life is shared by seahorses. All are at great risk from pollution and habitat destruction.

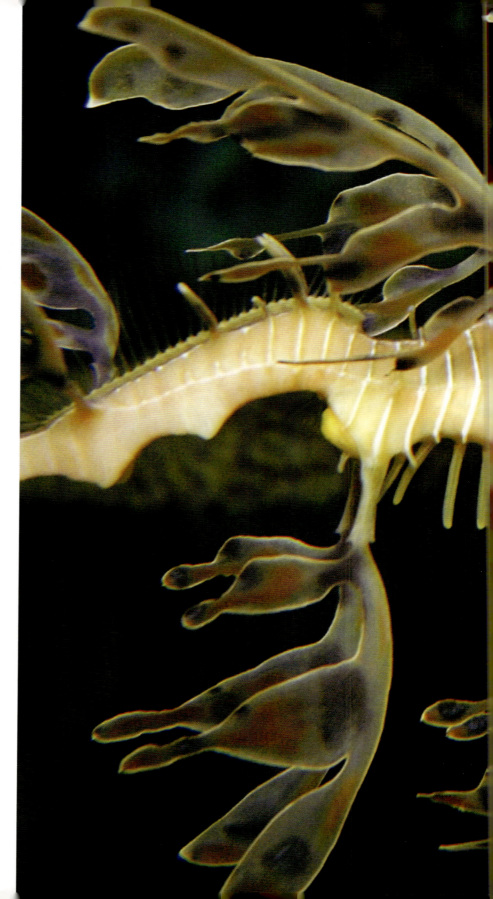

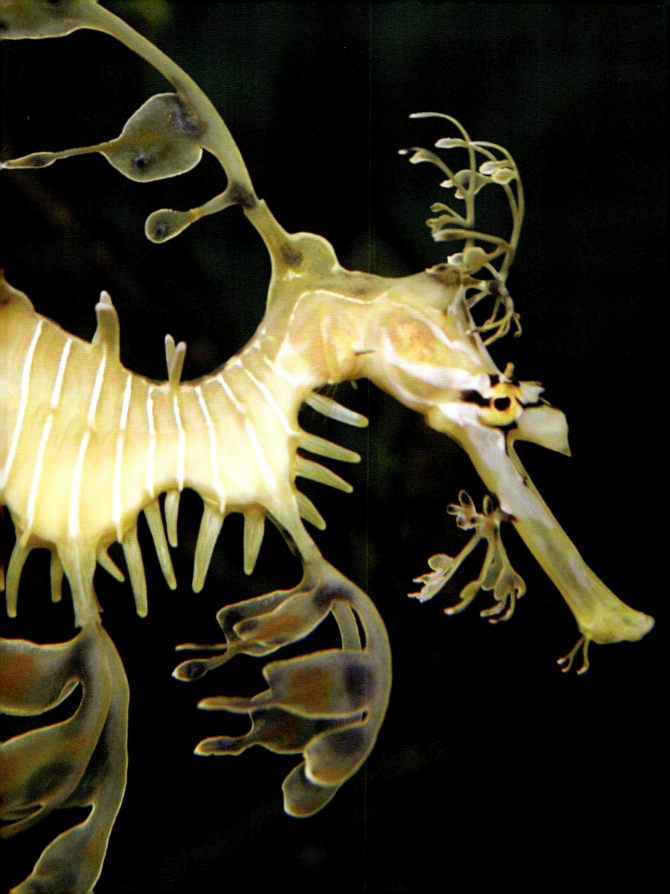

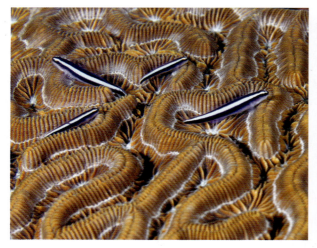

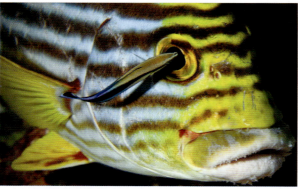

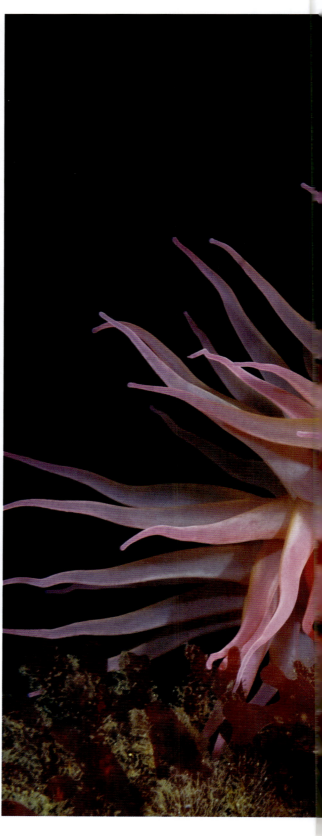

ABOVE ALL PHOTOGRAPHS:
Cleaner wrasse
These helpful little fish get their food supply from the bodies of other sea creatures. As their name suggests, they use their small pointed mouths to pluck off mites and other parasites as well as general organic gunk from larger creatures. Their hosts tolerate them and resist the urge to gobble up the little cleaner.

RIGHT:
Sea anemone
This is a sedentary relative of the jellyfish. It spends its life the other way up, with its tentacles pointing up and the body glued to a rock on the seabed. The tentacles are covered in poisoned stinger cells that jab into animals that brush past. The victim is then hauled into the central mouth.

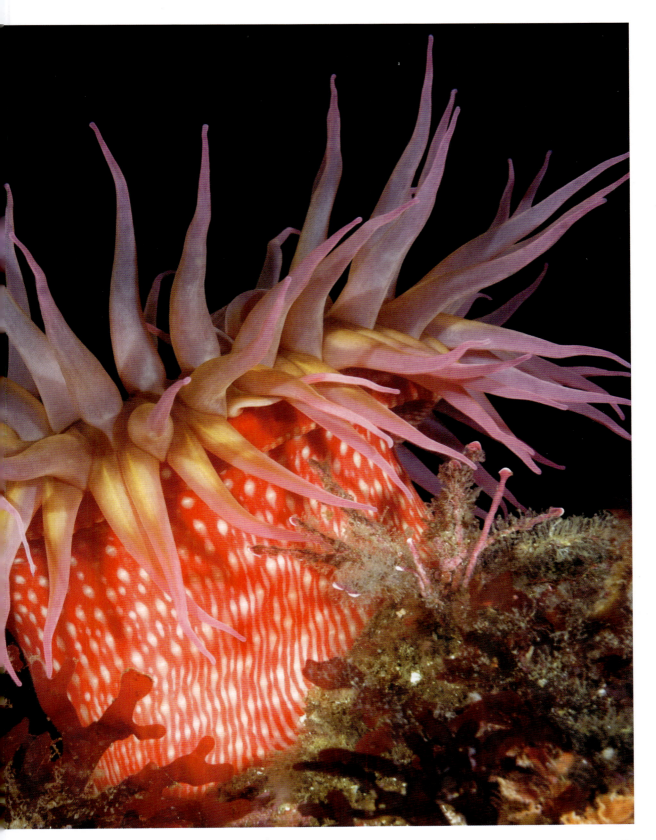

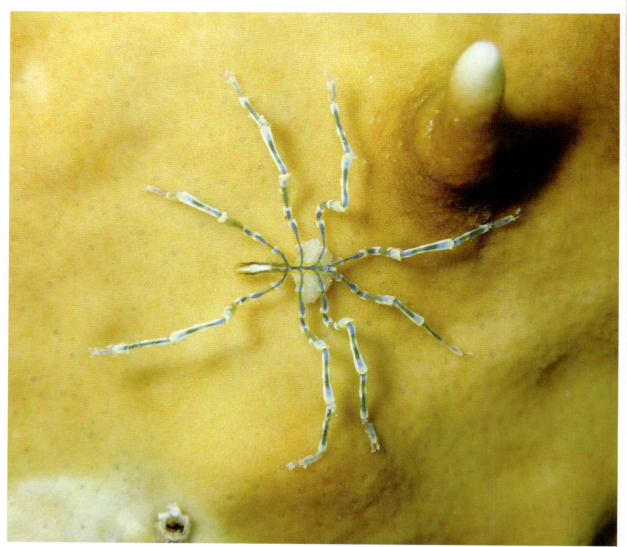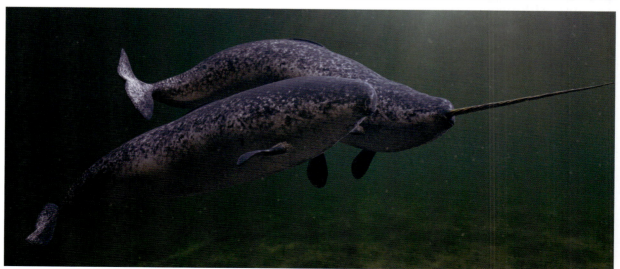

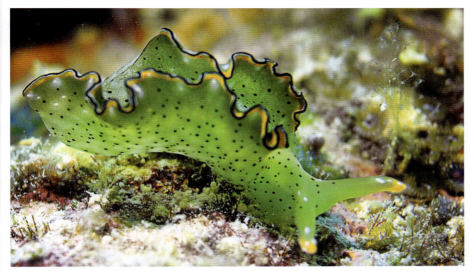

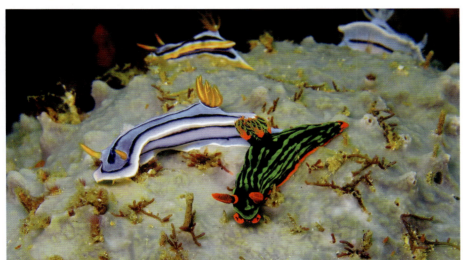

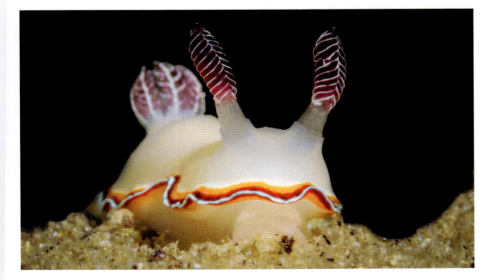

OPPOSITE TOP:
Sea spider
Spider by name but not by nature, this is an unusual distant relative of the arachnids that lives on the seabed, foraging for animal foods. They tend to be very small, perhaps only a few millimetres wide, but some grow to 70 cm (28 in) across.

OPPOSITE BOTTOM:
Narwhal
The unicorn of the sea, the male of this small toothed whale has a single straight, spiralled tusk that is in fact an enlarged front tooth. The length of the tusk is a sign of dominance, and it may also have sensory qualities. The narwhal is an Arctic hunter that sucks in fish and squid to its otherwise toothless mouth.

ALL PHOTOGRAPHS THIS PAGE:
Nudibranch
Also called sea slugs, these colourful ocean creatures are distant relatives of land snails. They have a shell for only the first stage of life, and then as adults, emerge as vibrant predators that eat sponges and assorted jellies, corals and shellfish. Denuded of their hard armour, the older slugs instead protect themselves with venomous appendages.

285

Index

Aadvark	220	Duck-billed platypus	224
African fat-tailed gecko	219	Dugong	192
African lion	18	Dumbo octopus	277
African wild ass	104		
African wild dog	106	Echidna	228
Alligator gar	255	Elephant beetle	260
Alligator snapping turtle	248	Eurasian lynx	78
American alligator	48	European sturgeon	172
American white pelican	246		
Andean cat	152	Flightless cormorant	158
Archerfish	226		
Asian elephant	124	Gerenuk	214
Asiatic black bear	22	Giant hornet	198
Atlantic puffin	274	Giant isopod	278
Axolotl	256	Giant panda	122
Aye-aye	112, 218	Giant tortoise	190
		Giant salamander	251
Bactrian camel	130	Giraffe	120
Badger	271	Giraffe weevil	212
Beaver	244	Golden dart frog	64
Bengal tiger	24	Golden snub-nosed monkey	134
Black-crested gibbon	126	Great white shark	9, 90
Black-footed ferret	153	Green anaconda	62
Black caiman	60	Grey wolf	80
Black rhinoceros	114	Grizzly bear	50
Blue whale	180		
Blue-ringed octopus	88	Hammer-headed bat	212
Box jellyfish	26	Harbour porpoise	182
Brazilian wandering spider	58	Harpy eagle	66
Brown bear	76	Hector's dolphin	183
Bull elephant	10	Hippopotamus	16
Bull shark	86	Hoatzin	258
Bullfrog	244	Honey badger	200
		Huon tree kangaroo	133
Californian condor	154		
Capybara	261	Iberian lynx	178
Caspian seal	150	Indian saw-scaled viper	28
Cheetah	12	Indian vulture	132
Chimpanzee	15		
Chincilla	156	Jaguar	68
Christmas tree worm	276		
Cleaner wrasse	282	Kea	228
Clouded leopard	127	Kiwi	237
Common chameleon	268	Koala	234
Common cuckoo	270	Komodo dragon	32
Common lancehead snake	61	Kookaburra	236
Common musk turtle	251		
Crowned sifaka	116	Land-based speedster	222
		Leaf insect	202
Death's-head hawkmoth	272	Leafy seadragon	280
Dhole	128	Leatherback turtle	186
Double-wattled cassowary	129	Leopard	35

286

Lion-tailed macaque	138	Sea spider	284
Lionfish	92	Seahorse	188
Long-footed potoroo	139	Secretarybird	108
		Scorpion	14
Macaroni penguin	160	Shoebill	102
Malleefowl	139	Siamese fighting fish	204
Maned wolf	70	Siberian tiger	82
Mandrill	110	Siberian sturgeon	205
Marabou stork	216	Snow leopard	34
Mediterranean monk seal	179	Southern bluefin tuna	194
Monarch butterfly	252	Spectacled bear	165
Mountain gorilla	119	Sperm whale	195
Mudskipper	208	Star-nosed mole	250
Musk ox	197	Steppe eagle	170
		Stingray	98
Narwhal	284	Stonefish	30
Nile crocodile	21	Strawberry poison-arrow frog	74
Nile lechwe	118	Sugar glider	240
Northern pudu	162	Surinam toad	264
Nudibranch	285	Sydney funnelhead spider	44
Ocean sunfish	194	Thorn bug	254
Orangutan	101, 140	Thorny devil	241
Orca	94	Three-toed sloth	263
		Tiger snake	38
Pacific hagfish	279	Tokay	206
Painted terrapin	143		
Pangolin	148	Vampire bat	266
Philippine eagle	142	Vancouver Island marmot	164
Pika	143	Vicuña	262
Polar bear	52		
Portugese man o' war	96	West Indian manatee	166
Proboscis monkey	210	Western diamond rattlesnake	54
Prsewalski's horse	146	Wētā	230
Puff adder	20	White-throated toucan	168
Puffer fish	94	Wild boar	84
Puma	46	Wolverine	56
		Wombat	242
Red howler monkey	267		
Red kangaroo	238		
Red panda	144		
Red-bellied piranhas	72		
Red-breasted goose	176		
Red-crowned crane	136		
Redback spider	40		
Reticulated python	36		
Rufous-headed hornbill	151		
Saiga	174		
Saltwater crocodile	42		
Sea anemone	282		
Sea otter	184		

Picture Credits

Alamy: 10 7 (Konstantin Kalishko), 17 top (Volodymyr Burdiak), 18/19 (Afripics.com), 22 bottom (Panther Media), 25 bottom (Panoramic Images), 26/27 (Helmut Corneli), 31 bottom (FLPA), 38 (Uwe Bergwitz), 39 (Jonathan Ayres), 52/53 (Judy Yaker/Dembinsky Photo Associates), 60 top (Jens Otte), 62 (Minden Pictures), 63 top (Robert Harding), 63 bottom (Imagebroker), 64 (Rod Williams), 65 top (Les Gibbon), 65 bottom (blickwinkel), 66 (Nature Picture Library), 68 (Giedrius Stakauskas), 69 top (Octavio Campos Salles), 74 top (Adrian Hepworth), 74 bottom (Klaus Ulrich Muller), 75 (Matthijs Kuijper), 79 (Mauritius images), 84 bottom (Lewis Thomson), 92 bottom (Stocktrek Images), 96 (Stephen Frink Collection), 97 top (Nature Picture Library), 102 (Zute Lightfoot), 103 (Ariadne Van Zandbergen), 104 (blickwinkel), 105 (FLPA), 109 (RooM the Agency), 111 bottom (Ger Bosma), 112/113 (RGB Ventures/Superstock), 116 (Ger Bosma), 117 & 119 (Nature Picture Library), 122 top (Dmitry Rukhlenko-Travel Photos), 126 (Xinhua), 128 (blickwinkel), 134 (F1online digitale Bildagentur), 139 top (Premaphotos), 143 bottom (Biosphoto), 144 (Robert Harding), 150 (Agami Photo Agency), 151 top (LUNA), 153 bottom (Nature and Science), 156/157 (Eric Gevaert), 159 (Robert Harding), 160/161 (Don Johnston-BI), 168/169 (F1online digitale Bildagentur), 176 (Mike Lane), 177 top (blickwinkel), 177 bottom (Joe Blossom), 186 bottom (Biosphoto), 187 (Scubazoo), 194 top (Natureworld), 195 bottom (Imagebroker), 196 (Giedrius Stakauskas), 198 (Phil Degginger), 205 top (ImageBroker), 208 top (blickwinkel), 208 middle (Robert Harding), 215 (Keren Su/China Span), 224/225 (Minden Pictures), 226 (Sara Sadler), 232 (Nature Picture Library), 236 (Ken Griffiths), 250 (Adisha Pramod), 251 top (Minden Pictures), 254 & 255 top (George Grall), 264 (Biosphoto), 265 bottom (Roberto Nistri), 271 (Stanislav Duben), 272 (Jeff Lepore), 277 top (Adisha Pramod), 278 (Nature Picture Library), 279 top (Mark Conlin), 279 bottom (Gina Kelly), 280/281 (Baronoskie)

Dreamstime: 9 (Ramon Carretero), 12/13 (Stu Porter), 14 (EPhotocorp), 15 (Sergey Uryadnikov), 16 (Heinrich Van Den Berg), 17 bottom (Artushfoto), 20 (Ecophoto), 21 top (Tjkphotography), 21 bottom (Johannes Gerhardus Swanepoel), 22 top (Jeeragone Inrut), 23 (Saranvaid), 24 (Jenslambertphotography), 25 top (Patrice Correia), 28 (EPhotocorp), 29 (Matthijs Kuijpers), 30 (Jxpfeer), 31 top (Wrangel), 32 top (Robert King), 32 bottom (Patrick Rolands), 33 (Anna Kucherova), 34 (Rgbe), 35 top (Stu Porter), 35 bottom (Altaoosthuizen), 36/37 (Scott Delony), 40/41 (Peter Waters), 42 top (Ken Griffiths), 42 bottom (Dwiputra18), 43 (Rafael Ben Ari), 44/45 (Ken Griffiths), 46/47 (Geoffrey Kuchera), 48/49 (Simonwehner), 50 (Derrick Neill), 51 top (Windowsontheworldphotography), 51 bottom (Dennis Donohue), 54/55 (Mikael Males), 56 (Moose Henderson), 57 top (Denisa Prouzova), 57 bottom (Dennis Jacobsen), 58 (Viniciussouza06), 59 (Tacio Philip Sansovski), 60 middle (Tristan Barrington), 61 (Ondrej Prosicky), 69 bottom (Kwitkor), 70/71 (Lukas Blazek), 78 (Christian Schmallhofer), 82 (Andrey Gudkov), 83 bottom (Vaclav Sebek), 84 top (Erik Mandre), 85 (Jens Klingebiel), 86/87 (Martin Prochazka), 91 top (Sergey Uryadnikov), 91 bottom (Ramon Carretero), 92 top (Asther Lau Choon Siew), 94 top (Allnaturalbeth), 94 bottom (Michael Herman), 98 top (Rafael Ben-Ari), 98 bottom (Cigdem Sean Cooper), 108 (Villiers Steyn), 110 (Cheryl Braye), 111 top (Lukas Blazek), 120/121 (Paul Banton), 123 (Minyun Zhou), 127 (Slowmotiongli), 132 (Sourabh Bharti), 133 top & bottom (Lukas Blazek), 135 (Liqiang Wang), 136/137 (Ondrej Prosicky), 139 bottom (Whitepointer), 141 (Luke Wait), 142 (Edwin Verin), 143 top (Cabinpress), 148/149 (Matthijs Kuijpers), 153 top (Paul Reeves), 154 (Christopher Moswitzer), 155 bottom (Mattscott), 158 (Martinmark), 164 (Anothergecko), 166/167 (Philip Lowe), 170/171 (Ondrej Prosicky), 174 (Mikhail Gnatkovskiy), 178 (StockPhotoAstur), 179 (Burnel1), 182 (Colette 6), 184 (Zastavkin), 185 top (Chase Dekker), 185 bottom (Jean Edouard Rozey), 189 (Richard Carey), 192/193 (Berdneeser), 195 top (Ruth Lawton), 200/201 (Wrangel), 202/203 (Mgkuijpers), 217 bottom (Sletse), 218 (Rinusbaak), 219 (Crysrob), 220 bottom (Paparico), 221 (Kaprik), 228 top (Pelooyen), 228 bottom (Xixau), 234 (Titicaca), 238 (Bennymarty), 239 top (Samantzis), 240 (Pleprakaymas), 241 top (Uwebergwitz), 241 bottom (Markrhiggins), 242 bottom (Marco3t), 245 (Jnjhuz), 249 bottom (Nopow), 251 bottom (Mgkuijpers), 252 (Albertoloyo), 253 top left & bottom (Gkapor), 255 middle (Kinnon), 255 bottom (Izanbar), 257 bottom (Hdamke), 261 top (Hdamke), 261 bottom (Oakdalecat), 262 (Edurivero), 263 (Janossygergely), 265 top (Dervical), 266 bottom (Gezafarkas), 267 (Salparadis), 268/269 (Mgkuijpers), 270 top (Howardk3), 273 top (Krjaki1973), 273 bottom (Prosunpaul006), 274 top (Alitaylor), 275 (Daviesjk), 276 (John Anderson), 282 top (Neese), 282 middle (Bip), 282 bottom (Mattiaath), 283 (Kelpfish), 284 bottom (Planetfelicity), 285 top (Aminorazmi)

NOAA Ocean Exploration/Attribution-share alike 2.0 Generic: 277 bottom

Shutterstock: 6 (Next is nicer-k-R7), 10/11 (CherylRamalho), 60 bottom (Uwe Bergwitz), 67 (feathercollector), 72/73 (Andrey Armyagov), 76/77 (Erik Mandre), 80/81 (Vlad Sokolovsky), 83 top (Jan Stria), 88/89 (elena_photo_soul), 90 (Alessandro De Maddalena), 93 (Michael Siluck), 95 (Love Lego), 97 bottom (NFKenyon), 99 (Serena Kelly), 101 (Sergey Uryadnikov), 106 top (Charles Hopkins), 106 bottom (Seyns Brugger), 107 (William Steel), 114/115 (Travel Stock), 118 (Danny Iacob), 122 bottom (gary718), 124/125 (Nachiketa Bajaj), 129 (CharlieWaradee), 130/131 (Mehmet O), 138 (NileshShah), 140 top (Kitch Bain), 140 bottom (Boule), 145 (Lubos Chlubny), 46/47 (Yantar), 151 bottom (Zuzana Gabrielova), 152 (Luis D Romero), 155 top (Real Deal Ruth), 162/163 (Helge Zabka), 165 (Ronald Wittek), 172/173 (Olga Alper), 175 (Nikolai Denisov), 180/181 (Chase Dekker), 183 (CarmenRL), 186 top (SLSK Photography), 188 (Andrea Izzotti), 190/191 (Pavel Korotokov), 195 bottom (wildestanimal), 199 (Thomas Lenne), 204 (Witoon Boonchoo), 205 bottom (Arunee Rodloy), 206 top (khlungcenter), 206 middle (Lauren Suryanata), 206 bottom (Wayan Sumatika), 207 (Lauren Suryanata), 208 bottom (Twospeeds), 209 (aDam Wildlife), 210 (Ken Griffiths), 211 top (Syarief Rakh), 211 bottom (Vasilyiakovlev), 212(Alex Stemmers), 213 top (Krisda Ponchaipulltawee), 213 bottom (Mgkuijpers), 214 top (Buckskinman), 215 bottom (Traci Beattie), 216 (Peter Schwarz), 217 top (Paco Como), 220 top (Attila Jandi), 222 & 223 top (Ken Griffiths), 223 middle (Slrphotography), 223 bottom (Ken Griffiths), 227 (Wirestock Creators), 229 (Lost in Time), 230/231 (Brian Donovan), 233 (Wirestock Creators), 235 (EQRoy), 237 (Vee Snijders), 239 bottom (K.A.Willis), 242 top (Ken Griffiths), 243 (Gekko Gallery), 244 top (Chris Hill), 244 bottom (Wasin Suriyawan), 246/247 (Jerek Vaughn), 248 (Mgkuijpers), 249 top (Sista Vongjintanaruks), 256 (ArnPas), 257 top (Andrea Izzotti), 258/259 (Morten Ross), 260 (Pablo Jacinto Yoder), 270 bottom (John Navajo), 274 bottom (D Rose), 284 top (Kyle Lippenberger), 285 middle (blue-sea.cz), 285 bottom (Sonja Ooms)